D1479859

THE FACE

OUR HUMAN STORY

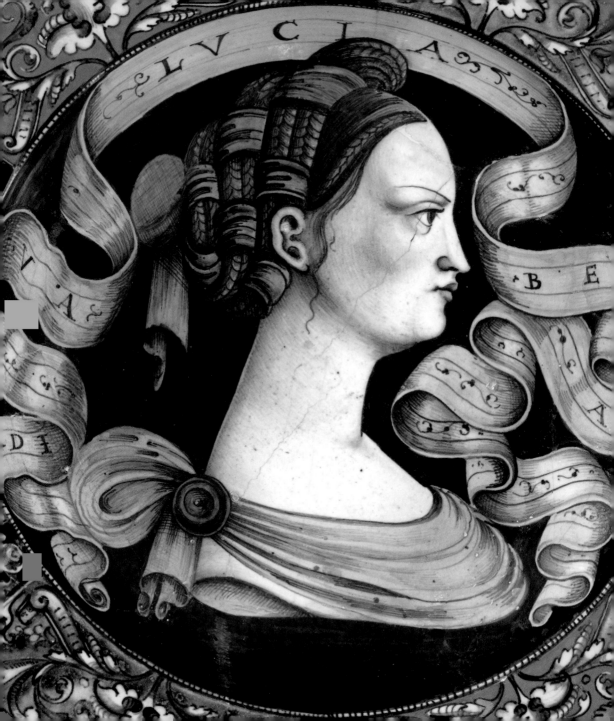

THE FACE

OUR HUMAN STORY

DEBRA N. MANCOFF

WITH 363 ILLUSTRATIONS

Thames & Hudson The British Museum

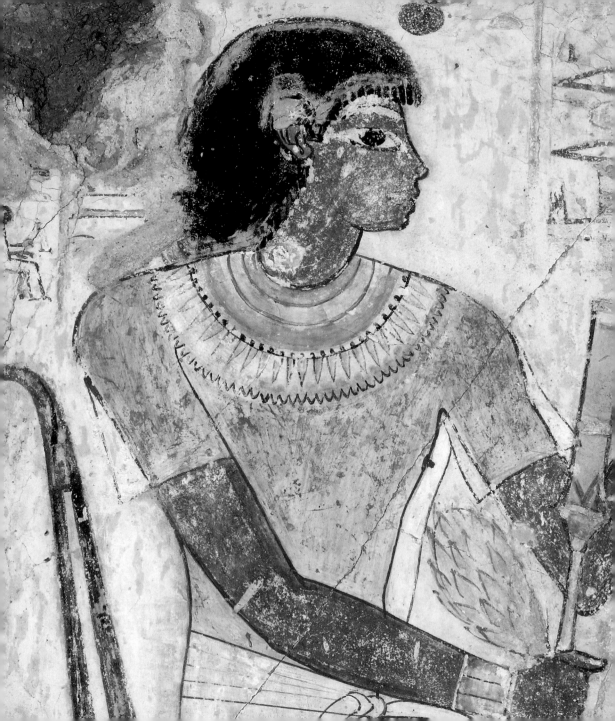

Contents

Introduction

WHEN A CHILD draws a picture of a person, the body may be no more than a suggestive summary of lines and volumes, but the face is dominant and well delineated. Even in the most rudimentary depiction, the head is large and facing front, framed by a strong outline and a halo of hair. The most mobile features – eyes, eyebrows and mouth – are emphasized, conveying energy and expression. Whether looking out with a wide-eyed stare, an open mouth, a grimace or a grin, that simple representation of a face carries a powerful message: here I am, and I am human.

The face is small in proportion to the rest of the body – no more than the front of the head to the tip of the chin – but its features play an outsized role in human experience. The main receptors for our senses of sight, smell, taste and hearing are located in or around the face, and our facial skin is highly sensitive and responsive to touch. Forty-three muscles, supported on fourteen bones, control both the reflexive and the deliberate movements of our facial features; our faces are never completely still. Our facial appearance places us within broad divisions of humanity – age, race, gender – but no two faces are exactly alike. We distinguish one person from another by looking at their face. Our features change with our thoughts and moods, suggesting that our facial expressions are a window to our hearts and minds.

We engage one another with our faces. Newborn babies will establish their first human connection by searching for their mother's face. An infant's limited but powerful ability to convey their wants and needs through facial expression led Charles Darwin to label smiling, laughing and crying as universal in his 1872 study *The Expression of Emotions in Man and Animals*. Later anthropologists, led by Franz Boas in the early twentieth century, refuted Darwin's assertion, arguing that facial expression is culturally specific and a learned skill, rather than an innate response. Investigations of recent decades strike a balance between instinct and culture, nature and nurture. Studies reveal that within the first year of life, most infants acquire – and successfully employ – a basic repertoire of facial expressions.

OPPOSITE
Mask depicting Xiuhtecuhtli,
one of the Turquoise
Mosaics
Mixtec-Aztec, 1400–1521
Mexico
Wood, turquoise and shell
H 16.8 cm, W 15.2 cm

PAGE 8
Studies of a seated Arab
Eugène Delacroix
(1798–1863)
1832
French
Black, red and white chalk
H 30.8 cm, W 27.4 cm

PAGE 9
Silver medallion showing
Hadrian (obverse)
c. AD 119–122
Minted in Rome, Italy
Diam. 3.8 cm
See also p. 234

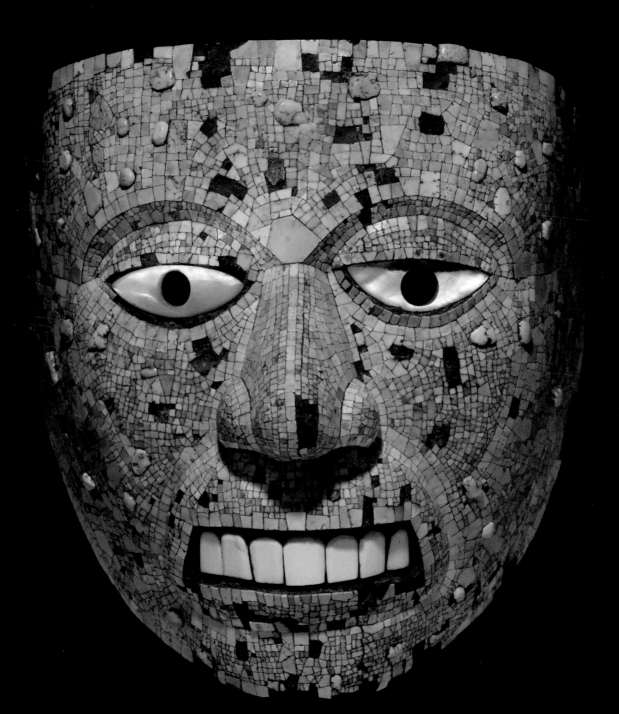

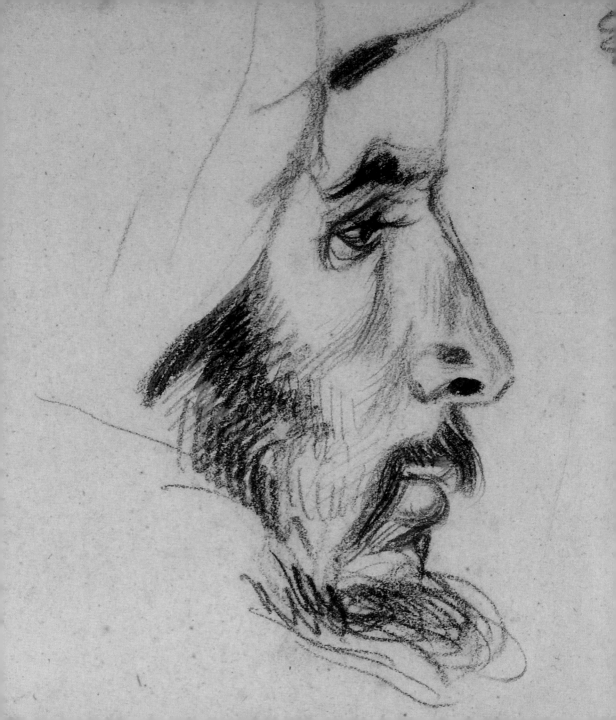

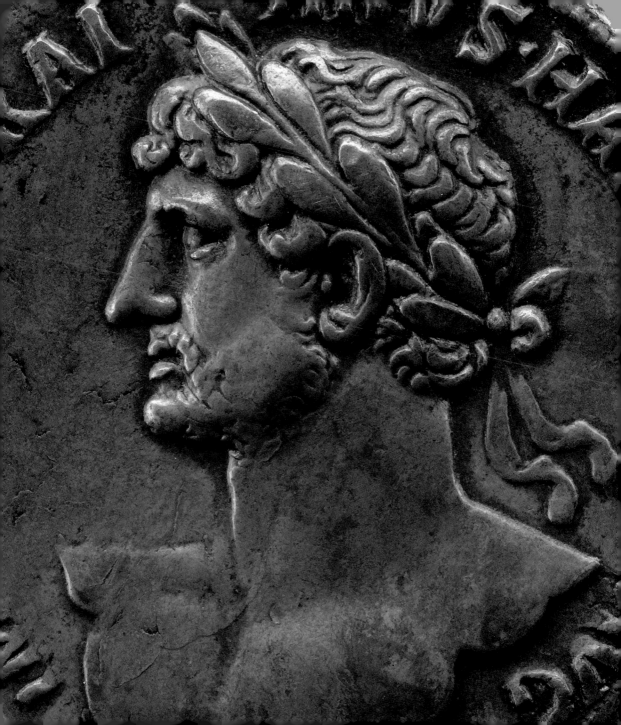

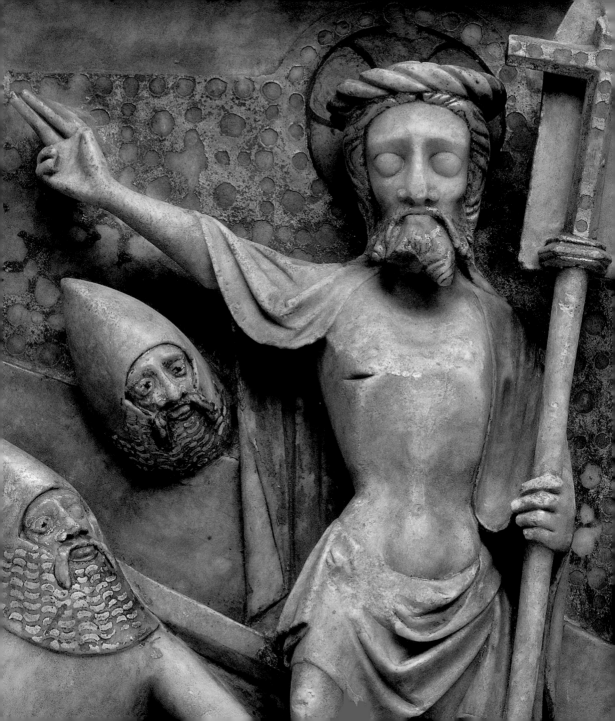

OPPOSITE
Panel of the Resurrection
c. 1370
Made in England
Alabaster
H 42.5 cm, W 29.5 cm
See also p. 294

PAGE 12
A 'passionate beauty' sitting
on the floor combing her hair
Made by the Chore Bagan
Art Studio
1850–1950
Found in Calcutta
Colour lithograph
H 40.5 cm, W 30.5 cm
See also p. 100

PAGE 13
The Tragic Muse
Anonymous, in the style of
Richard Cosway (1742–1821)
1730–1800
British
Pen and brown ink over
graphite
H 29.2 cm, W 23.5 cm

They smile or open their mouths and widen their eyes in surprise shortly after birth. By three months infants furrow their features in distress and manipulate their mouths and tongues to convey disgust. By seven months they master the signs of anger, with clenched features often giving way to an open-mouthed wail. But, while it is innately human to connect and communicate through facial expressions, the content of the expression depends upon cultural context and circumstance.

We learn to read facial expression as a language, building on the shared vocabulary of our community. Every culture has its own concepts of what a certain cast of features conveys. In English we speak of a stern mouth and impassive gaze as a brave face ready for any challenge. A long face – downturned mouth, sad eyes, lax facial muscles – displays disappointment. Subtle variations of a common facial gesture add complexity and nuance; even the slightest variance in a smile can hint at restraint, amusement, shyness or flirtation. A single feature can send a powerful signal: a gimlet eye, a stiff upper lip. The word 'face' embodies ideas about purpose and intention. Someone who is two-faced cannot be trusted; a difficult situation is best handled face to face. Something that is obvious and undeniable is as plain as the nose on your face. When circumstances are hard, we must face up to it. Most cultures associate an individual's face with their reputation. We strive to present our best face and avoid being shamefaced. A face has social value; it must be protected, can be saved, but it can also be lost. The elemental power of facial expression can transcend that of words; a popular African proverb suggests that sometimes the face can tell us what the lips can't say. But every culture warns us not to take an expression at face value; children quickly learn to feign smiles or to pout and frown to achieve their desires. In plotting to avenge his father's murder, Shakespeare's Hamlet observes that 'one may smile and smile and be a villain', while a Chinese commonplace warns that it is easy to know men's faces, but not their hearts.

Each individual face is a record of a unique fusion of genes, social custom and personal history. Some of us share common traits with others of our racial

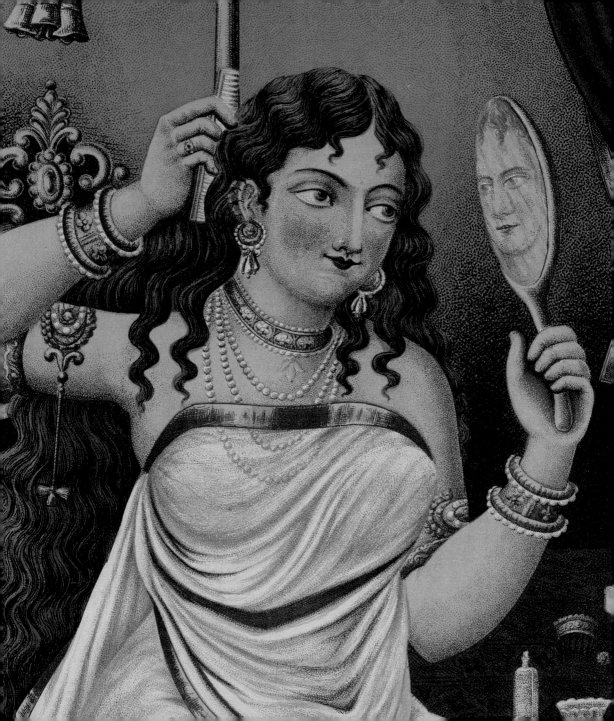

and ethnic heritage. Many of us bear a strong family resemblance to a parent or sibling, a distant cousin or an ancestor, but none of us, not even identical twins, look exactly alike. We mark and modify our faces with cosmetics, tattoos, scars and surgery to conform to the practice of our social affiliations. Our faces bear witness to the effects of weather, experience, age and injury. All these forces inscribe a manifest individuality, so much so that our faces become indistinguishable from our identity; indeed, in many cultures the face represents the whole being. We think of a friend or an acquaintance as a familiar face. We use the image of our face as a badge of identification, on our passports and our driving licences. There is a common, if unreliable assumption that a face is a guide to character. We identify people as kind or cruel, clever or dull simply by the set of their features, and we are surprised when proven wrong. Our faces function as a window to our thoughts and feelings and as a mirror of social attitudes and expectations; they connect our inner life with our outward experience.

All these factors – meaning, identity, emotion and connection – have made the human face the most potent and persistent subject in the history of art. Across time and cultures, depictions of the human face display an inherent significance, no matter the mode, medium or message. Just as infants seek their mother's face, we find the representation of a face endlessly compelling and a passageway to meaning in an unfamiliar work. Whether a perfect likeness of a renowned figure in history, a fragment of a facial feature or simply two dots and a crescent enclosed in a circle, we respond to the image of a face with a sense of recognition and identification, opening the way to engagement, empathy and cross-cultural understanding. Within its cultural and historical context, the representation of a face can carry the essence of national identity or spiritual belief. It can house memory, stir the heart or transform attitudes. It can ignite allegiance or incite violence; seen as an image of power, the representation of a face may even be prohibited, defaced or destroyed. It can also embody our common humanity.

OPPOSITE
Crowds at the Horse-riding Stunts at Ryōgoku
Utagawa Kuniyoshi (1797–1861)
1851–3
Japan
Woodblock triptych print
H 37.6 cm, W 25.4 cm (each panel)
See also p. 115

PAGE 16
Bust of a sleeping child wearing crepundia (amulets and charms) on a cord across his chest
1st–2nd century AD
Marble
H 26 cm

PAGE 17
Mummy portrait of a woman
AD 100–120
Found in Hawara, Egypt
Encaustic on limewood
L 38.2 cm, W 20.5 cm

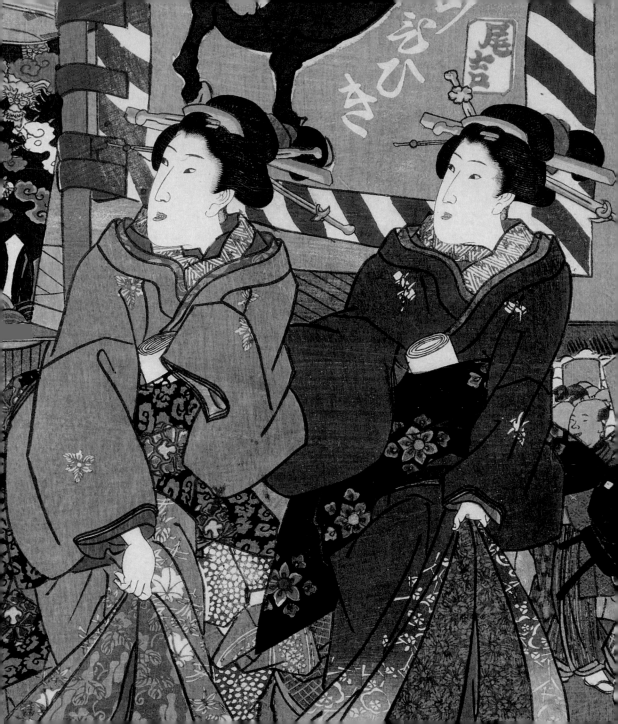

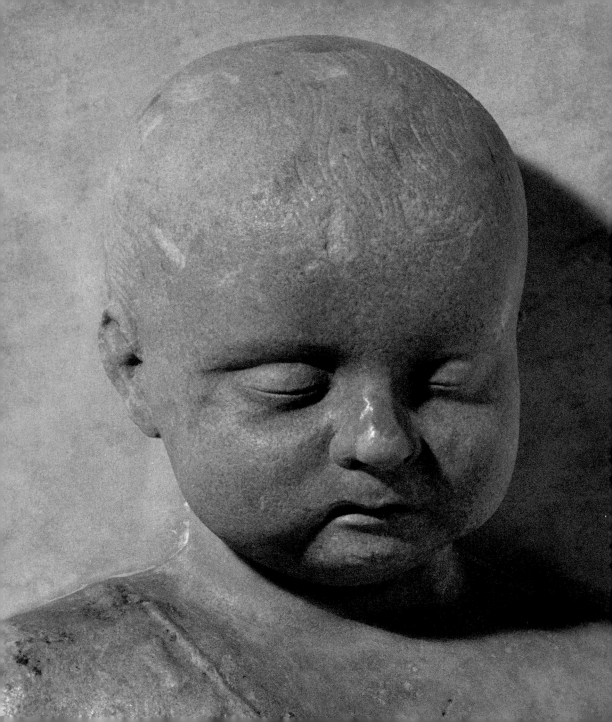

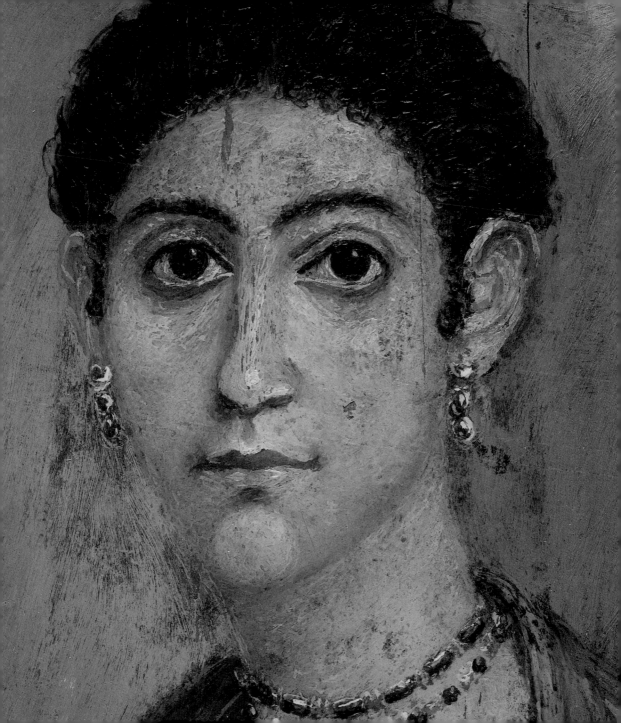

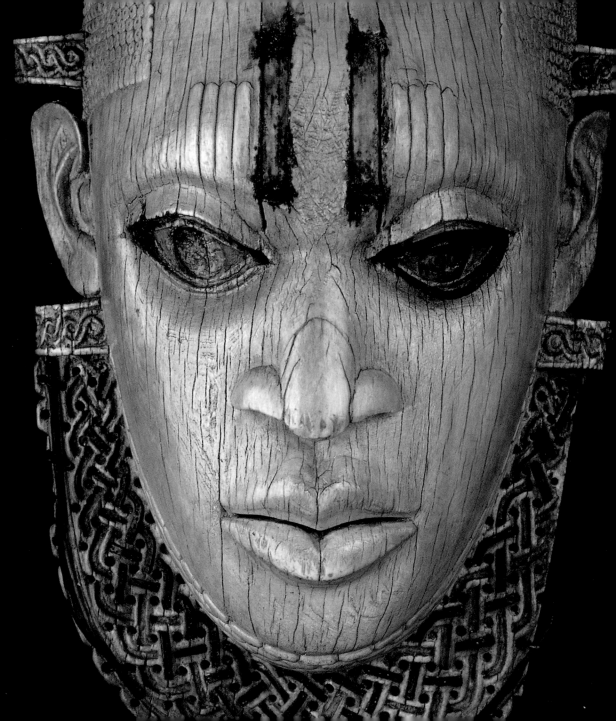

Pendant mask associated
with Queen Idia
16th century
Benin, Nigeria
Ivory with iron and copper
inlays
H 24.5 cm, W 12.5 cm
See also p. 172

In the pages that follow, we explore the human experience through the depiction of the face in art. The objects, selected from the rich and varied collections of the British Museum, span history, cultural diversity and the globe. Each chapter highlights an aspect of the human experience through a universal theme. 'Birth & Childhood' explores the importance of shared glances and facial expressions in welcoming an infant into the world, and how children's faces chart the often unsettling journey from innocence to experience. In 'Love & Beauty' the face reflects every aspect of human passion and attraction, and reveals how beauty is seen and defined through the lens of love. 'Everyday Life' looks at our daily round of activities: waking, eating, working, play and rest. Whether deep in concentration, daydreaming, sharing a joke or sighing in contentment, our faces offer an intimate glimpse of our private lives. In 'Faith & Ritual' the human face is depicted to symbolize the spirit, incarnate divine authority, and give a familiar physical form to the intangible forces that affect our existence. The idea of putting a human face on a deity is so powerful that many religious practices have proscribed it. In the form of ancestor portraits, masks and icons, faces can transport us or connect us to a realm beyond our day-to-day existence. 'Rulers & Warfare' examines the images created to signify sovereignty and command, as well as those of the soldiers who serve and sacrifice. 'Identity & Disguise' reveals the delicate play between appearance and authenticity; we all adopt some mode of disguise, whether it be the right facial expression for a particular circumstance, temporarily or permanently altering our natural looks or covering our faces with a veil or mask. Finally, 'Death & the Afterlife' reflects upon our response to the end of known life and how we face the enigma of what may come next. From the ebbing of vitality to the portrayal of lifelessness, mourning and even the harbinger of our demise, we are compelled to put a face on death.

Within each of these chapters, every object has its own history and cultural significance. But taken as a whole, these objects tell our story – the human story – as seen in and through the representation of the face.

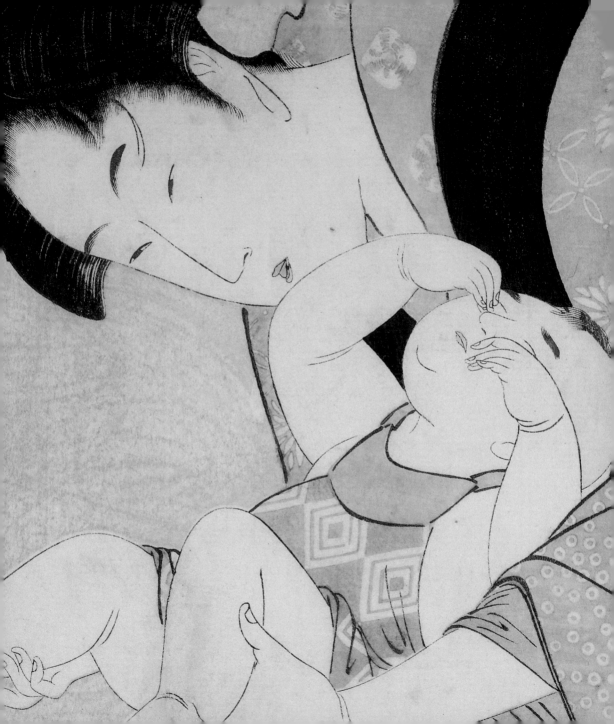

1 Birth & Childhood

MOMENTS AFTER BIRTH, newborns fix their gaze upon their mother's face. The sum of her features, in form and expression, orients them to their new and bewildering world. Throughout the first weeks of life, babies seek out faces, staring in fascination at eyes that blink and dart, at lips that form words, at brows that wrinkle, at heads that tilt and turn. They are drawn to face-like objects, preferring them to other forms. Babies quickly develop the ability to distinguish between faces: this is my mother's, that is not. And, as they learn to return and hold a glance, the face of their mother becomes their lodestar, building their sense of safety, security and love (pages 28–9).

In depictions that range across time, cultures and geographic borders, we recognize this elemental relationship in the gentle but firm embrace of mother and child, yet we understand the depth of that bond through facial expression. While the child's guileless features convey every nuance of emotion, the mother's looks are tempered, ever concerned with the child's comfort and contentment. The intimacy of face-to-face encounters with loving adults develops an infant's connection to the outer world (page 33). The fixed stare transforms into an exchange of glances, and the infant quickly discovers which expressions command attention, and how a smile encourages that glance to linger.

Babies are born mimics. They purse their lips, stick out their tongues and widen and narrow their eyes, mirroring expressions that they see. Their artless charm wins them eye contact, attention and interaction. There is a reason why all infant mammals have appealing features: unable to survive on their own, they must attract the stronger, older and wiser of their kind to care for them (pages 34–5). With their large eyes, chubby cheeks, soft skin and rosebud lips, human babies turn vulnerability into allure.

Very young children project their desires and reactions through unguarded facial expression. They furrow their brows in frustration and anger; they pout if dissatisfied and open their mouths wide in delight. A hungry child will reach for food with her lips as well as her hands, but will clamp them shut if the taste

displeases her. And crying children surrender to sorrow, distorting their features to convey their dismay. Their skin flushes with the effort of expressing such intense emotion, and they stretch their mouths to capacity, inhaling deeply to power each full-throated sob (pages 36–7). Children sleep with sprawled limbs and weighty bodies, but flickers of motion continue to animate their faces, revealing a constant response to physical sensations and the fleeting thoughts of a resting mind.

As children grow and come to inhabit a wider world, they must refine and extend their fluency in reading other faces. One way they do this is through play. Children gravitate to toys with faces; they bond with animals and objects – as well as dolls – that are anthropomorphized with a familiar set of human features. When a doll has no face, the child treats it as a blank slate or a mirror, picturing smiles and frowns that facilitate imaginative interaction. When fully engaged in play, some children exhibit total and unselfconscious absorption. Their focused gaze and set lips announce that nothing can interrupt their concentration. The sheer joy of play can inspire a beaming smile, aimed at the world and anyone who happens to notice (pages 44–5). The dynamics change when a playmate is present; children use their expressions in a more calculated way, signalling mutual regard and reciprocal feelings, as well as dislike or distrust. Through play, children learn to negotiate society and how to make their faces suit their circumstances.

Children age and their faces change. By their sixth year they begin to lose their milk teeth; the size and shape of permanent teeth give a harder set to the mouth. Noses become more pronounced, forecasting an adult profile, and cheeks start to lose their rounded contours and rosy glow. But more than a transformation of features, the transformation of expression marks a child's passage from childhood to adolescence. The impulsive display of simple joy, unabashed misery or unconstrained fury is replaced with a far more complex range of emotional intensity, shaded by such new concerns as identity, self-consciousness and temperament (pages 50–1). The open face of childhood gives way to the cautious and cryptic face of youth, a bulwark against the new and often perplexing experience of adolescence.

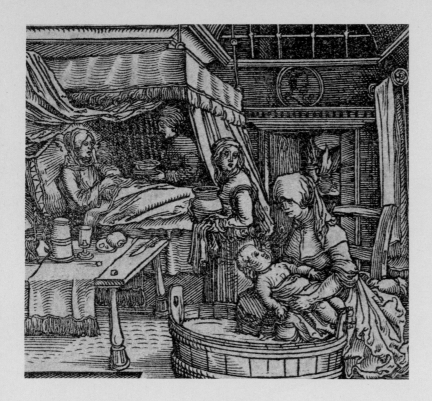

The Essential Bond

With wide-eyed wonder, the midwife's assistant in Hans Weiditz's woodcut looks at the infant Virgin cradled in the midwife's arms. Drawn to the child's presence, she tilts her head in tender regard, her lips encircling a silent sigh. Her pause in her duties may be brief, but its purpose is powerful: her reverent glance conveys the marvel of the moment. Whether mother or midwife, the caregiver bonds to an infant with her gaze – an unspoken promise of compassionate care and abiding love.

The Birth of the Virgin
Hans Weiditz (*c.* 1500–1536)
c. 1520
German
Woodcut on paper
H 6.8 cm, W 7.3 cm

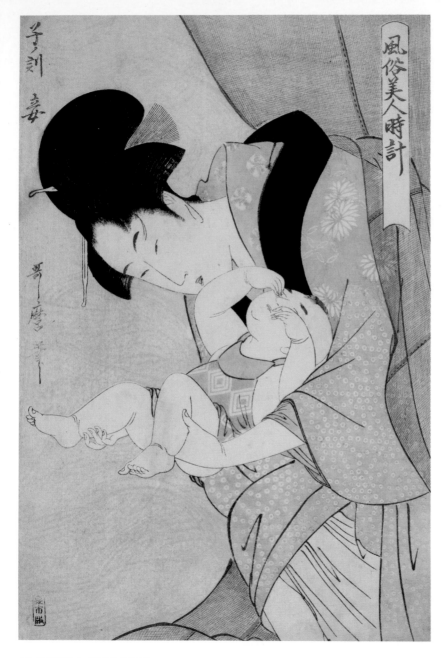

*Mother and Child under
a Mosquito Net*
Kitagawa Utamaro (died 1806)
c. 1798–9
Japan
Woodblock print
H 37.8 cm, W 24.7 cm

Embroidery panel depicting
the Nativity with the Virgin, Child,
an angel and an ass
1310–40
Made in England
Silk, linen
H 53.5 cm, W 24 cm

'I think my life began with waking
up and loving my mother's face.'

George Eliot, *Daniel Deronda*, 1876

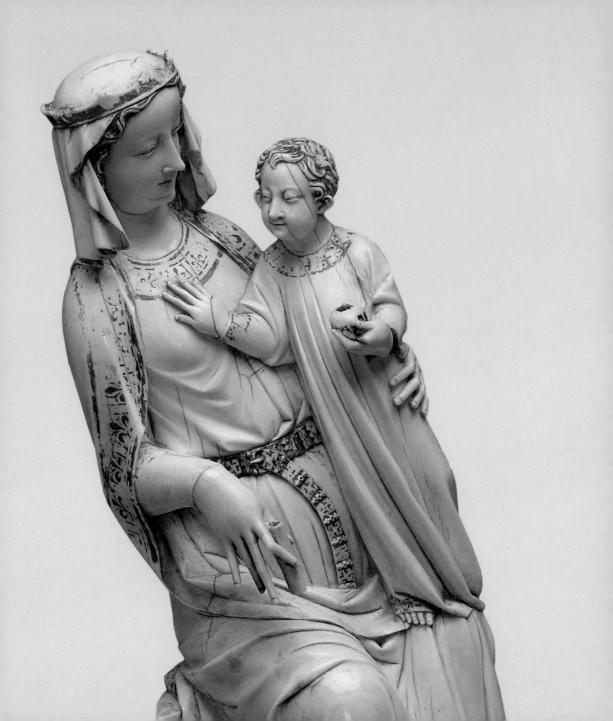

OPPOSITE

Statuette of the Virgin and Child
c. 1310–30
Made in Paris, France
Ivory
H 33.2 cm, W 11.8 cm

RIGHT

Mother with a Child on Her Arm
Käthe Kollwitz (1867–1945)
1910
German
Etching, printed in black and
overworked with brown wash
on cream paper
H 19.7 cm, W 13.1 cm

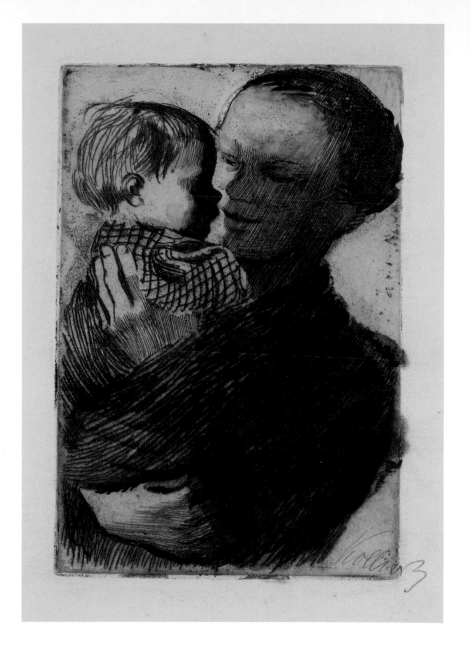

The bond between a mother and her child is expressed through gesture. The firm hold of a mother's hands – gentle yet secure – steady the child and physically convey reassurance. But a mother's face reveals the deep concerns of the nurturer's role as a compassionate protector, defining the essential and purposeful significance of an iconic dyad.

BELOW, LEFT
Pottery figurine of a woman holding an infant
Middle Cypriot, c. 2100–1900 BC
Made in Cyprus
Red polished ware
H 26 cm

BELOW
Portrait of an Egyptian woman carrying a young child
Photographed by McCarthy
1886
Egypt
Photographic print
H 26.2 cm, W 22.3 cm

OPPOSITE
The Virgin and Child
Raphael (1483–1520)
1509–11
Italian
Black chalk and/or charcoal
H 70.7 cm, W 53.3 cm

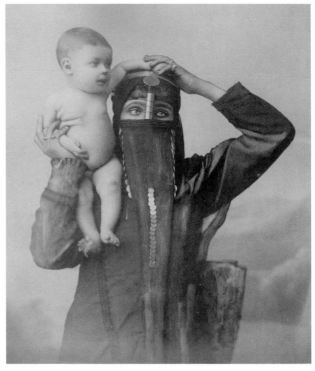

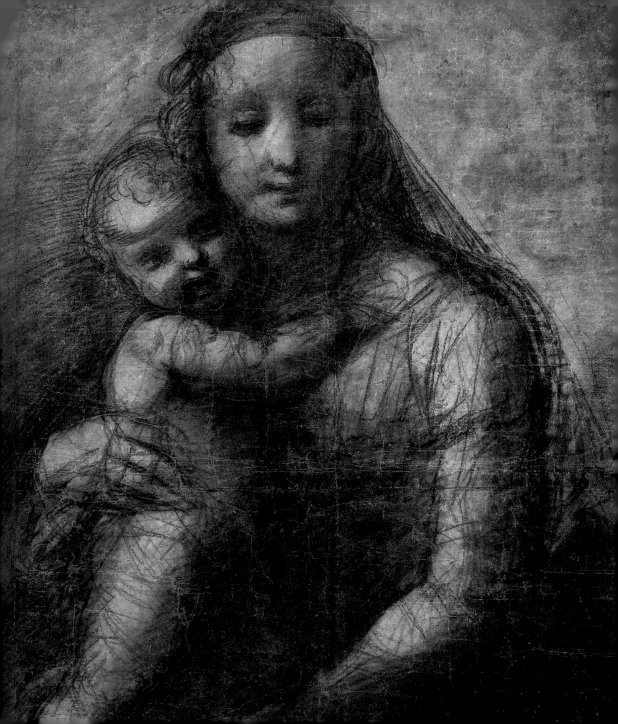

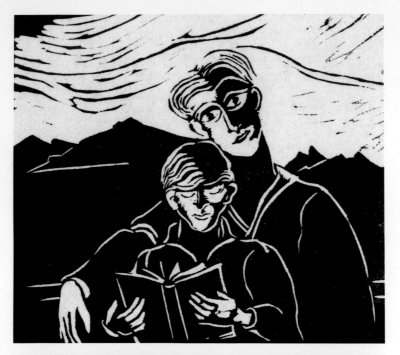

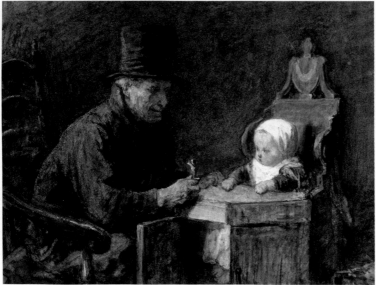

LEFT

**Father and son against
a mountain landscape**
Bettina Adler (1913–1993)
1988
British
Linocut
H 19.5 cm, W 17.5 cm

LEFT, BOTTOM

**An old man in a top hat playing
with a child**
Jozef Israëls (1824–1911)
After 1839
Dutch
Black chalk, watercolour and
bodycolour
H 26.3 cm, W 35.7 cm

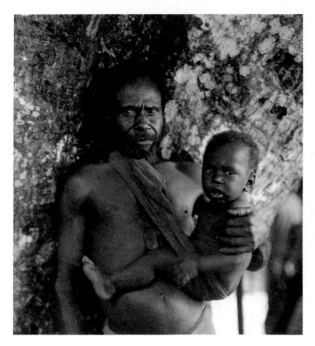

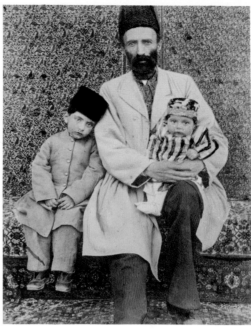

Portrait of a father and child
taken in the Solomon Islands
Photographed by John Watt
Beattie
1906
Lakona Bay, Vanuatu
Photographic print
H 14.8 cm, W 19.9 cm

Lantern slide showing a father
with two children
c. 1900
From Iran

Whether father, grandfather, brother or family
friend, a man uses facial expressions as well as
gestures to settle children into their place in society.
The photographs above convey the immediacy of
a caring and affectionate father's devotion to his
offspring, providing security yet allowing them to turn
their gaze towards the wider world. Bettina Adler's
linotype of her husband and son (opposite, top)
captures a similar moment, but filtered through
memory. Her husband had just died, and she chose
to recall the time thirty years earlier when, with tender
encouragement, he had taught their son to read.

Baby Face

The soft contours and delicate features of babies' faces endear them to their caregivers. The infants portrayed here – a future king of England, an anonymous boy from the early Qing dynasty, a prince and princess of the House of Bourbon – all have large eyes, plump cheeks and rose-bud lips. Their charming and vulnerable looks prompt us to engage with them in play and protection. Infants rapidly master a repertoire of articulate expressions – happiness, interest, anger, even disgust – mimicking and experimenting as they learn to make the faces that have meaning in their world.

BELOW, LEFT
Edward Prince
Portrait of Edward VI when an infant Prince of Wales
Print made by Richard Dalton (c. 1715–1791) after Hans Holbein the Younger (1497/8–1543)
After c. 1730
British
Etching, hand-coloured
H 24 cm, W 17.5 cm

BELOW
Figure of a boy, standing on a plinth and holding a vase containing a lotus bud and leaf
Qing dynasty, 1662–1722
Jingdezhen, China
Porcelain
H 28 cm, W 7 cm

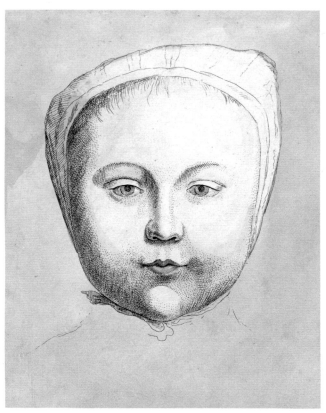

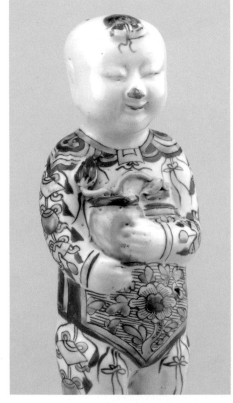

Busts of Prince Louis Charles
de Bourbon and Princess Marie
Zephirine de Bourbon
Originals modelled by Johann
Joachim Kaendler in 1755
Made by Meissen Porcelain
Factory, Germany
Porcelain
Each bust: H 16.1 cm, L 6.2 cm
(base)

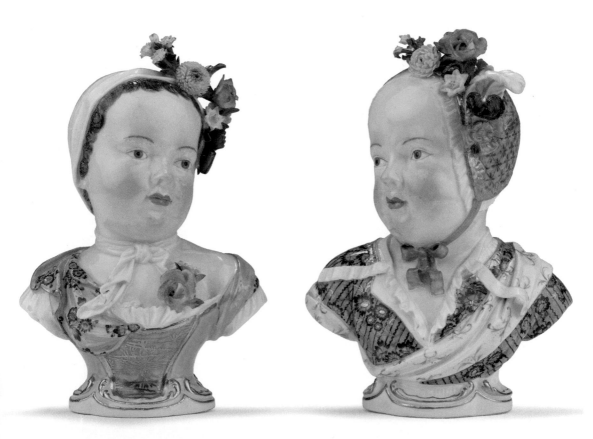

Crying

ABOVE
A boy crying, one of nine
heads copied or adapted from
Hudibras, *A Harlot's Progress*
and *The Four Times of Day*
After William Hogarth (1697–1764)
1738–94
British
Pen and black ink
H 3.7 cm, W 3.5 cm

ABOVE, RIGHT
Crying girl with her hands raised
to her head
Wilhelm Süs (1861–1933)
c. 1894
German
Colour lithograph
H 30.4 cm, W 25.8 cm

RIGHT
US presidential election badge
of a baby crying
1984
Issued in the United States
Plastic, paper and metal
Diam. 7.6 cm

OPPOSITE
Head of a small girl crying
Phil May (1864–1903)
Production date unknown
British
Pen and black ink
H 41.4 cm, W 34.2 cm

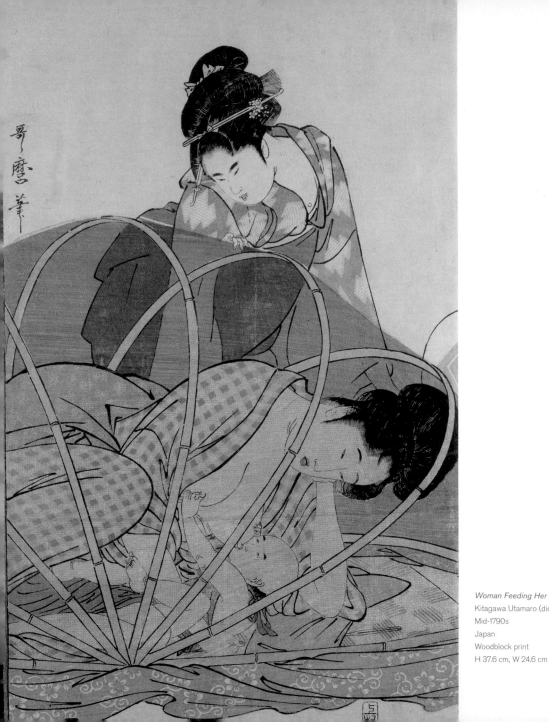

Woman Feeding Her Baby
Kitagawa Utamaro (died 1806)
Mid-1790s
Japan
Woodblock print
H 37.6 cm, W 24.6 cm

Feeding

A nursing child's face reveals the elemental need for nourishment. Once engaged in the act of feeding, very little can distract the hungry child; his eyes may dart, but an expression of intense concentration remains until he is sated. As his cheeks relax and mouth slackens, his eyelids flutter and close, submitting to contented sleep. Throughout, the mother or nursemaid's attention does not waiver; her face reflects concern, and her eyes are on only the child.

Mother and child
Nicolaes Maes (1634–1693)
c. 1655
Dutch
Red chalk, pen and brown ink
H 15.8 cm, W 12.2 cm

Sleeping

'There was never a child so lovely but his
mother was glad to get him to sleep.'

Ralph Waldo Emerson, *Journals*, 30 September 1837

RIGHT

**William Paedts as a child asleep
in a cradle with his nurse**
Frans van Mieris I (1635–1681)
c. 1664
Dutch
Black chalk on vellum
H 29.4 cm, W 23.3 cm

OPPOSITE

**Portrait of Mrs Abraham
Raimbach when a child**
Francesco Bartolozzi (1727–1815)
Production date unknown
Italian
Black and red chalk
H 21.5 cm, W 18.2 cm

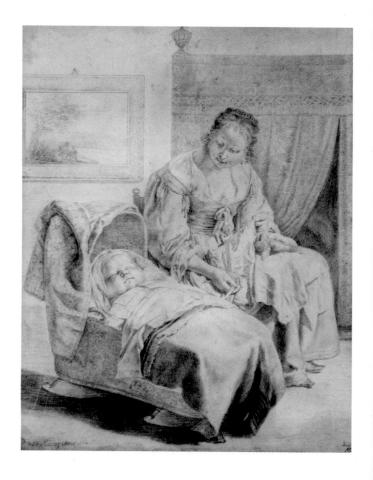

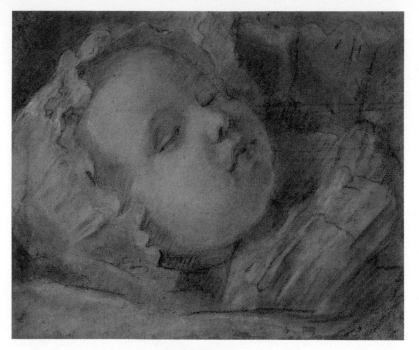

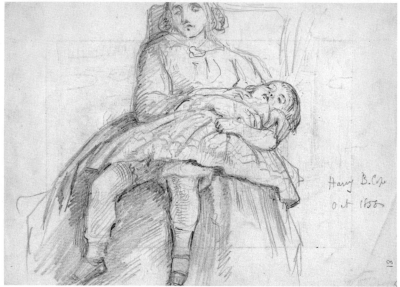

LEFT

Head of a sleeping child
William Hogarth (1697–1764)
c. 1740–2
British
Black and red chalk
H 22.8 cm, W 27 cm

LEFT, BOTTOM

**Woman seated on a chair with
a young girl sleeping on her lap**
Charles West Cope (1811–1890)
1858
British
Graphite
H 15 cm, W 21.3 cm

OPPOSITE

*Elegant Comparisons
of Little Treasures*
Kitagawa Utamaro (died 1806)
c. 1802
Japan
Woodblock print
H 38 cm, W 24.8 cm

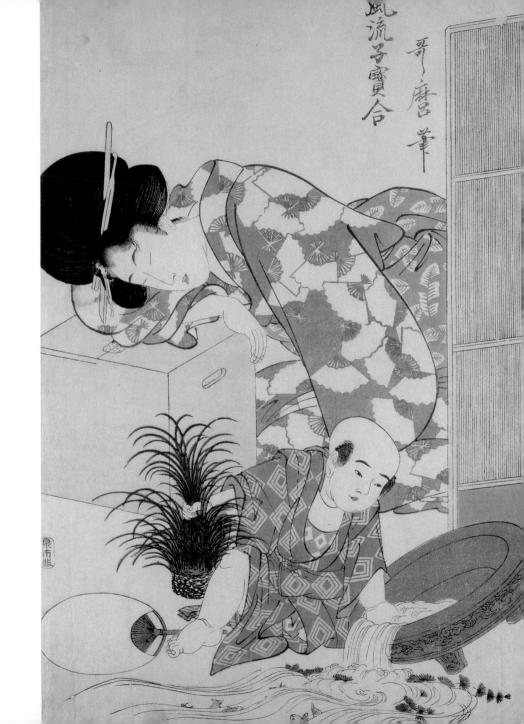

Play

As children discover the world through play, their faces reflect their every emotion. The Japanese *netsuke* (meaning 'to attach', from the object's original function of securing the ends of a silk cord on a pouch) depicts two boys engrossed in private but side-by-side play. Reaching into the fishbowl, the mischievous boy depicted in *Gold and Jade* concentrates on his catch. But the longevity symbols that surround him – as well as the fish, or *yu*, which is pronounced similarly to the character for 'plenty' – reveal that the print conveys a wish for happy, healthy sons.

BELOW, LEFT
Portrait of a child sitting on a swing on a veranda in Polynesia
1889–90
Photographed in Polynesia
Photographic print
H 14.9 cm, W 9.9 cm

BELOW
Two boys with a hobby horse, *shishi* mask, flute and puppy
Ono Ryōmin (mid- to late 1800s)
c. 1850–1900
Japan
Ivory *netsuke*
H 3.3 cm

OPPOSITE
Gold and Jade
1960–91
Weixian, Shandong province, China
Woodblock print
H 53.6 cm, W 39.1 cm

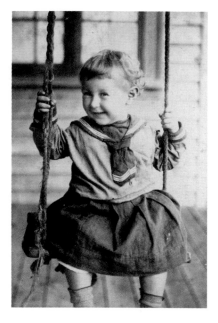

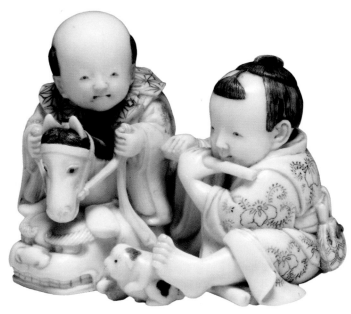

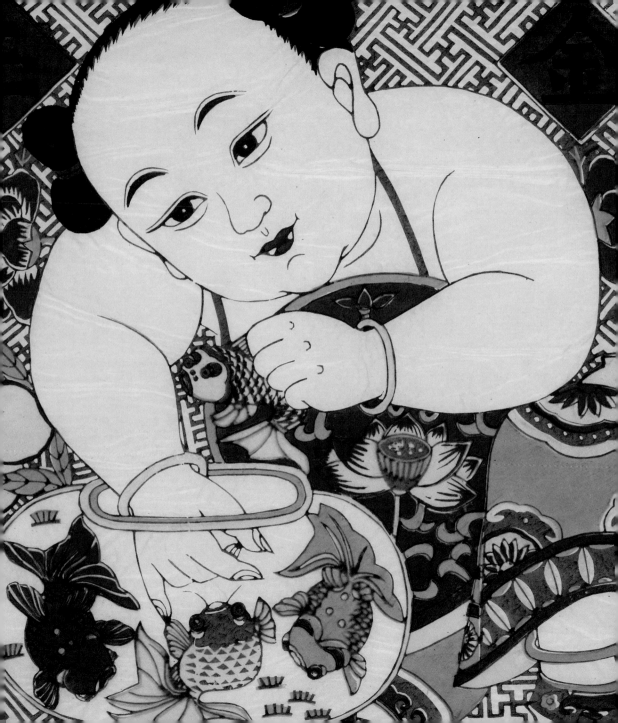

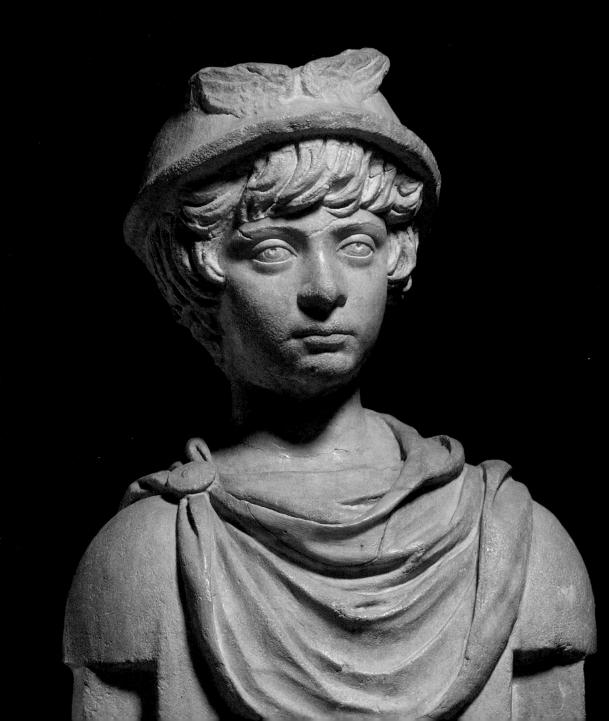

The Changing Face of Childhood

From different times and circumstances, these
children – a Roman boy dressed as the god Mercury,
a French boy destined to be king, an anonymous Italian
boy, an aristocratic English girl – all seem to be lost in
their own thoughts. Their expressions are serious,
pensive, even poignant; they seem to carry concerns
beyond their young years. As children enter their
adolescence they become more self-conscious and
introspective; once open and unguarded, they learn
to mask their thoughts and feelings by turning a more
enigmatic face to the world.

BELOW, LEFT

Portrait of King Charles IX
Attributed to François Clouet
(c. 1515–1572)
c. 1555
French
Black and red chalk
H 32.7 cm, W 22.5 cm

BELOW, CENTRE

Portrait of a child with a hat
Andrea Lilio (c. 1570–1631)
Before 1610
Italian
Red chalk
H 13.3 cm, W 9.4 cm

BELOW

Portrait of a girl
Sir Peter Lely (1618–1680)
Production date unknown
British
Black and white chalk
H 28.2 cm, W 19.7 cm

OPPOSITE

**Portrait herm of a youth
as Mercury**
Roman, c. AD 150–170
From Frascati, Italy
Marble
H 152 cm

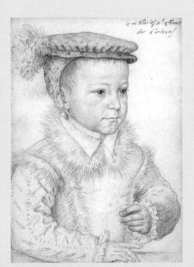

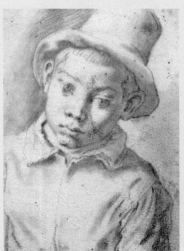

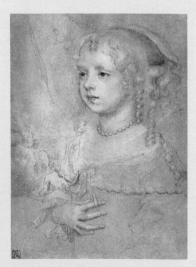

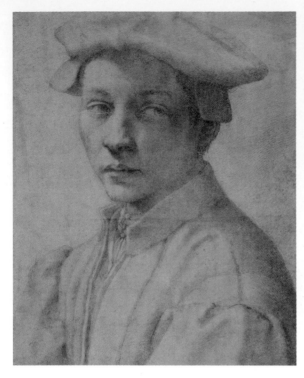

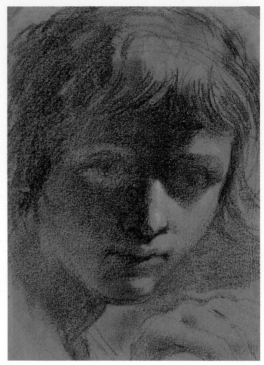

ABOVE

Portrait of Andrea Quaratesi
Michelangelo (1475–1564)
1530
Florentine
Black chalk
H 41 cm, W 29 cm

ABOVE, RIGHT

Head of a youth
Attributed to Guercino
(1591–1666)
After 1606
Italian
Oiled charcoal and white chalk
H 40.2 cm, W 27.7 cm

OPPOSITE

Head from the statue
of a youth
100–75 BC
Found in Alexandria, Egypt
Siltstone
H 24.2 cm, W 20 cm

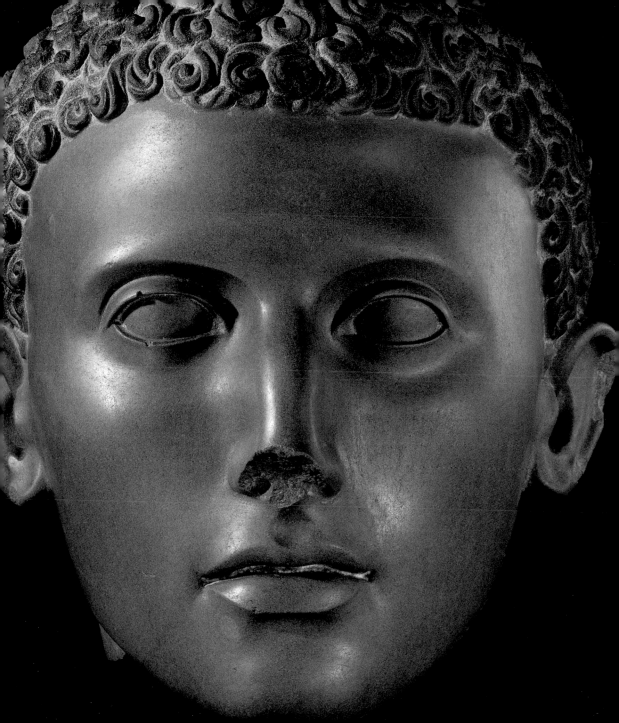

LEFT

The Sick Child
Jan Toorop (1858–1928)
1898
Dutch
Hand-coloured drypoint
H 16.7 cm, W 13.8 cm

OPPOSITE

Printed postcard of a young man
with a musket and postcards
c. 1930s
Published in Tangiers, Morocco
H 13.9 cm, W 8.9 cm

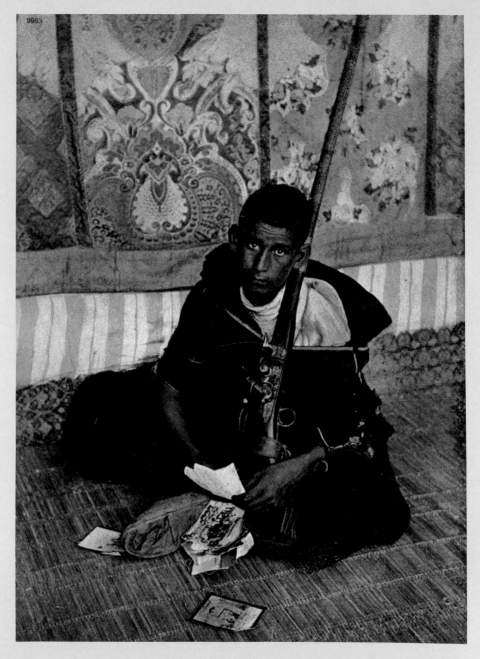

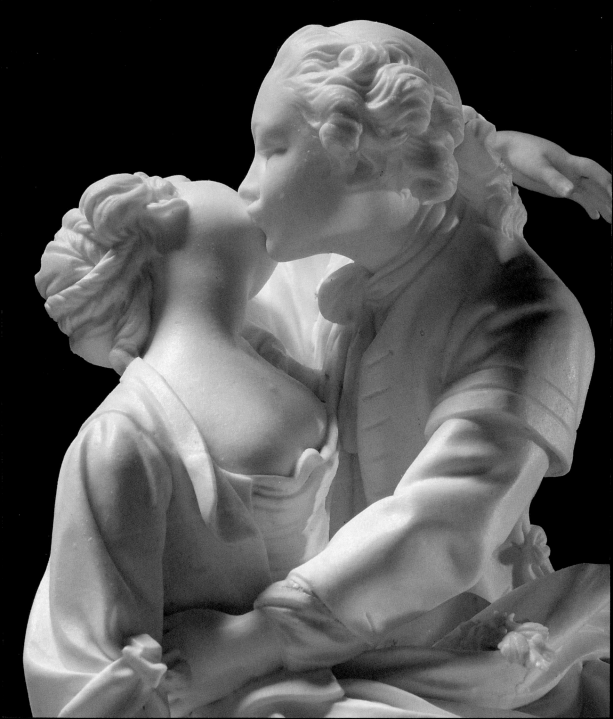

2 Love & Beauty

LOVE SPARKS THE SENSES. The sound of a loved one's voice, the texture or scent of his skin, the taste of her kiss – all arouse the heart and mind, igniting complex, even bewildering emotions. But of all the five senses, sight reigns supreme when it comes to love. From the long-standing belief in love at first sight to the deep and rewarding pleasure of a lingering gaze on familiar features, it is the face that is the locus of love (pages 59, 73). Lovers find solace, inspiration or even agony in a beloved face. They search for the hint of a smile or the lift of a brow that confirms mutual attraction. The desires of the body transform the face: eyes widen, pupils dilate, lips relax as if in open welcome, all at the sight of one's sweetheart. Love may manifest as joy or pain, longing or fulfilment, impulse or hesitation; the face serves as both mirror and window, revealing every aspect of love.

What does a lover see in the face of their beloved? Across cultures and over the centuries, writers have turned to allusion and analogy in order to convey the complex passions stirred by a glimpse of their loved one. The twelfth-century Persian poet Nizami tells us that Prince Khusraw adored the beautiful Shirin, whose face was 'like a wild rose' and whose lips were 'sweet as her name'. In the Song of Solomon, the bridegroom celebrates the arrival of his bride by comparing her eyes to doves, her cheeks to pomegranates and her lips to a scarlet thread. Dante Gabriel Rossetti, founder of the Pre-Raphaelite Brotherhood, likened the beauty of his beloved to 'genius', that eternal and inexplicable spark of creativity that drives the artist's hand and fuels the poet's imagination. But it was Leonardo da Vinci who claimed that, when it came to evoking an impression of the face of desire, the power of the painter transcended that of the poet, for only the painter could craft a likeness so true that the lover would be compelled to speak as if in the presence of their beloved.

Although love's ancient agent Cupid is often represented as blind, ideas of beauty are entangled with those of love. Fine features and a comely mien can kindle infatuation; but just as there are many aspects of love, there are many

standards of beauty. Difference plays out in proportion and detail: the shape of the eyes or lips, the depth of the forehead, the contour of the cheek, the shade of the skin. But despite cultural distinction and preference, certain qualities – symmetrical features, a clear complexion and large, bright eyes – seem to possess universal appeal (pages 62–5). They are also the hallmarks of youth and health, making beauty fleeting and therefore more precious. Time takes its toll on beauty: firm skin sags, bright eyes dim and life's experience leaves its mark on every face. But love can outlast beauty, for it engages the mind and heart as well as the eye. Indeed, a beloved face has a beauty all of its own, rooted in an endearing individuality, a shared history and the compassion and respect between those who love (pages 82–3).

No single facial expression can encapsulate the range of emotions that stir the heart. Fond glances and flirtatious smiles may signal the start of a seduction, affirm an established bond or mark a passing fancy. Lovers may show their restraint in calm, composed dignity, or they may indulge their desires in a heartfelt kiss (pages 74–5). Sexual passion is more than a matter of bodily union; the faces of the lovers reflect their individual ardour, whether in surrender, ecstasy or pure delight. But attraction is not always mutual, and love is not always reciprocated. A lonely lover yearning for another turns inward, lost in bittersweet thoughts that are burnished by memory or desire (pages 88–9). False love is calculating, and the deceitful lover seduces through feigned smiles and sly glances, luring victims into temptation's trap. A kiss that enflames one may disgust another, and love that fails devolves into anger and hate, turning fond glances to furious glowers and gentle smiles into sullen scowls (page 90). A disappointed lover cannot hide heartbreak. Lost love – whether through betrayal, rejection or even death – brands the face with sorrow. The eyes, once focused and bright, turn distant and dark; the cheek pales and hollows; and the mouth, no longer mobile and yielding, settles into a hard line of regret or resignation. The power of love wields pain as well as pleasure, and each romantic story leaves telling traces on a lover's face.

The Look of Love

'There was but one beloved face on earth,
And that was shining on him'

Lord Byron, 'The Dream', 1816

OPPOSITE
Figure of a Dutch commercial
attaché with an inset portrait
of his lady
Utagawa Sadahide (1807–1873)
c. 1861
Japan
Woodblock print
H 36.5 cm, W 25.4 cm

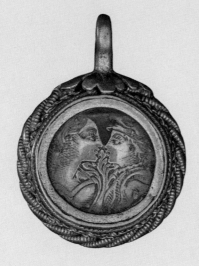

ABOVE
Medallion depicting two lovers
confronted with flowers
Production date unknown
Made in Italy
Niello, silver
H 3.5 cm

RIGHT
Love in a Village
Published by Carington Bowles
(1724–1793), after Robert Dighton
(1752–1814)
1784
British
Hand-coloured mezzotint
H 35 cm, W 25 cm

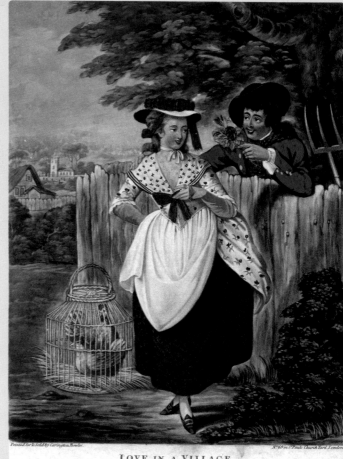

LOVE IN A VILLAGE.

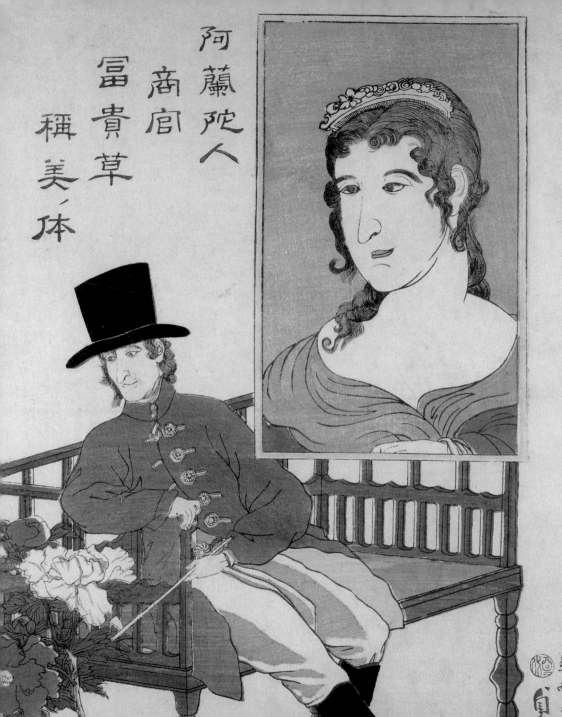

A small erotic print depicting
lovers against a pink background
Attributed to Keisai Eisen
(1790–1848)
c. 1820
Japan
Surimono-style woodblock print
H 9.4 cm, W 13.2 cm

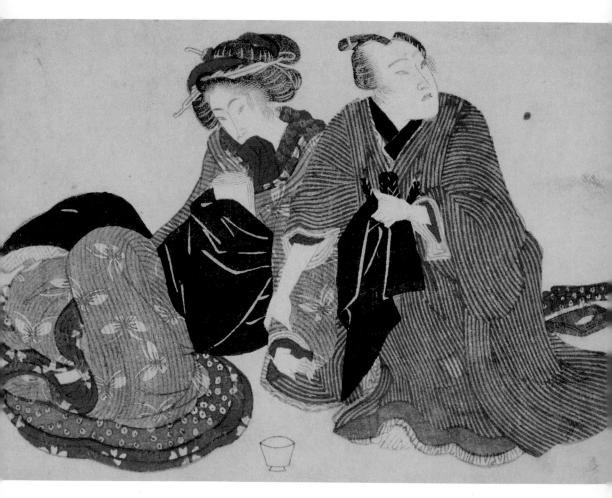

Lady embraced by a gentleman
holding two cherries
Print by Cornelis Danckerts I
(1603–1656) after Johann Liss
(c. 1597–1631)
1630–50
Dutch
Etching
H 28.3 cm, W 19.9 cm

Lovers
Christopher Wood (1901–1930)
1920–30
British
Graphite with watercolour
H 38 cm, W 27.7 cm

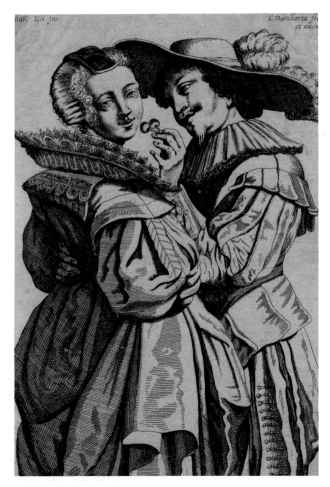

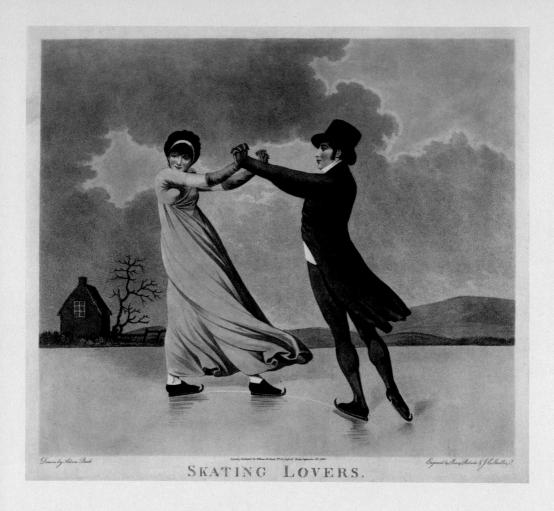

Drawn by Adam Buck London Published by William Holland N°50 Oxford Street September 20 1800 Engraved by Piercy Roberts & J. C. Stadler.

SKATING LOVERS.

Skating Lovers
Print by Piercy Roberts
(1795–1824) after Adam Buck
(1759–1833)
1800
British
Hand-coloured aquatint
H 46.9 cm, W 51.3 cm

Conventions of Beauty

There is no single standard of human beauty, but the culturally and temporally diverse objects shown here and overleaf share such commonly pleasing qualities as a broad brow, wide cheekbones and well-shaped facial features that are large in proportion to the rest of the face. The Bapunu mask, worn by male masqueraders to represent the returning spirits of deceased young women, has an opaque, white-painted complexion, indicating female beauty and the power to ward off witchcraft. The paint that defined the facial features of the Cycladic figure has worn away; ornamental patterns enhanced the image of nubile beauty. Whether rendered in firm detail, as in the portrait of artist Albrecht Dürer, or reduced and abstracted, as in the ancient South Arabian head, symmetry in shape and features provides the template for a striking appearance.

RIGHT
Mask associated with the performance of funerary rites in southern Gabon
19th century
Punu people, Gabon
Wood, fibre
H 30 cm, W 17 cm

OPPOSITE
Albertus Durerus Noricus
(Albrecht Dürer)
Print by Ferdinand Piloty I
(1786–1844) after Albrecht Dürer
(1471–1528)
c. 1811–16
German
Lithograph
H 46.5 cm, W 38.4 cm

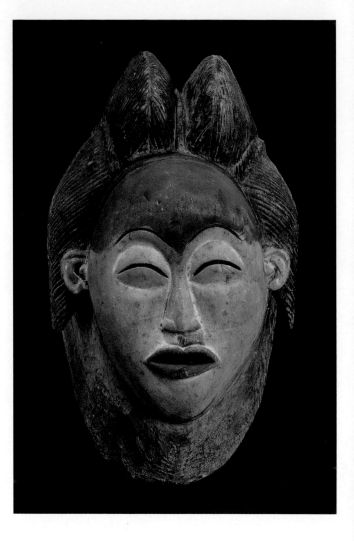

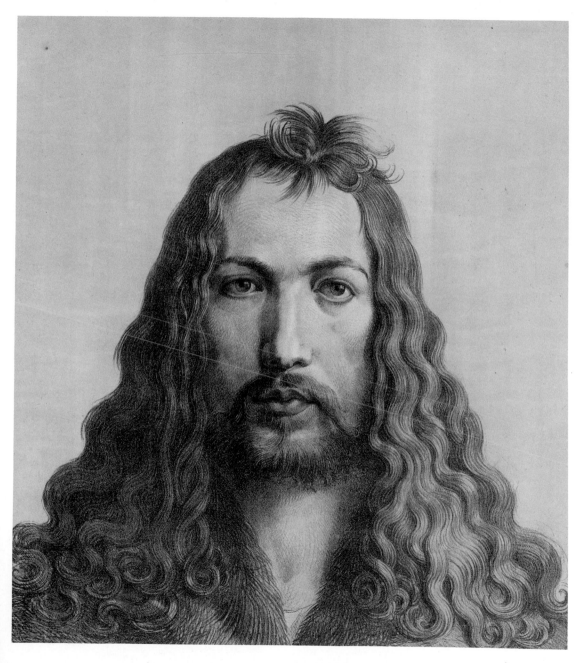

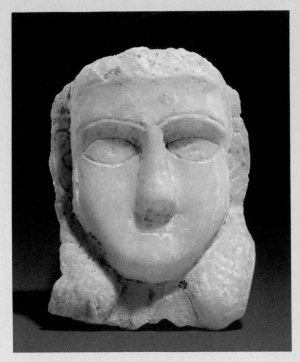

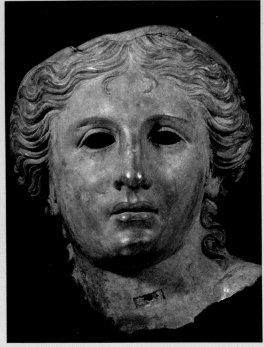

Sculpture of a human face,
with long hair, eyes, eyebrows
and mouth represented by
incised lines
3rd–2nd century BC
Made in Yemen, found in Marib
Calcite
H 15 cm, W 12 cm

Head from a cult statue of
Anahita in the guise of Aphrodite
or Artemis
Hellenistic, 1st century BC
From Satala, Turkey
Bronze
H 38.1 cm

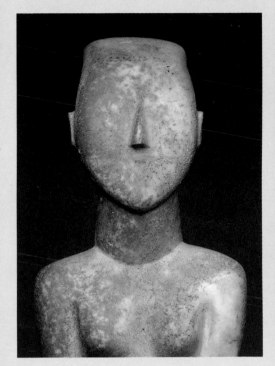

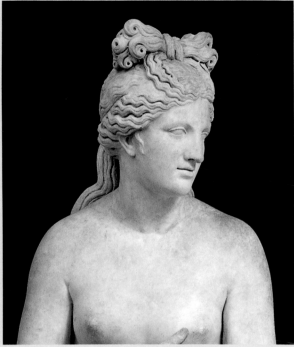

Figurine of a woman
of the Spedos type
Greek, *c.* 2700–2500 BC
Made in the Cyclades, Greece
Marble
H 76.8 cm

Statue of Venus, of the
Capitoline Venus type
Roman, *c.* AD 100–150
From Campo Iemini, Lazio, Italy
Marble
H 223.5 cm

'Was this the face that launch'd a thousand ships,
And burnt the topless towers of Ilium?'

Christopher Marlowe, *Doctor Faustus*, 1604

BELOW

Maiolica basin with a profile
portrait bust of a woman
and the inscription 'Divine
and beautiful Lucia'
Made by Master of the Triumph
of the Moon at Marcigny
1524
Made in Italy
Tin-glazed earthenware
Diam. 42.2 cm, D 0.9 cm

BELOW, RIGHT

Cameo of Diana, the Roman
goddess of the hunt depicted
in profile with her bow and quiver
16th century
Made in Italy
Onyx, gold and enamel
L 4.8 cm, with frame

OPPOSITE

The Bathing Beauty
Print by Philip Dawe (c. 1750–1791),
after Prince Hoare (1755–1834)
1771
British
Mezzotint
H 50.7 cm, W 35.3 cm

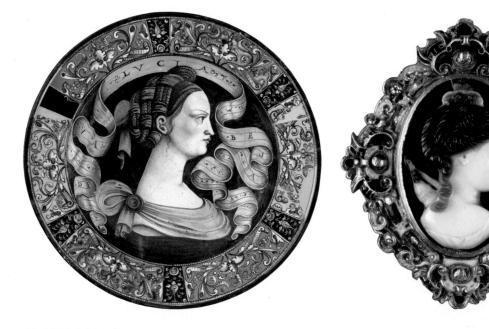

To depict an ancient Pictish warrior, the English artist and explorer John White may have consulted the accounts of ancient Greek and Roman historians who lived in the first and second centuries AD. The source for the impressive proportions of his figure were even older. The warrior's physique conforms to the classical concept of ideal male beauty, as seen in the muscular contours of the Strangford Apollo. Like its body, the face of this statue of a *kouros* (youth/young man) reflects centuries of subtle refinements, culminating in a naturalistic appearance. White departed from the serenity of the prototype, giving his woad-stained warrior rolling eyes and a howling mouth to convey his savage nature.

RIGHT

**Statue of a *kouros* (youth/
young man) known as the
Strangford Apollo**
Greek, *c.* 490 BC
From Anaphe, Cyclades, Greece
Parian marble
H 101 cm, W 37 cm

OPPOSITE

**A Pictish warrior holding
a human head**
John White (*fl.* 1585–93)
Production date unknown
British
Watercolour
H 24.3 cm, W 17 cm

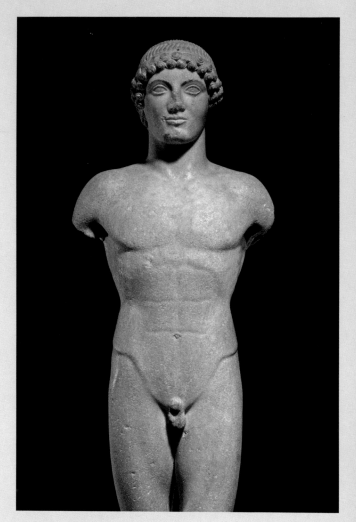

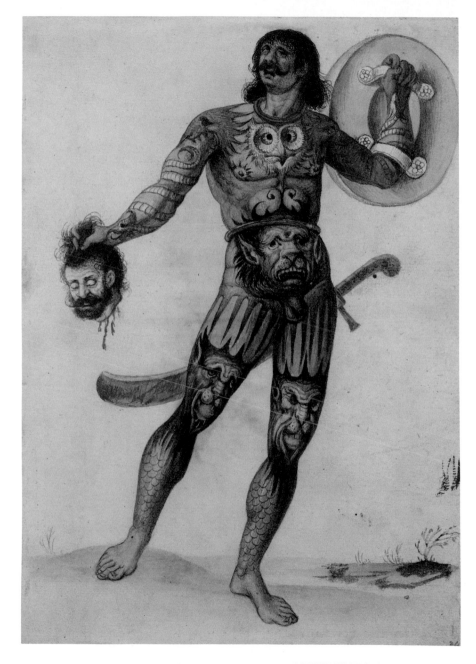

Two lovers in European clothing
seated on a terrace
c. 1720
India
Painting on paper
H 18.6 cm, W 11.4 cm

Figure group of Scaramouche
and Columbine from the Italian
comedy embracing, after a
Meissen model
c. 1755–7
Made by Wegely's Porcelain
Factory, Berlin, Germany
Porcelain
H 17.1 cm

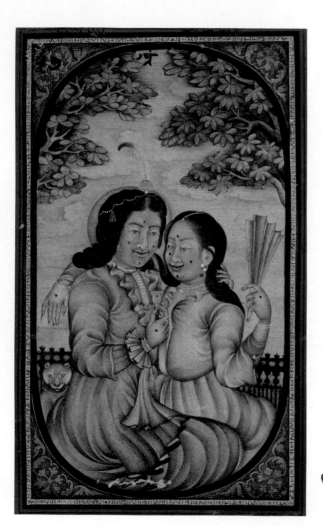

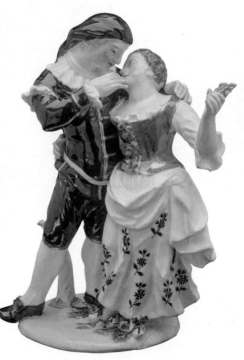

The Loving Touch

Lovers long for each other's touch. A gentle hand on a shoulder can lead to an ardent embrace. Enwrapped in each other's arms, the Rajasthani couple (opposite, left) smile in joy and anticipation. The porcelain figures from Berlin are coy, as the man tenderly tilts the head of his willing partner to gaze into her eyes. The legendary lovers Tristram and Isolde, depicted in the left-hand panel on the front of the ivory casket, surrender to forbidden love with a single glance.

Romance casket with ivory plaques illustrated with scenes from the story of Tristram and Isolde
1180–1200
Made in Germany
Copper, bone
L 14.3 cm, W 9.5 cm, H 9.3 cm

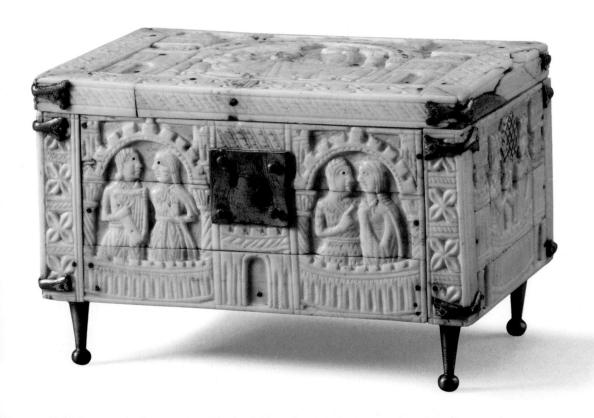

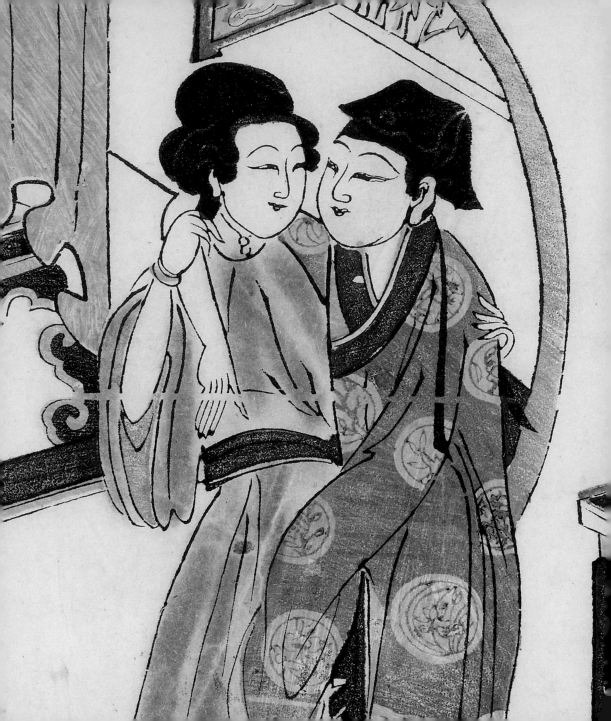

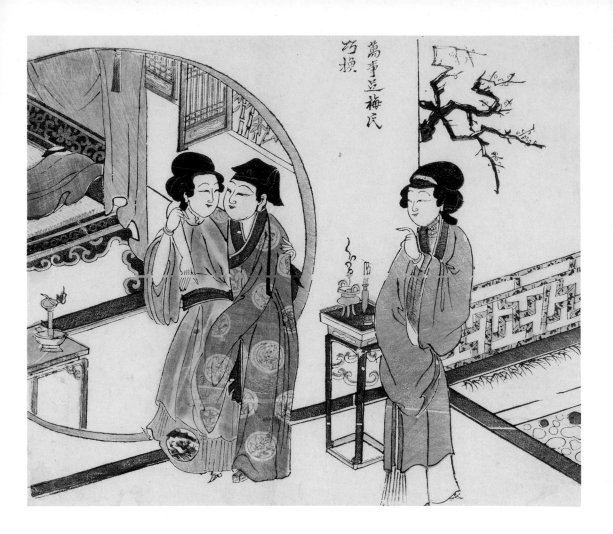

All Things Fulfilled, Mr Mei
Is Able to Exchange
Qing dynasty, Kangxi reign,
1662–1722
Suzhou, China
Woodblock print
H 23.5 cm, W 27.2 cm

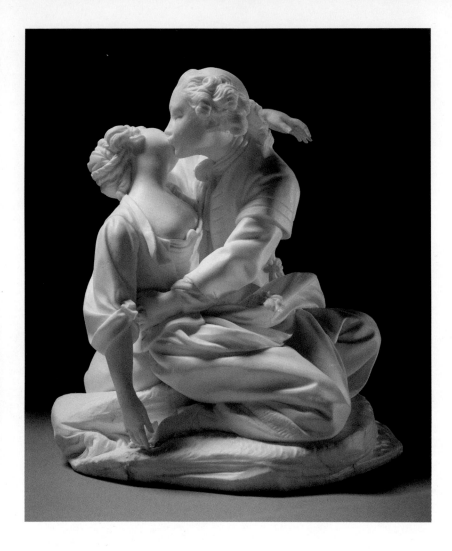

LEFT

Le Baiser donné

Modelled by Étienne Maurice
Falconet (1716–1791)

c. 1786 (first modelled in 1765)

Made by Royal Porcelain Factory,
Sèvres, France

Soft-paste porcelain

H 18.1 cm

OPPOSITE

Architectural fragment with two
lovers carved in high relief

c. AD 950–1000

India

Sandstone

H 54 cm, W 46 cm

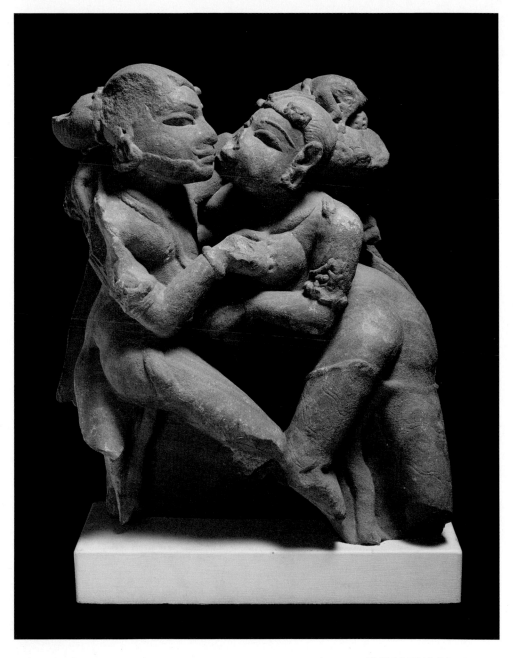

Ain Sakhri lovers figurine
Natufian, c. 9000 BC
Found at Wadi Khareitoum,
Judea, near Bethlehem
Calcite
H 10.2 cm

Double-spout-with-bridge
jar with two human figures
100 BC – AD 600
From Nasca, Peru
Pottery
H 14.5 cm, W 9.5cm

To be wrapped in a lover's arms, to feel the warmth of another's skin and a beating heart against one's own breast, is an ancient and universal desire. The Natufian figurine, found at Wadi Khareitoum near Bethlehem, is carved from a single piece of calcite; even without facial features, the entwined lovers appear fully absorbed in each other's gaze. In the case of the Nasca double-spout jar, the bodies of the lovers combine to form a single vessel, while their respective faces reflect their mutual joy.

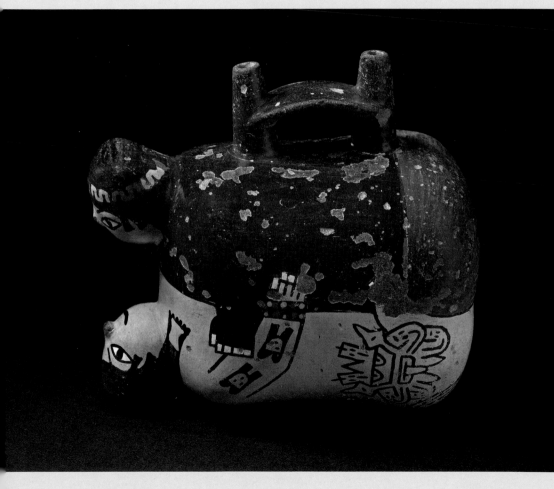

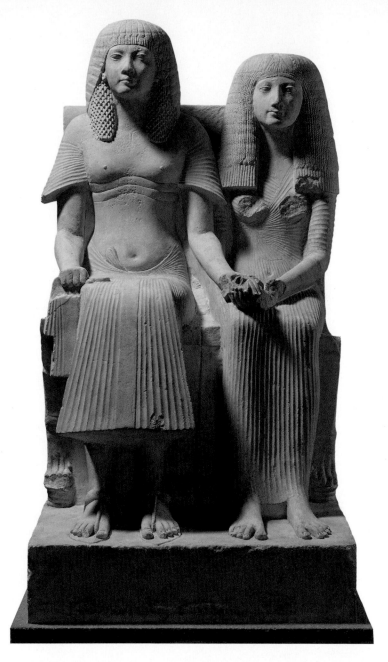

Statue of Horemheb and one
of his wives
Late 18th dynasty, *c.* 1330 BC
From Saqqara, Egypt
Limestone
H 130 cm

RIGHT

Lovers on a grassy bank
Print by Master E. S.
(*fl. c.* 1450–67)
Production date unknown
German
Engraving
H 13.4 cm, W 16.2 cm

RIGHT, BOTTOM

Russian Lovers
Figure group in the form of a pair
of seated lovers
Modelled by Ernst Barlach
(1870–1938)
1908 (modelled), 1909–13
(produced)
Made by Schwarzburger
Werkstätten für Porzellankunst,
Germany
Porcelain
L 35 cm

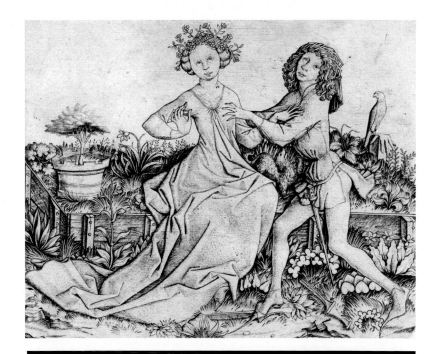

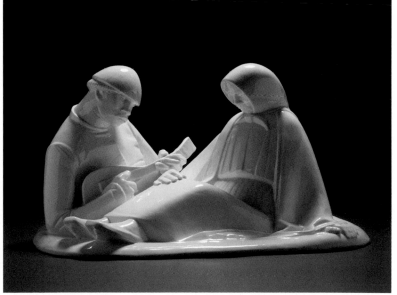

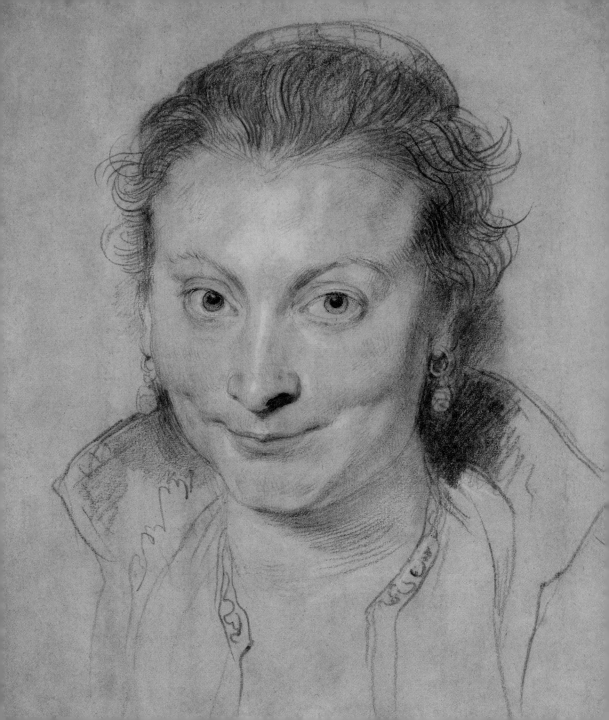

In the Eye of the Beholder

A lover often finds beauty in features that defy convention. The bump and hook of a man's nose gives him an irregular profile; a woman's most striking feature – unruly hair, thick eyebrows, elongated neck – may not conform to common standards. But it is difference that makes a beloved's face like no other, giving it a beauty all of its own.

OPPOSITE
Portrait of Isabella Brant
Peter Paul Rubens (1577–1640)
c. 1621–2
Flemish
Black and red chalk
H 38.1 cm, W 29.4 cm

BELOW, LEFT
Painted cartonnage mummy-mask
c. AD 100–120
Found in Egypt
Plaster, linen
H 68 cm, W 39 cm

BELOW
Study of Jane Morris as Beatrice
for the painting *Dante's Dream*
Dante Gabriel Rossetti
(1828–1882)
1870
British
Black, red and white chalk
H 60 cm, W 51.1 cm

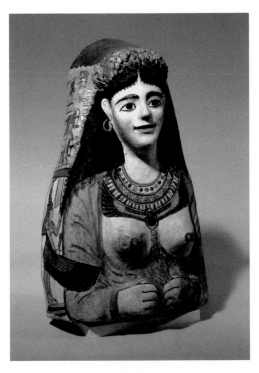

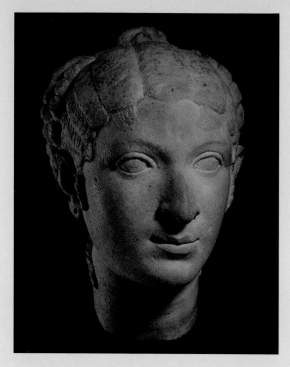

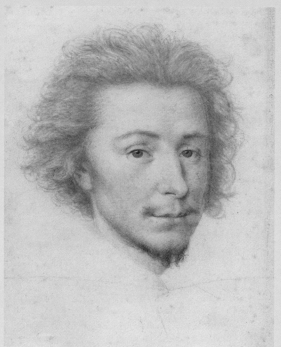

'Where the mouth is sweet and the eyes intelligent,
there is always the look of beauty, with a right heart.'

Leigh Hunt, *The Autobiography of Leigh Hunt*, 1850

ABOVE, LEFT
Portrait head of a woman
resembling queen Cleopatra VII
Roman, *c.* 50–30 BC
Limestone
H 28 cm

ABOVE
Portrait of an unknown man
Daniel Dumonstier (1574–1646)
Production date unknown
French
Charcoal with coloured chalks
H 34 cm, W 23.3 cm

A sketch of a lady's face
in profile
c. 1890
India
Drawing on paper
H 27.4 cm, W 15.7 cm

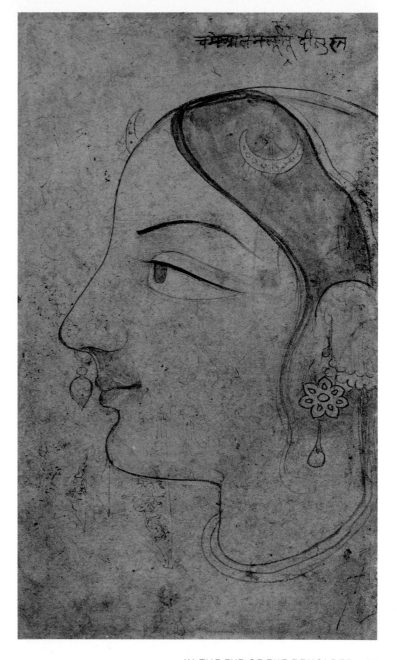

Relationships and Marriage

Every bride and groom wants to look their best on their wedding day, whether they are mere mortals or glorious gods. When the terrifying Hindu deity Shiva wed Parvati, he cleansed his skin of ashes, oiled his hair and dressed in magnificent silks: every woman in the court envied Parvati and longed to lie upon his chest. The Mexican tradition of *Día de los Muertos* (Day of the Dead) defies the belief that marriage lasts only until death; once a year, the spirits of the dead return to celebrate their lives.

The marriage of Shiva and
Parvati with the god and
goddess standing with their
arms around each other
11th century
Made in Tamil Nadu, India
Bronze
H 34 cm, W 19 cm

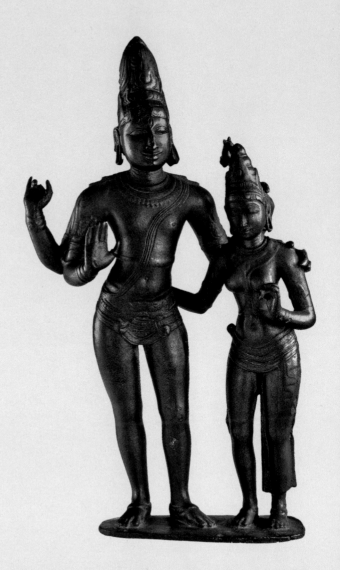

Figurine in the form of skeleton
bride and groom
1980–9
From Oaxaca or Guanajuato,
Mexico
Papier mâché, paper and cotton
H 20 cm, W 16.5 cm

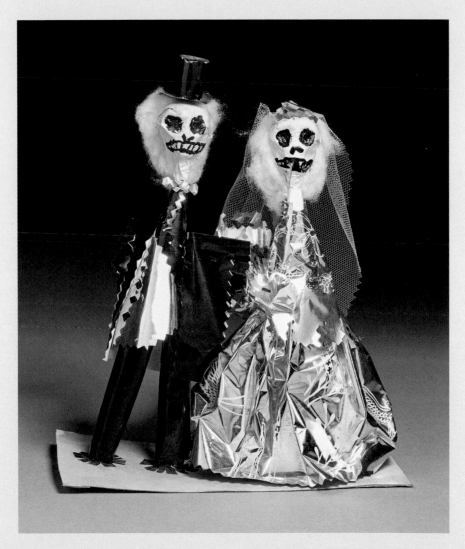

RIGHT

Marriage ring with a male and
female bust and child's head
below
c. 4th–5th century AD
Found in Constantinople
Gold
Diam. 1.9 cm

BELOW

Painted enamel plaque of the
marriage of King Louis XIII and
Anne of Austria
Attributed to Joseph Limousin
(c. 1600–1650)
c. 1610
Made in Limoges, France
Enamel, copper
L 7.6 cm (with frame), W 13.2 cm
(with frame)

OPPOSITE

Painting from the *Ramayana*
showing Rama and Sita with
attendants, including Hanuman
and Lakshmana
c. 1790–1810
India
Gouache on paper
H 25 cm, W 19.3 cm

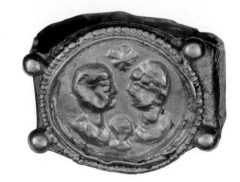

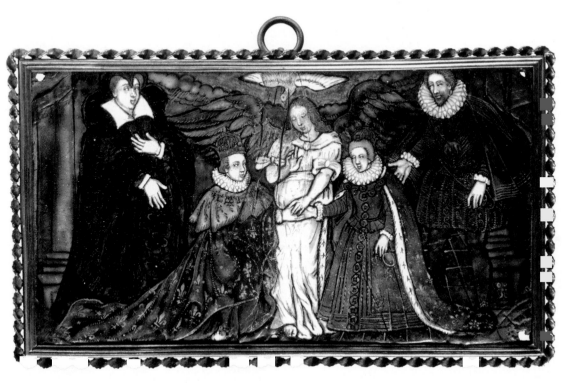

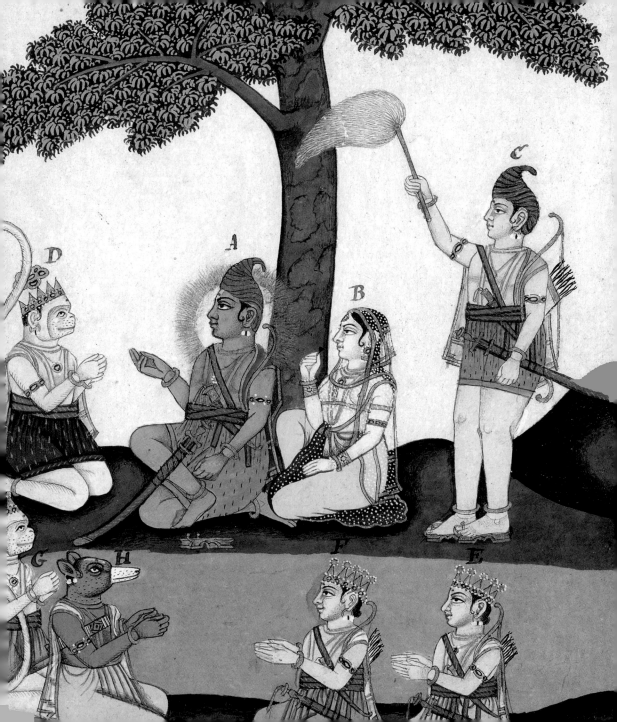

LEFT
Portrait of a youth
Single-page painting mounted
on a detached album folio
Signed by Muin Musavvir
(*fl. c.* 1630–1700)
1676, mount made in India at
a later date
Isfahan, Turkey
Ink, opaque watercolour and gold
on paper
H 14.3 cm, W 8.5 cm

OPPOSITE
**Music cover with a pensive young
man sitting at a parapet for**
Que je voudrais avoir vos ailes
Print by Jules David (1808–1892)
1856
French
Lithograph
H 19.2 cm, W 14 cm

Longing and Loss

'To be loved at first sight, a man should have at the same
time something to respect and something to pity in his face.'
Stendhal (Marie-Henri Beyle), *On Love*, 1822

PAROLES DE M: JULES DE WAILLY FILS

PRIX: 2f 50

MUSIQUE DE

PAUL HENRION

ALBUM 1856

N° 1
Baryton

N° 2
Ténor

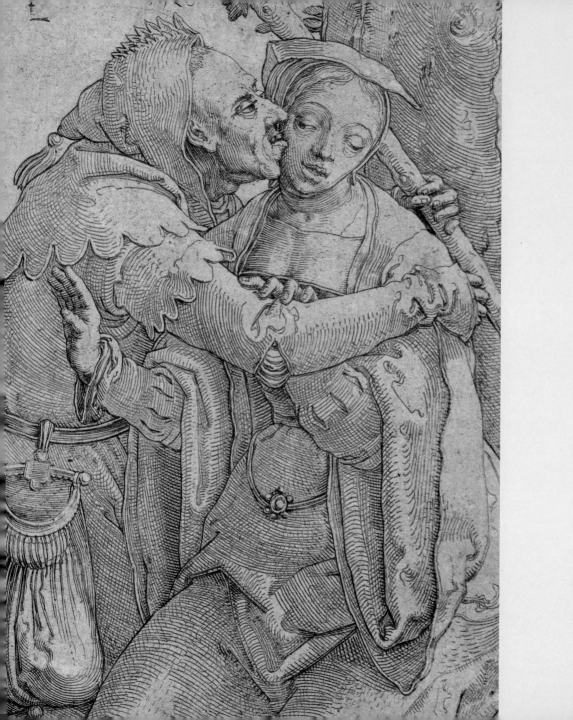

OPPOSITE

A Fool and a Woman
Print by Lucas van Leyden
(c. 1494–1533)
1520
Netherlandish
Engraving
H 10.5 cm, W 7.4 cm

ABOVE

The Unfortunate Lover
Published by Carington Bowles
(1724–1793)
c. 1770–5
British
Mezzotint
H 35.4 cm, W 25 cm

ABOVE, RIGHT

L'Amour et la mort
Print by Alphonse Hirsch
(1843–1884) after Francisco
de Goya (1746–1828)
1868
French
Etching
H 12.9 cm, W 10 cm

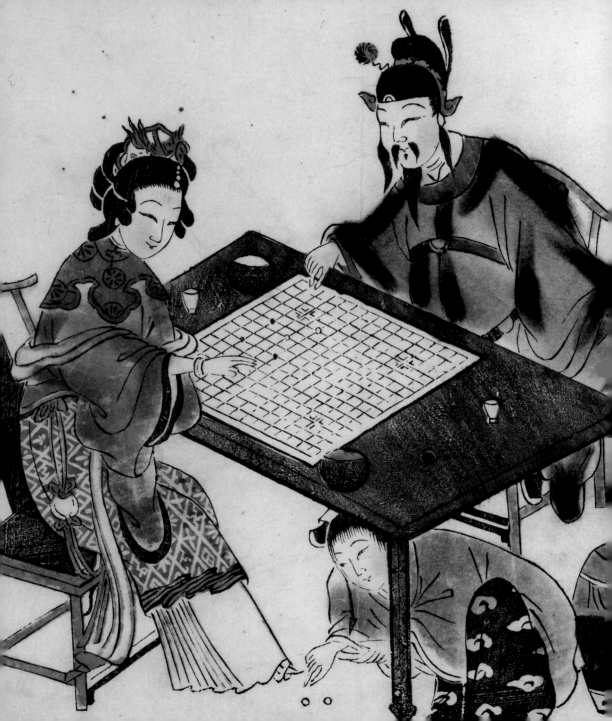

3 Everyday Life

WE WAKE FROM SLEEP with small, involuntary gestures. Eyelids flutter, then open, and the pupils of our eyes contract, adjusting to the light after hours of darkness. We yawn, stretching our lips and opening our jaws to their fullest extent to facilitate a deep inhalation of air and invigorate blood circulation. Our faces reveal how well we have rested. A good night's sleep refreshes, smoothing our skin and relaxing our features. A restless night takes its toll, leaving puffy, shadowed eyes and a sallow or ashen complexion; not everyone greets the day like Shakespeare's schoolboy, with a 'shining morning face'. Whether we bound out of bed, energized for the hours ahead, or rise with reluctance, longing to return to sleep, we must face the day and its tasks. And as we engage with those tasks, seemingly routine and unremarkable, our facial expressions add an intimate and telling dimension to our human story.

Facing the day requires preparation. We wipe away the traces of the night's sleep, splashing water on our faces to cleanse our skin of accumulated body oils, perspiration and the residue of yesterday's make-up. Our hair, flattened and tangled from hours spent prone or rubbing against the pillow, must be combed and coiffed (page 101). We shave to whisk away a night's growth of beard; we embellish our features with cosmetics. We dress, slipping garments over our heads, drawing stockings over our legs, fastening buttons and belts (page 102). Each task involves concentration and self-scrutiny (page 103); our eyes narrow in a critical gaze as we assess the results of our efforts in the mirror. These rituals of grooming and dressing are more than acts of necessary hygiene or self-indulgent vanity; performed in private, they prepare us for appearing in public and show respect for the prevailing social conventions.

Few daily activities are more commonplace than cooking and eating. Some meals are prepared in a hurry, involving tasks so familiar that we hardly notice them; our distracted expressions reveal that our thoughts have strayed elsewhere. Others require full attention; our features tense while we concentrate on kneading the dough or bringing the pot to boil. The anticipation of a delicious meal sparks

the senses: eyes close as we inhale rich and spicy scents, our mouths water, and we smile as we anticipate the flavours. And as we savour food, our faces reveal our instinctive pleasure, contentment or surprise at the tastes we experience. Sharing a meal bonds us with others. We exchange glances, and even feed each other morsels, opening our own mouths as if in mutual delight (pages 104–5). Drinking can be similarly convivial. A cup of tea, a glass of wine or a crisp cocktail gives us an excuse to linger in good company. But our faces betray the effects of stimulants and intoxicants: flushed skin, bleary eyes, wayward glances and loose lips that release reckless words or raucous laughter.

Work fills many hours of our day. Engaged in tasks that require skill and attention, we incline our heads towards what we are doing. Our gaze is intent, and complete absorption stills our features, as if to direct all our energy to the job at hand. In traditional trades, an apprentice or a family member might stand at the ready, expression alert and eager to help, while learning through rapt observation (page 109). But recreation can demand equal attention. Hunting, for example, has bridged the realms of work and pleasure for millennia; but whatever the motive, the hunter eyes his target with the same intensity, his face a study in disciplined purpose (pages 110–11). Sport also demands our full concentration, and our faces register the range of our exertions. Strain compresses our features, our pounding hearts heighten our complexions, our skin glows with effort, and a deep, visceral pleasure in our body's power wreathes our faces in triumph.

As the day winds down, our activities take on a slower pace. We spend the hours recounting our day, playing a game or indulging in favoured pastimes (pages 116–17). Unconsciously, we drop the public mask of position and purpose, and our features soften into an expression of quiet contentment. Whether shared or private, such pleasures prepare us for rest. As at the start of the day, involuntary actions shape our expressions. We feel the muscles of our face relax and slacken; our brows unfurrow, our lips part and we yawn. Our eyelids grow heavy; they flutter and then close. And in sleep, our faces reflect not our everyday life but our dreams.

The Enduring Rhythm of Everyday Life

The original function of the Standard of Ur is not known. The two side panels, beautifully inlaid, depict the activities associated with war and with peace respectively. The 'peace' side (below, bottom) features men and animals, laden with bundles of grain, fish and other goods that furnish the privileged feast depicted in the top register. Each individual has work to do and a role to play, and their facial expressions reflect their sense of purpose and belonging.

The Standard of Ur depicting scenes of war and a royal banquet
2500 BC
From the Royal Cemetery at Ur, Iraq
Mosaic of shell, red limestone and lapis lazuli
H 21.7 cm, L 50.4 cm, W 11.6 cm (base)

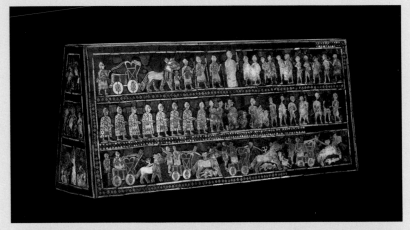

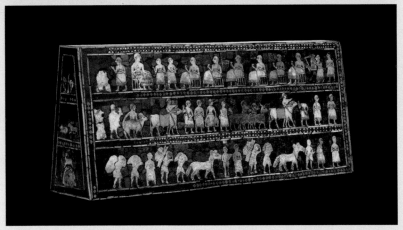

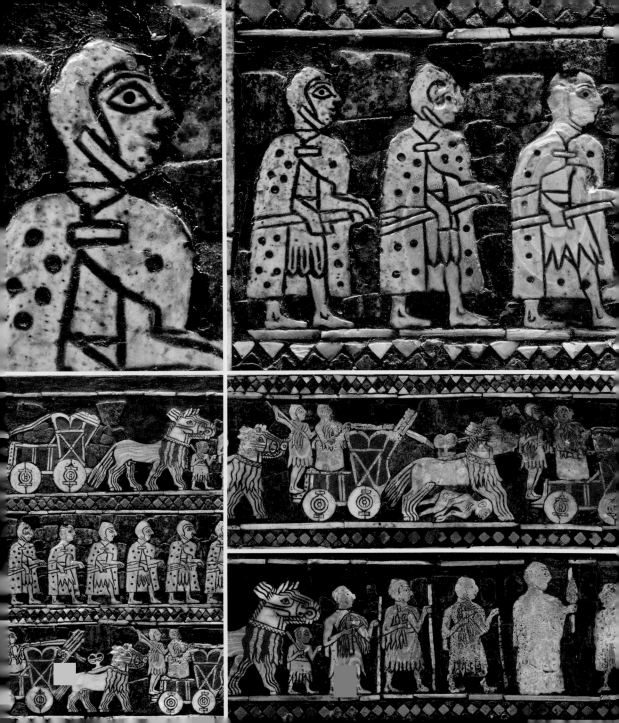

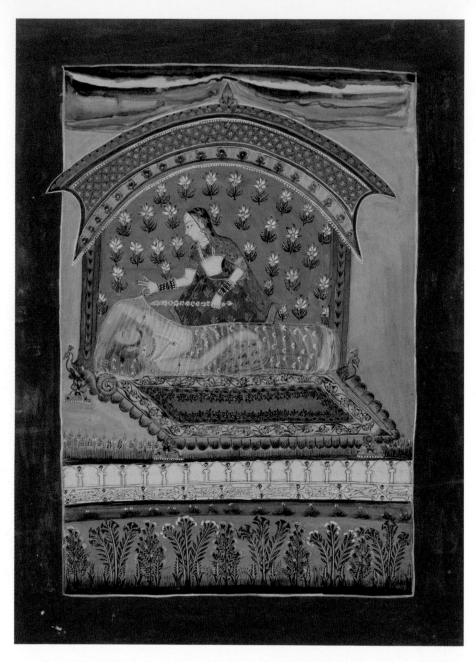

Waking Up

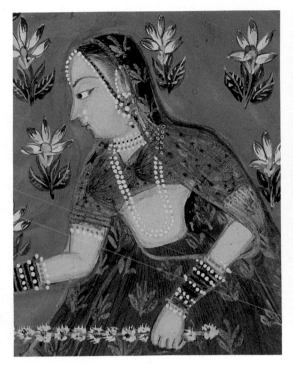

With a tender glance and a delicate touch, a sumptuously dressed woman lifts the diaphanous mosquito net from the richly adorned bed of a sleeping man. Their exquisite jewels and garments reflect their high status, while their beauty and the intimacy of the moment suggest that they are lovers. This painting was once part of a *ragamala*, a series of images that visually interpret a range of musical modes known as *ragas*. The Sanskrit word *raga* implies colour and mood, and the musical motifs are often linked to the seasons or different times of the day. To be woken by one's lover evokes a most pleasurable way to greet the dawn.

An illustration from a dispersed
ragamala series showing a
woman waking a sleeping man
1772
Found in India
Gouache on paper
H 34 cm, W 24.5 cm

Grooming and Dressing

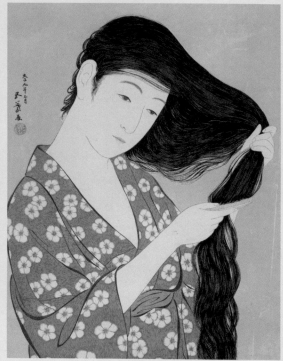

ABOVE

A 'passionate beauty' sitting
on the floor combing her hair
Made by the Chore Bagan
Art Studio
1850–1950
Found in Calcutta, India
Colour lithograph
H 40.5 cm, W 30.5 cm

ABOVE, RIGHT

Combing the Hair
Hashiguchi Goyō (1880–1921)
1920
Japan
Woodblock print
H 44.8 cm, W 34.8 cm

OPPOSITE

The Toilette of Salome
Aubrey Beardsley (1872–1898)
1893
British
Pen and black ink
H 22.7 cm, W 16.2 cm

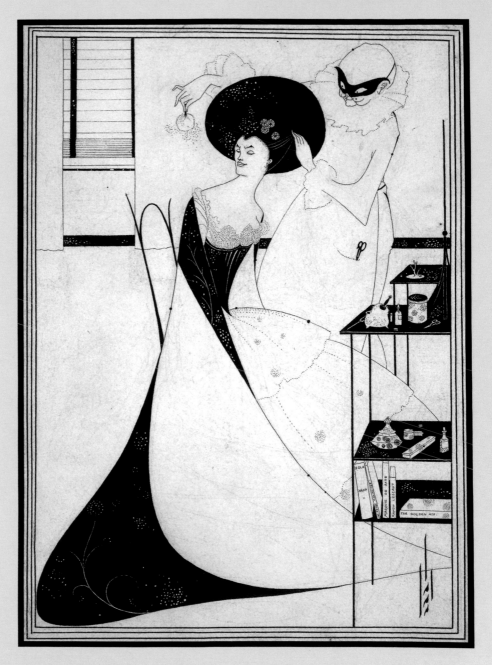

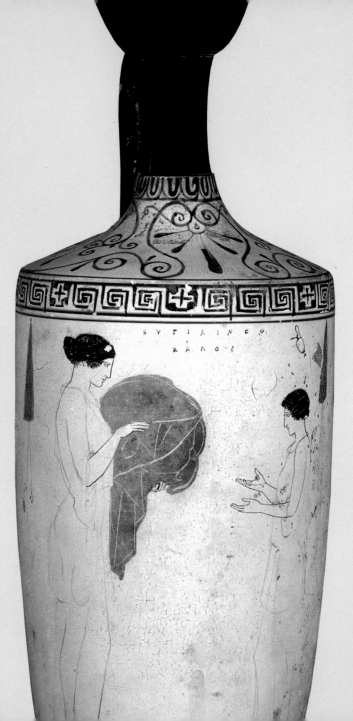

Grooming practices are culturally specific, but most people follow some form of morning regimen to ready themselves for the day. Washing, dressing, shaving and styling hair do more than improve appearance; they allow an individual to differentiate between their private and public faces. The *lekythos*, made to hold oil or perfume, features a woman with her hair neatly bound by a band, handing a mantle to a younger girl with shorn hair. The English writer and politician Edward Bulwer-Lytton attends to his own appearance in the mirror, trimming his copious side-whiskers with a 'hoe-type' razor, which features a honed blade set perpendicular to its handle.

OPPOSITE

White-ground *lekythos* depicting
women dressing
Attributed to the Achilles Painter
(*fl.* 460–430 BC)
c. 445–440 BC
Made in Athens, Greece
White-ground pottery
H 35.6 cm

RIGHT

Portrait caricature of Edward
Bulwer-Lytton
Print by Daniel Maclise
(1806–1870)
1832
British
Lithograph
H 26.7 cm, W 21 cm

AUTHOR OF "THE SIAMESE TWINS".

Published by James Fraser, 215, Regent Street.

LEFT

An Indian man and woman eating
John White (*fl.* 1585–93)
Production date unknown
British
Watercolour over graphite
H 20.9 cm, W 21.4 cm

LEFT, BOTTOM

Man and woman
having a meal
Hoga
19th century
Japan
Ivory *netsuke*
H 3.3 cm, W 4.6 cm

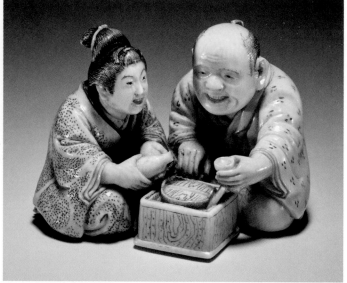

Eating and Drinking

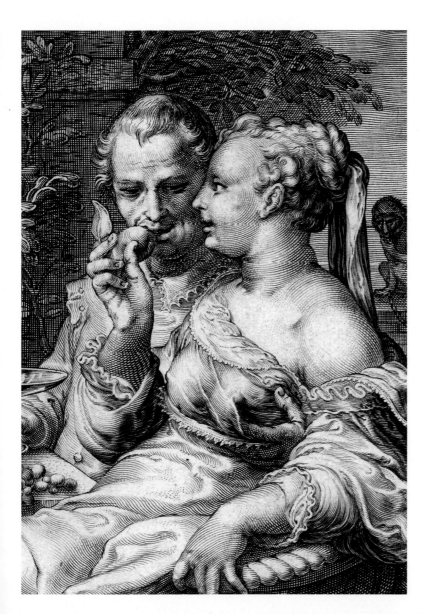

Taste from 'The Five Senses'
Print by Jan Saenredam
(*c.* 1565–1607) after Hendrik
Goltzius (1558–1617)
c. 1595
Dutch
Engraving
H 17.3 cm, W 12.3 cm

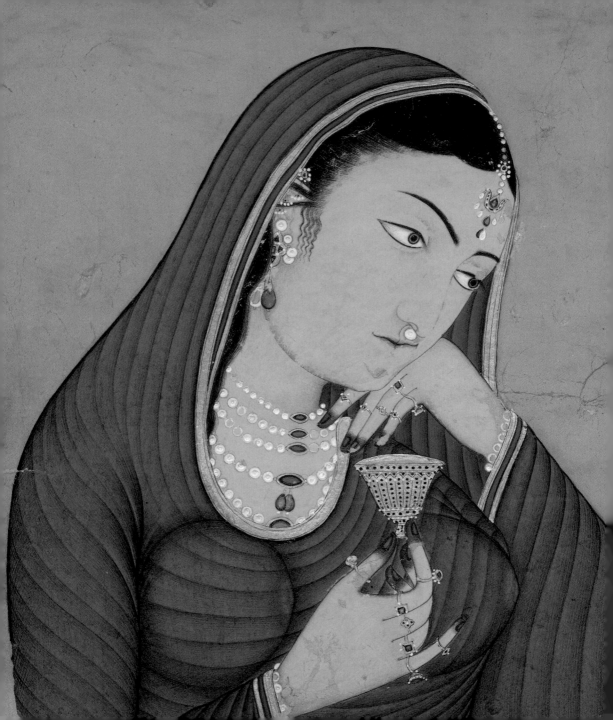

OPPOSITE

A bust portrait of a lady drinking wine
c. 1750
Found in India
Gouache on paper
H 29.3 cm, W 27.5 cm

RIGHT

Sherd depicting two seated figures
c. 1200–1250
Made in Rusafa, Syria
Glazed pottery
Diam. 9.9 cm

RIGHT, BOTTOM

Cocktails
Print by Jean Émile Laboureur (1877–1943)
1931
French
Engraving
H 20 cm, W 19.2 cm

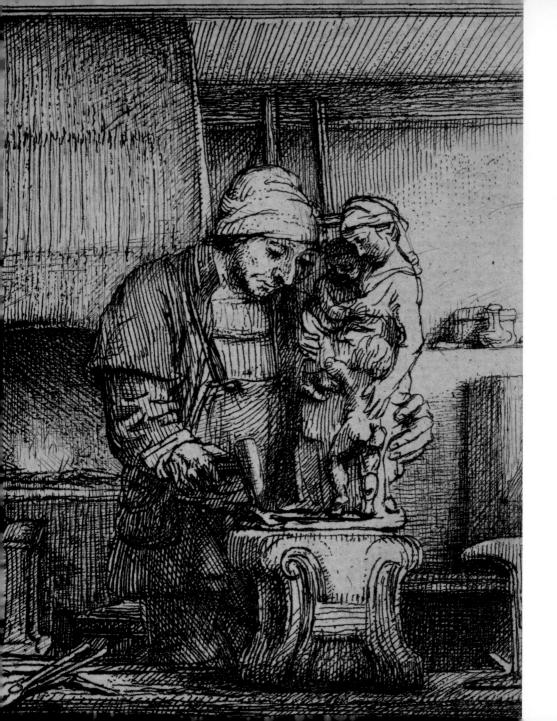

Working

Fine craftwork requires deep concentration. A quick glance at this ensemble of metalsmiths suggests that the artisans appear at ease in their work. But a closer look at their faces betrays the rapt attention associated with skilled and challenging endeavour: lowered eyelids, furrowed brow, firm lips and facial muscles slightly contracted. The tension is subtle, but it is a reminder of the deliberate and dexterous physical control required in expert craftsmanship.

OPPOSITE
The Goldsmith
Rembrandt van Rijn (1606–1669)
1655
Dutch
Etching and drypoint
H 7.7 cm, W 5.5 cm

BELOW, LEFT
Painting of a goldsmith
with his wife and son
c. 1830–5
From Tamil Nadu, India
Opaque watercolour
on European paper
H 18.2 cm, W 11.3 cm

BELOW
A Coppersmith
Single-page painting
c. 1850
Iran
Ink and watercolour on paper
H 15.4 cm, W 11.1 cm

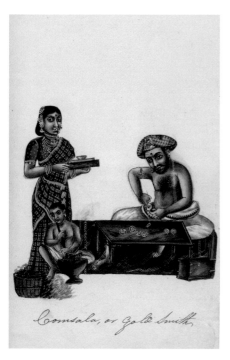

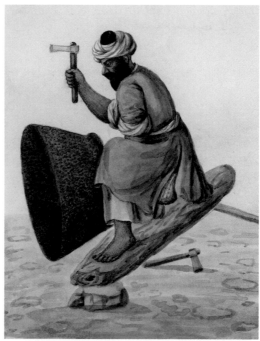

Hunting and Sport

Throughout history, monarchs, warriors and even gods have been depicted hunting for sport. More than a pastime, hunting requires a keen eye and sharp concentration, a strong and steady arm, and boldness, skill and power. Whether practised by courtly women on horseback, the Mughal emperor Jahangir or the Neo-Assyrian king Ashurbanipal, it alludes to both the martial and the athletic prowess of the hunter.

Jahangir with a hawk
Single-page painting mounted
on a detached album folio
1605–27
India
Ink, opaque watercolour and gold
on paper
H 13.6 cm, W 8.2 cm

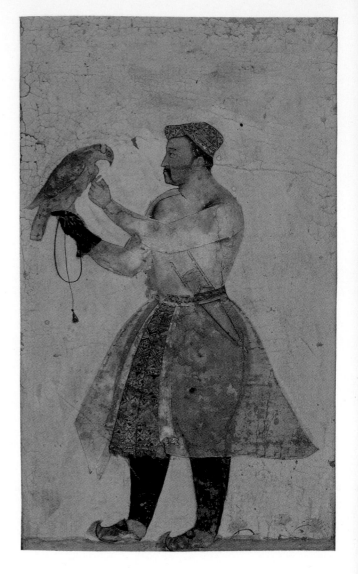

RIGHT
**Assyrian relief depicting
the royal lion hunt**
King Ashurbanipal shoots lions
with his bow from a chariot
c. 645–635 BC
From the North Palace
at Nineveh, Iraq
Gypsum
H 162.6 cm, W 114.3 cm

RIGHT, BOTTOM
**Two ladies on horseback hunting
wild boar**
c. 1760
India
Gouache on paper
H 26 cm, W 33.9 cm

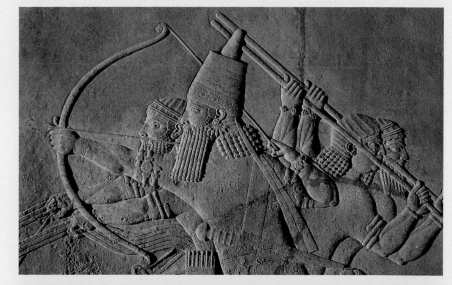

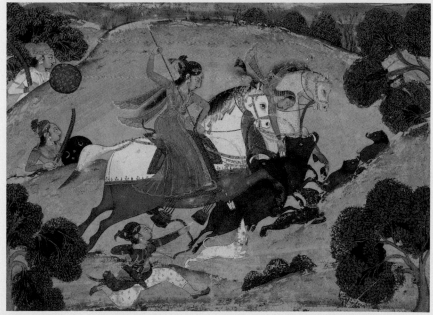

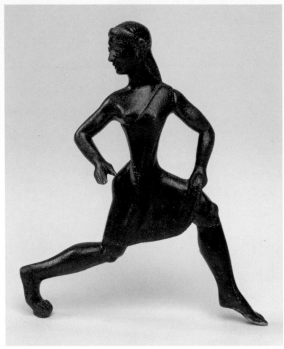

**Head of a victorious athlete
wearing a** *taenia* **(headband)**
Roman, 100 BC – AD 100
Marble
H 42 cm

ABOVE, RIGHT
Figure of a running girl
Greek, 600–500 BC
Said to have been found
at Prizren, Kosovo
Made in Laconia, Greece
Bronze
H 11.4 cm

OPPOSITE
Ragamala **painting of
Sindhuri Ragini (centre left)**
c. 1790
Painted in Panjab Hills,
India
Painted on paper
H 25.3 cm, W 18.5 cm

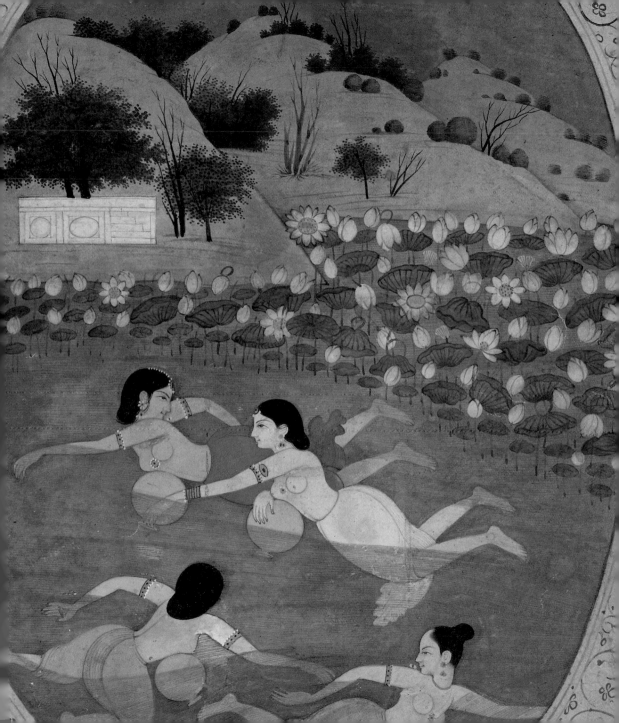

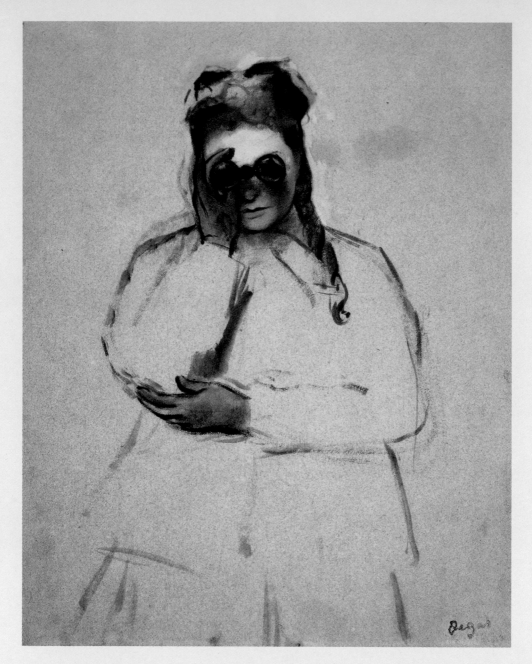

Degas

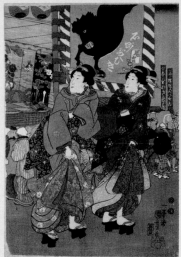

Games and Pastimes

We cannot see the eyes of the attentive young woman in Edgar Degas's study, but the tilt of her head and the set of her mouth as she peers through her field glasses at a horse race express her rapt concentration. In Utagawa Kuniyoshi's woodblock triptych, excited women and children turn to watch expert equestrians providing entertainment on a public street. A different kind of engagement can be seen in the depictions of board and card games (overleaf), in which each player keeps their eyes on the other, curious about the next move.

ABOVE

Crowds at the Horse-riding
Stunts at Ryōgoku
Utagawa Kuniyoshi (1797–1861)
1851–3
Japan
Woodblock triptych print
H 37.6 cm, W 25.4 cm (each panel)

OPPOSITE
Young woman with field glasses
Edgar Degas (1834–1917)
c. 1866–8
French
Oil thinned with turpentine
H 27.9 cm, W 22.4 cm

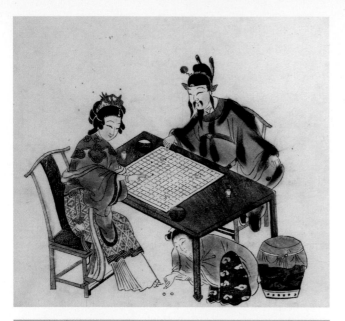

LEFT

**A man and a woman playing
chess (*weiqi*)**
Qing dynasty, Kangxi reign,
1662–1722
China
Woodblock print
H 28.8 cm, W 29.2 cm

LEFT, BOTTOM

A happy couple
Thomas Rowlandson (1757–1827)
Production date unknown
British
Pen and brown ink
H 14.7 cm, W 14.2 cm

Figure group of two women
playing knucklebones
Greek, *c.* 330–300 BC
From Capua
Made in either Campania
or Puglia, Italy
Terracotta
H 21.3 cm

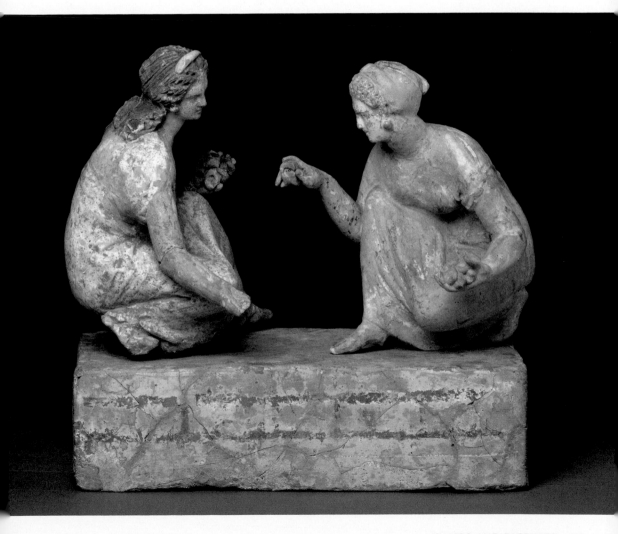

Private Time, Reading

OPPOSITE

**Head of a young girl reading
a book**
Gaetano Gandolfi (1734–1802)
After 1749
Italian
Black and red chalk
H 29.4 cm, W 20.4 cm

RIGHT

Young Woman Reading a Letter
Kitagawa Utamaro (died 1806)
c. 1795–1800
Japan
Woodblock print
H 36.2 cm, W 23.7 cm

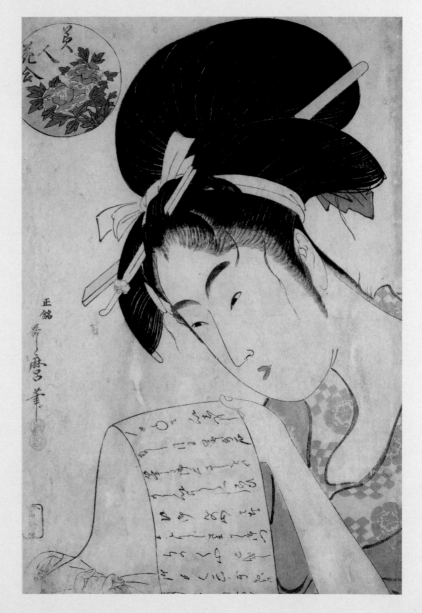

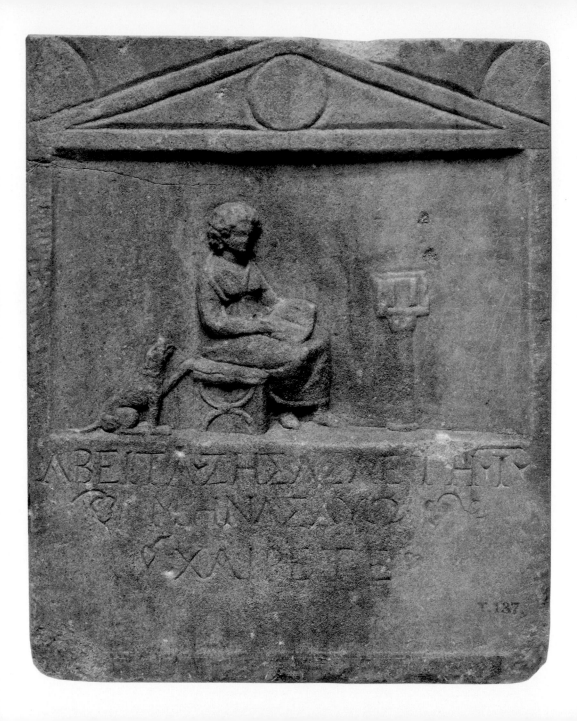

ΛΒΕΙΤΙΑΣΗΔΙΑΣΚΕΤΗΤΙ
ΜΩΝΥΖΑΥΟ
ΧΑΙΡΕΤΕ

T.187

These two readers are very different from each other, notably in terms of age, gender and culture. The ancient Greek gravestone depicts a girl, seated near a lectern, reading from a scroll. The inscription identifies her as Avita, who lived for little more than ten years. The name of the Persian scholar is not known, but his full, dark beard and substantial physique suggest that he is middle-aged. With their narrowed eyes and inclined heads, they share a similar state of deep concentration, fully absorbed in the world of words.

OPPOSITE
**Epitaph of Avita, depicted
reading from a scroll**
Greek, 1st century AD
Marble
H 33 cm

RIGHT
Seated Scholar
Single-page drawing
Late 19th century
Iran
Ink on paper
H 15 cm, W 9.8 cm

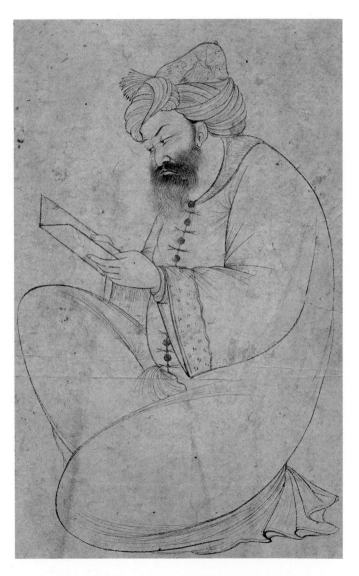

And So To Bed

LEFT
Mould-made terracotta figure
of a boy sleeping in squatting
position
500–400 BC
Made in Rhodes, Greece
Terracotta
H 7.5 cm

LEFT, BOTTOM
Girl Sleeping
Print by Sir George Clausen
(1852–1944)
1884–1905
British
Lithograph
H 14.5 cm, W 25.2 cm

OPPOSITE
A *ragamala* painting of a woman
sleeping on a terrace with an
attendant nearby and a man
walking away, carrying garlands
c. 1750
India
Gouache on paper, highlighted
with gold
H 20.3 cm, W 14.8 cm

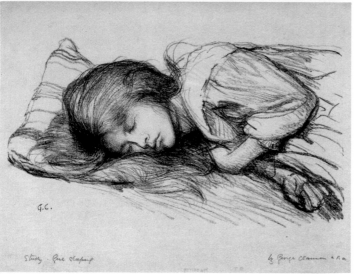

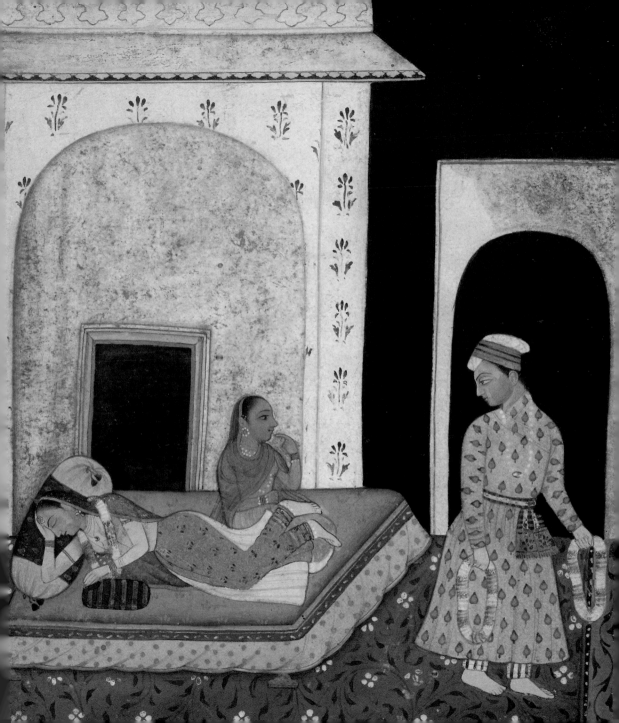

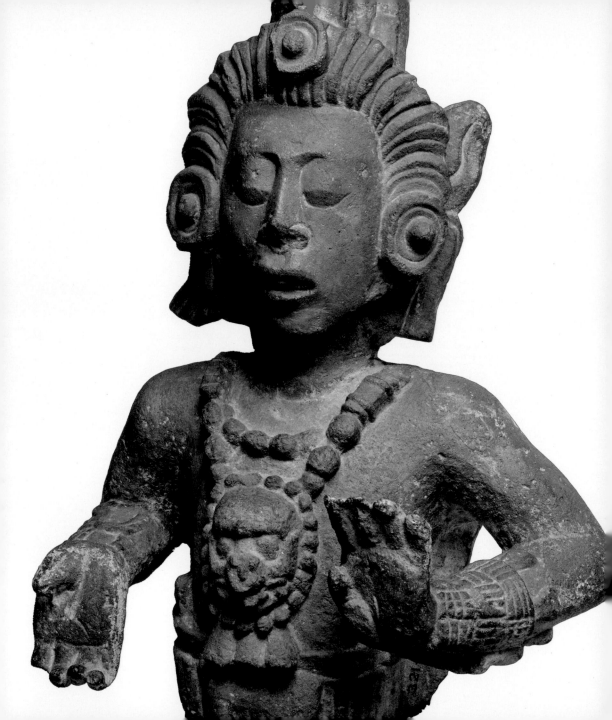

4 Faith & Ritual

JANUS, THE ANCIENT ROMAN protector of passageways, has two faces, one to look forward and the other to look back. The Hindu god Shiva is sometimes depicted with three: one fierce and one blissful, flanking a countenance of serene self-possession (page 139). Svantevit, the Slavic deity of war and divination, has four faces, one to survey each of the four cardinal directions; Brahma, the Hindu demiurge, also has four. With eleven heads – as well as up to a thousand arms, each with an eye in the palm of the hand – the bodhisattva Avalokiteśvara exhibits his unlimited compassion, ever watchful for human suffering. These multifaced gods rise from different faiths and diverse traditions, but they illustrate a shared concept of the sacred: one face is never enough to represent divine dominion.

From a kiss of blessing to an act of anointment, heads and faces have special significance in our diverse beliefs and practices. The ancient Hebrew word *paniym* means more than just the physical face; it indicates the capacity of the face to represent the physical and spiritual whole. The divine face manifests benediction; in the Old Testament (Numbers 6:25), the Lord charges Moses to tell the Israelites that he will bestow peace and protection through his shining countenance. In the *Popol Vuh*, the creation saga of the K'iché Maya, the supernatural being Seven Macaw boasts that, like the sky, the sun and the moon, his face radiates across huge distances. Indeed, the divine face holds such power that in many traditions it can neither be seen nor represented. The fourth-century Greek historian Eusebius of Caesarea contended that, after the crucifixion, Christ's face was too glorious to behold. The Qur'an (6. 103) explains that, while the divine encompasses all vision, 'No vision can grasp him', prompting Islamic theologians to proscribe the depiction of God's face, as well as that of his prophet, Mohammed.

Genesis (1:27) asserts that 'God created man in his own image', and many of the world's religions envision the divine through the lens of humanity (pages 130–3). Benevolent deities show their natures through kind expressions and breathtaking beauty. A wrathful god inspires obedience through a formidable aspect. Some gods personify their special concerns: the womanly beauty of

a harvest goddess, a well-fed and sanguine god of wealth, the peaceful visage of a god that bestows soothing sleep, or the valiant face that heralds victory or heroic death. A holy figure may have historic origins, but the representation of his or her face is based on ideas rather than observed reality. There is no known likeness of Siddartha Gautama dating from his lifetime (*c.* 563 – *c.* 460 BC), but more than five centuries after his death, the face given to him as the Buddha resolved into handsome and placid features crowned by a topknot and framed with elongated earlobes, a vestige of the heavy earrings that he wore in his days as a prince (pages 135, 138).

When Moses climbed Mount Sinai to receive the Ten Commandments, he heard the Lord's words but dared not look at Him. He descended the mountain with a face so radiant that he frightened the people of Israel; after delivering the holy laws to them, he veiled his face. In many faith practices, a select member of the community possesses the power to cross the boundary between the secular and the sacred. The role of the shaman, central to diverse beliefs on every continent across the globe, provides a conduit to the spiritual realm, and the experience is transformative. To connect to the empowering spirits, shamans often don headdresses and masks, replacing their quotidian appearance with a likeness of an ancestor or a spirit animal, or that of a god or a demon. Masks also serve to transform members of the community in rites that honour their deities or mark transitions from one life stage to the next. Ritual objects – shrines, icons, relics – often feature holy faces that help to connect the faithful to their faith (pages 154–5).

Worship similarly demands transformation. The head may be lowered or tilted up to the heavens. Eyes close to gaze inward or open wide to see what is beyond normal perception. Lips may part in silence or in spoken prayer. Common to all these physical expressions of faith is an indication that an individual's heart and mind are concentrating on something other and greater than themselves (pages 156–7). Our faces reveal our own experience of connection with who we are and what we believe.

Divine Countenance

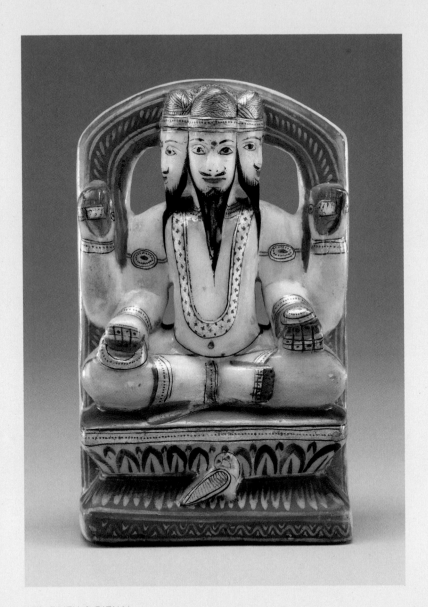

LEFT
Figure of Brahma, the first god in the Hindu triumvirate (completed by Vishnu and Shiva) responsible for the creation, upkeep and destruction of the world
19th century
Found in Jaipur, India
Painted marble
H 17.5 cm, W 11 cm

OPPOSITE
Print depicting the Holy Trinity
1980s
Papantla, Mexico
H 48.5 cm, W 39 cm

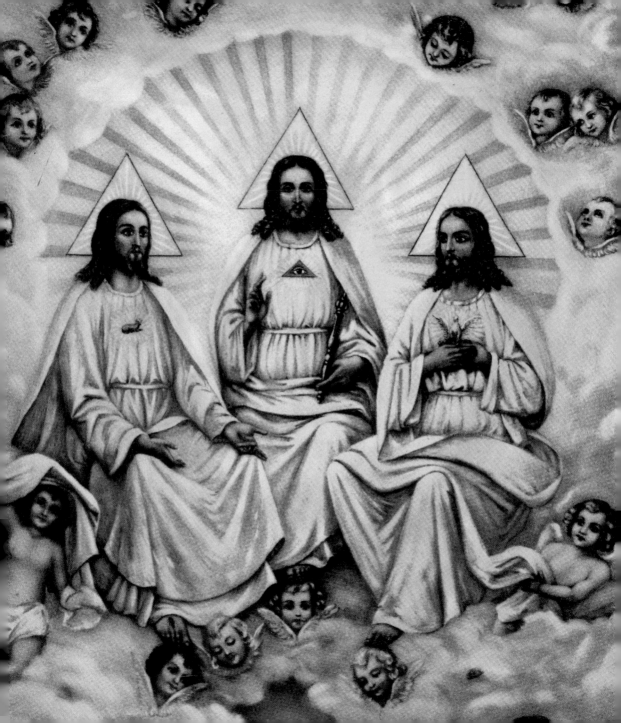

In the face of a deity, the faithful perceive aspects of their beliefs. Christ's compassion is seen in his soulful eyes, while the stern Zeus (page 133) has a steely gaze. Bes, an ancient Egyptian household god, was a trickster with a grotesque visage, scheming to chase away evil and ignite joy. With his traditional topknot and elongated earlobes, the Buddha is easily recognized, but the smoothly modelled planes of the depiction shown opposite make this type distinctive to the Khmer period. The youthful beauty of Chalchiuhtlicue (page 132), an Aztec goddess linked to spring water, purity and irrigation, represents the natural forces that help to sustain life on earth.

BELOW, LEFT
The Sudarium
Anonymous
1530–80
Italian
Engraving
H 16 cm, W 11.5 cm

BELOW
Amulet of the face of Bes
c. 1295–1170 BC
Found in Egypt
Gold
H 3.1 cm, W 2.8 cm

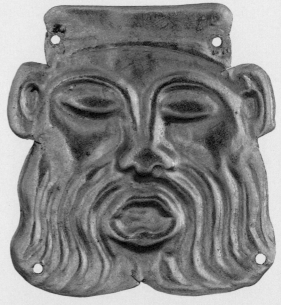

Figure of ornamented Buddha
head, with long, smoothly
modelled face
c. 1200–1250
Thailand
Sandstone
H 40 cm

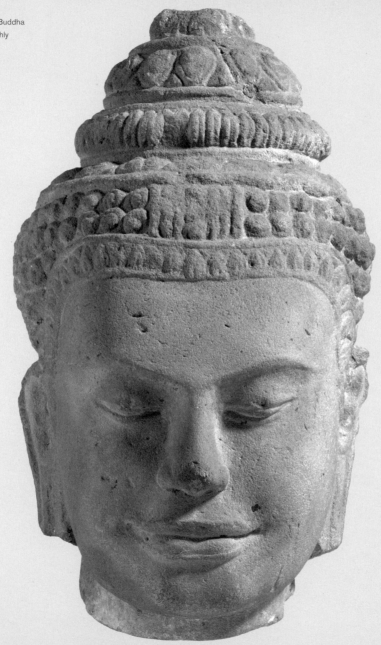

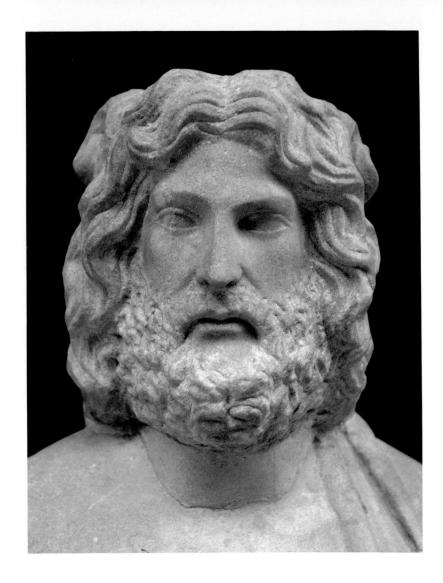

OPPOSITE
**Figurine of Aztec goddess
Chalchiuhtlicue**
Aztec, 1400–1650
Mexico
Andesite
H 37 cm, W 19.5 cm

RIGHT
Statue of Zeus Ammon
Roman, 1st century AD
From the Temple of Apollo
at Cyrene, Cyrenaica (Libya)
Marble
H 83 cm

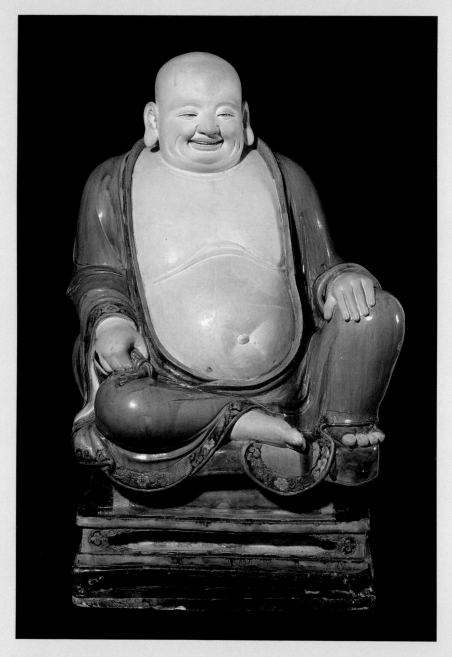

Figure of Budai Heshang
(Laughing Buddha), dressed in
the loose, amber-coloured robes
of a mendicant Buddhist monk
Ming dynasty, Chenghua period,
1486
Liuzhen, Henan, China
Stoneware
H 119.2 cm, W 65 cm, D 41 cm

Seated Buddha preaching
2nd–3rd century AD
Made in Gandhara, found
in Jamalgarhi, Pakistan
Schist
H 95 cm, W 53 cm

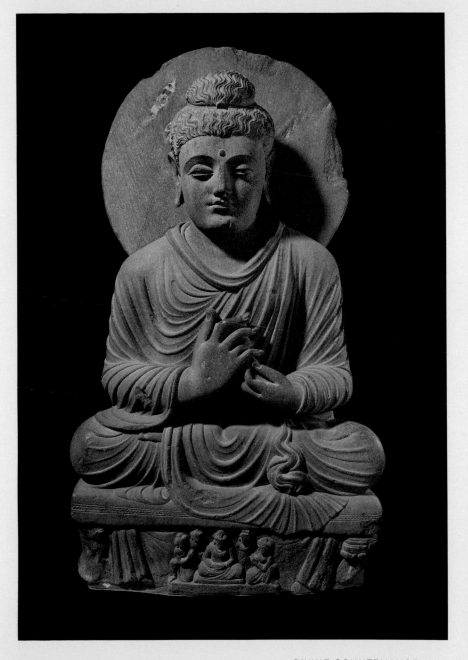

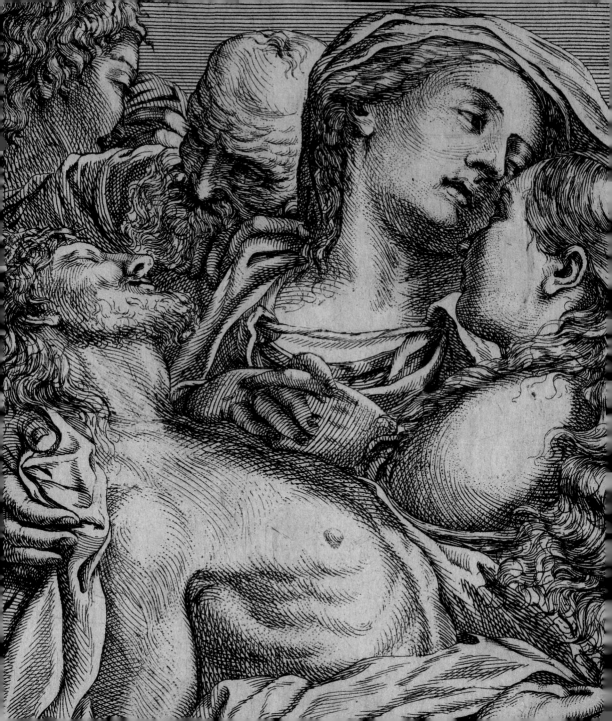

Aspects of Divinity

To visualize divine power in human form, the artist must give the deity a face. A god may appear as serene as the Maya maize god, recognized by his corn-cob headdress; his youthful beauty is a reminder of the rejuvenating cycle of the earth's bounty and its parallel in human birth, death and rebirth. In the resolute face of Christ, believers seek the story of suffering that leads to salvation.

OPPOSITE
The Virgin holding the dead Christ
Formerly attributed to Domenico
Maria Canuti (1625–1684)
1620–70
Italian
Etching
H 21 cm, W 15.8 cm

BELOW, LEFT
Sculpture of the Maya maize god
Late Classic Maya, AD 715
Copan, Honduras
Limestone
H 89 cm, W 56.5 cm

BELOW, CENTRE
Figure of Amitābha Buddha
seated on a lotus base, his
hands forming the *mudrā*
(symbolic hand gesture) known
as *dharmacakra*
Qing dynasty, 1692
China
Wood, lacquer and gold
H 32 cm

BELOW
Unfinished figure of Shiva
c. 1950
Found in Orissa, India
Wood
H 36 cm, W 17.3 cm, D 14.5 cm

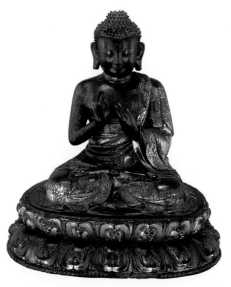
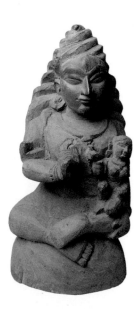

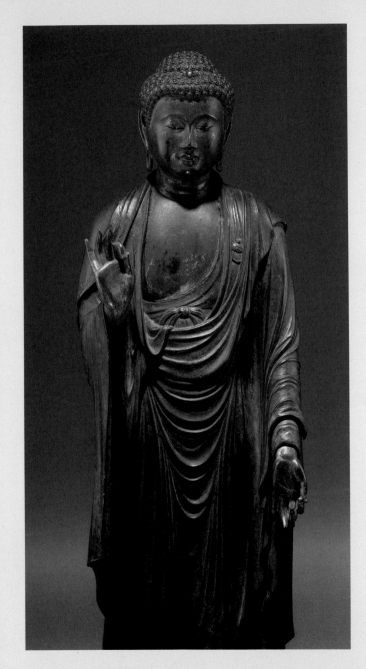

LEFT
Figure of Amida Buddha
standing with his hands in
a *vitarka mudrā*, welcoming the
faithful followers of Pure Land
Buddhism into the Western
Paradise
Kamakura period, 13th century
Japan
Wood, lacquer
H 96 cm

OPPOSITE
Shiva as Natarāja (Lord of the
Dance), with the goddess Ganga
(the personification of the holy
River Ganges) nestled in his hair
and Apasmara, the dwarfish
demon of ignorance, under his
right foot
c. 1100
Made in Thanjavur or Tamil Nadu,
India
Bronze
H 89.5 cm

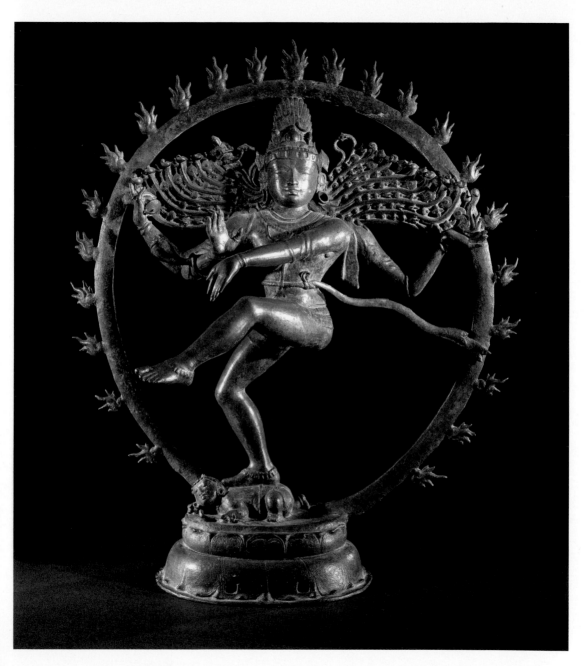

ASPECTS OF DIVINITY 139

While deities are defined by their qualities, in some cases their powers are so vast and varied that they must incarnate in multiple forms. In Chinese traditions, for example, different individuals embody different aspects of affluence and prosperity; in the painting shown opposite, the robust and red-faced Guan Yu is attended (on his right) by another god of wealth, the more aggressive Zhao Gongming. The Hindu goddess Durga possessed the collective energy of Brahma, Vishnu and Shiva, who created her to slay Mahishasura, the Buffalo Demon. As a warrior goddess, her attributes include such weapons as an arrow and a noose, but motivated by love and protection her face is always serene.

RIGHT

Painting depicting the goddess Durga
c. 1790–1810
India
Gouache on paper
H 21.1 cm, W 15.8 cm

OPPOSITE

Painting of Guan Yu and two attendants, Zhao Gongming and Guan Ping
19th century
Guangzhou, China
Ink, colours, gold and silver
on paper
H 39 cm, W 29 cm

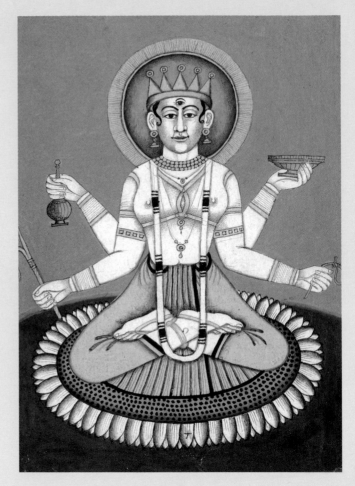

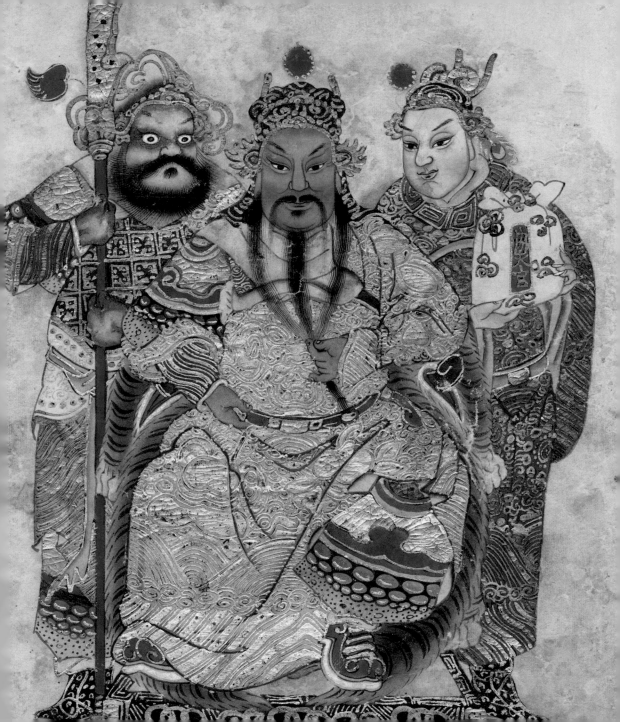

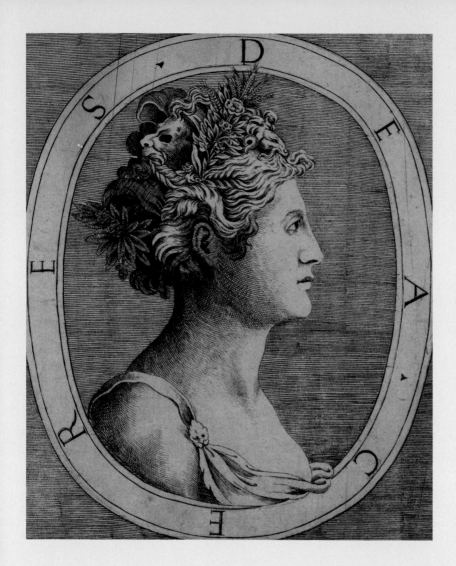

Portrait bust of Ceres
Anonymous
1530–70
Italian
Engraving
H 17 cm, W 13.5 cm

Personified Power

Many cultures embody abstract ideas in human form. The poignant face on the cameo evokes Selene, the ancient Mediterranean moon goddess, pining for her human lover. Ceres, the Greek goddess of terrestrial abundance, is represented as a comely matron with symbols of flora and fauna binding her hair. The Huaxtec goddess, from the Gulf Coast of Mexico, presided over childbirth, fertility and curing the ill, as well as spinning and weaving. Her lively expression may reflect her complicated responsibilities; as the 'eater of filth', she even relieved and redeemed human misdeeds.

ABOVE
Cameo of a crescent and full-moon with face
17th century
Italian
Onyx
Diam. 1.8 cm

RIGHT
Female figure depicting Tlazolteotl
Huaxtec, AD 900–1450
Mexico
Sandstone
H 150 cm, W 57 cm

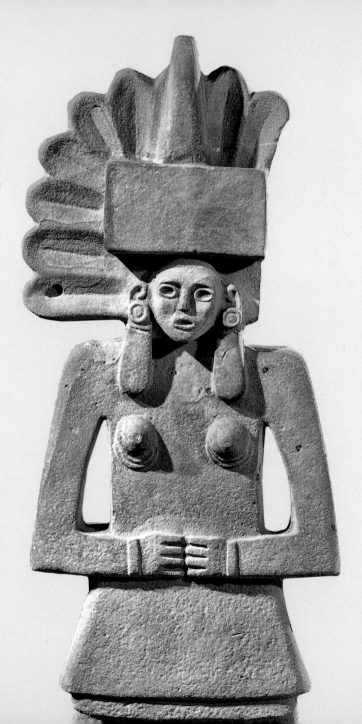

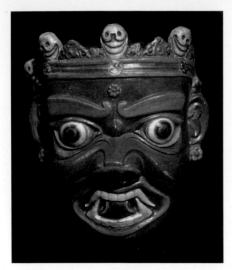

Through emphasis and exaggeration, facial features define divine power. The ferocious nature of Zhao Gongming, a former general to Emperor Zhao, is expressed through his furious glower. He will endow wealth, but only to those who earn it. Sharp fangs, an unblinking stare and a crown of five skulls associate the Tibetan mask with the protector god Mahakala, a fierce emanation of Avalokiteśvara, the bodhisattva of unlimited compassion. The amalgamation of the face of a man with that of a lion reveals the savage power of Narasimha, an avatar of the Hindu god Vishnu, who used his terrifying prowess to combat religious persecution and restore order.

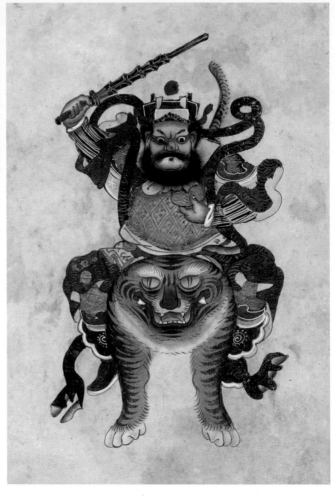

ABOVE

Mask in the form of moustached, bearded face with fangs wearing a coronet with five skulls
Before 1895
Tibet
Plaster
H 21.2 cm, W 21 cm

ABOVE, RIGHT

Painting of the Daoist deity Zhao Gongming
19th century
Guangzhou, China
H 42.5 cm, W 23.3 cm

OPPOSITE

Painting of Narasimha, with twelve arms, seated on a stump, tearing apart Hiranyakaśipu, who lies prone in his lap
c. 1830
Painted in Tiruchirapalli, India
Gouache on paper
H 21.5 cm, W 17 cm

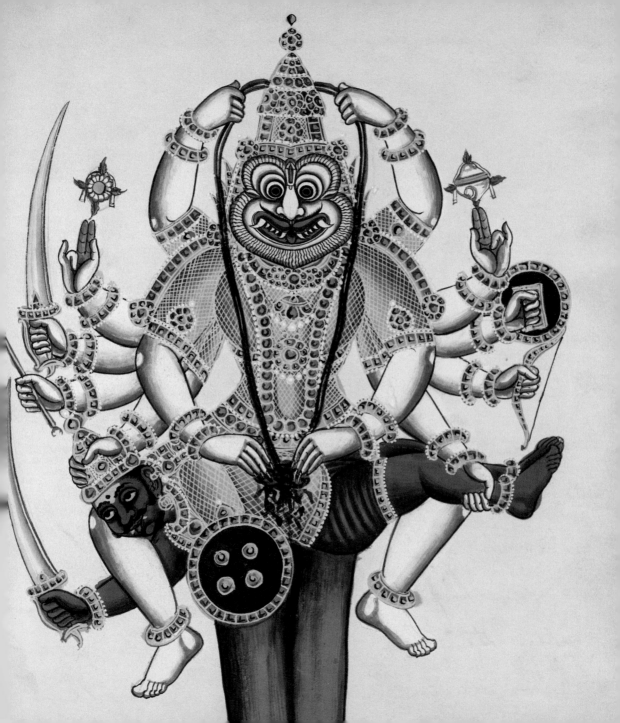

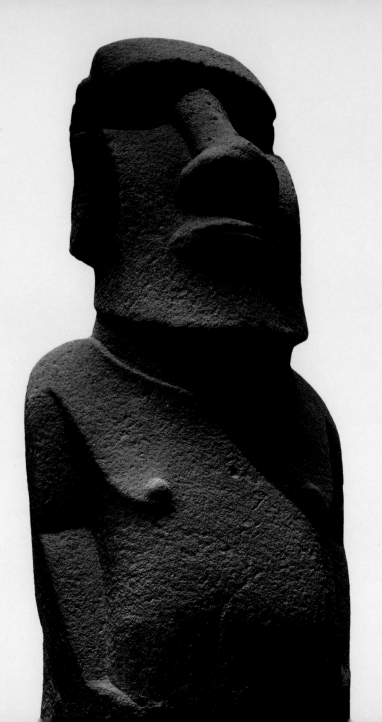

Hoa Hakananai'a (hidden
or stolen friend), a *moai*
(ancestor figure)
c. 1000–1200
Found in Orongo, Rapa Nui,
Easter Island
Basalt
H 242 cm, W 96 cm

Revered Ancestors

Rather than a commemorative likeness, ancestor figures embody the ongoing concern of past generations for those in the present. Hoa Hakananai'a (hidden or stolen friend) is one of more than a thousand monumental sculptures, or *moai*, from Rapa Nui (Easter Island). The maternity theme of the *ntadi* (watchman) funerary figure from the Congo reveals that it once stood on the grave of a woman, to bear witness and honour the dead. With ancestry central to their beliefs, the Fang people of Gabon made reliquary guardian figures and attached them to boxes containing ancestors' bones.

BELOW, LEFT

Ntadi funerary figure depicting
a woman nursing a child
Late 19th – early 20th century
Kongo people, Congo
Steatite
H 41.8 cm, W 15.2 cm

BELOW

Male reliquary figure
Late 19th – early 20th century
Fang people, Gabon
Wood, iron and brass
H 60.5 cm, W 16 cm

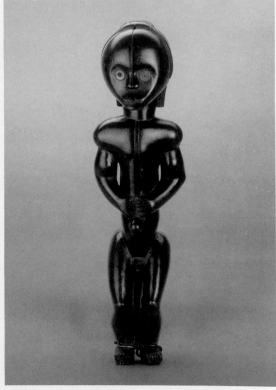

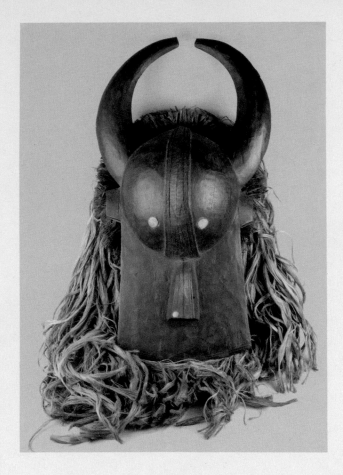

LEFT
Wooden mask with two curved
horns
Early 20th century
Chamba Daka people, Nigeria
Wood, fibre
H 72 cm, W 40.5 cm (mask only)

OPPOSITE
Aaron the High Priest
Print by John Saunders
(*fl. c.* 1790s), after Richard
Corbould (1757–1831)
c. 1796–1800
British
Etching and engraving
H 25.5 cm, W 28.5 cm

Priests and Practitioners

Historically, the term *juju* (magical power) often
carried ancestral references; the mask seen above is
associated with a hereditary priesthood passed from
father to son. Its curved horns and squared jaw evoke
the appearance of a bush cow. The mask would be
worn with layers of garments covered with shredded
fibres. This complete concealment of head and body
transformed the man who wore the ritual garments
into a spirit leader.

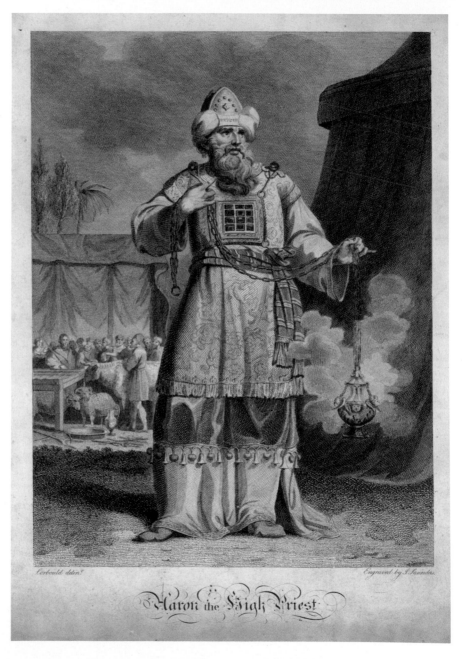

Aaron the High Priest

Corbould delin.^t Engraved by J. Saunders

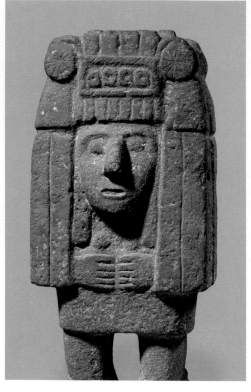

Ghanaian *akua'mma*, or fertility dolls, were the exclusive property of women, kept to protect their ability to bear healthy children. The Aztec figurine holding two corn cobs can be recognized as the maize deity Chicomecoatl by her elaborate headdress (*amacalli*, or 'house of paper'). Worn during a harvest festival, her image guaranteed a community's sustenance. The masks of the Ekpo society of the Ibibio people of Nigeria petitioned ancestors and deceased society members to guard against such misfortunes as infertility and child mortality. Here, the mask abstracts the facial features of an elephant; a raffia cloak would complete the ritual ensemble.

ABOVE, LEFT

Akua'mma fertility figures
Late 19th – early 20th century
Akan people, Ghana
Wood
Left: H 47 cm, W 21.5 cm;
right: H approx. 32 cm, W 12.5 cm

ABOVE

Standing figure of a woman
Aztec, 1300–1521
Mexico
Limestone
H approx. 62.5 cm

Ekpo society mask
Late 19th – early 20th century
Ibibio people, Nigeria
Wood, grass
H 48.3 cm

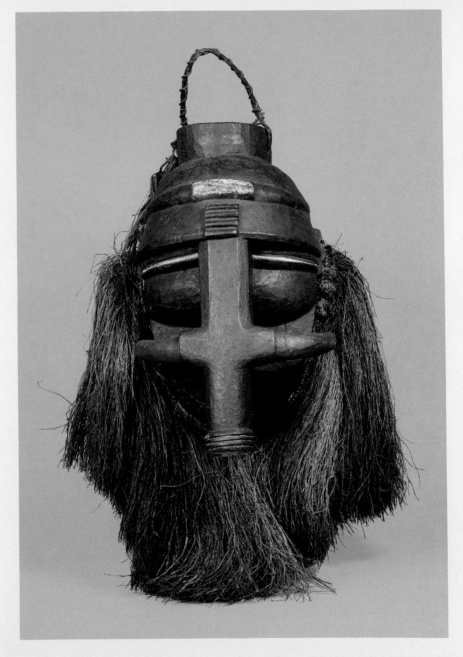

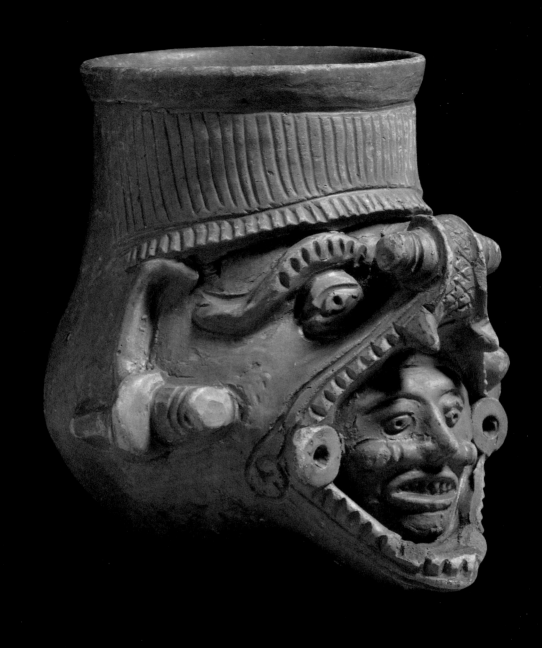

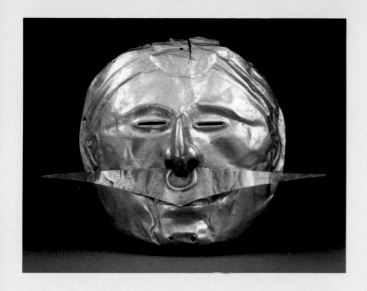

Ritual Objects

Ritual objects blend form with meaning. Snakes often feature in Mesoamerican objects as a metaphor for the umbilical cord; emerging from the gaping jaws of a serpent, the human head may be regarded as a symbol of spiritual creation. The exquisitely hammered gold funerary mask from Colombia would have covered the face of the wrapped body, transforming the deceased from a community member into an ancestor. The Japanese theatrical dance tradition *kagura* (literally, 'god-entertainment') has ancient Shinto roots. The rounded dimpled cheeks and rosy, red-lipped smile of this mask identifies it as representing the character of Otafuku, the goddess of mirth.

OPPOSITE
Vessel with human head
emerging from serpent jaws
Post-Classic, AD 900–1521
Isla de Sacrificios, Veracruz,
Mexico
Pottery
H 12.7 cm, W 12 cm

ABOVE, LEFT
Anthropomorphic mask with
triangular nose ornament
Yotoco or Late Quimbaya,
100 BC – AD 1600
Colombia
Gold
H 15.5 cm, W 18 cm

ABOVE
Okame mask for a *kagura*
performance
20th century
Japan
Wood
H 16.7 cm, W 13.4 cm, D 5.4 cm

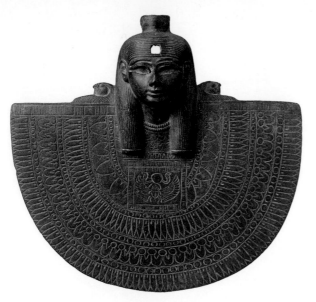

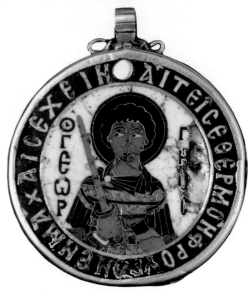

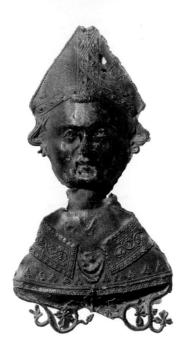

ABOVE, LEFT

Aegis of Isis
Late period, 664–332 BC
Egypt
Bronze
H 14.5 cm, W 15.5 cm

LEFT

**Pilgrim souvenir bust reliquary
of St Thomas Becket**
c. 1320–75
Made in Canterbury, England
Found in Billingsgate, England
Lead alloy
L 8.9 cm, W 4.5 cm

ABOVE

Reliquary pendant of St George
11th century
Made in Thessaloniki, Greece
Gold, enamel
Diam. 3.7 cm

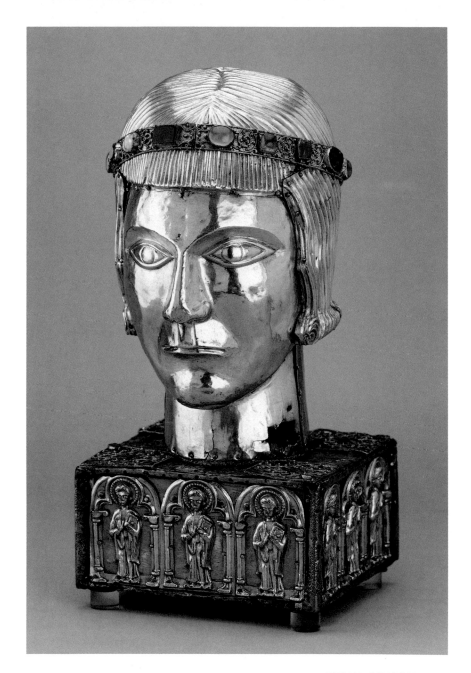

Reliquary of St Eustace with
a silver-gilt *repoussé* head
and gem-set filigree circlet
1180–1200
Made in Basel, Switzerland
Wood, silver, gold
H 35 cm

Worship

'Seek the Lord and His strength, seek His face continually.'

1 Chronicles 16:11

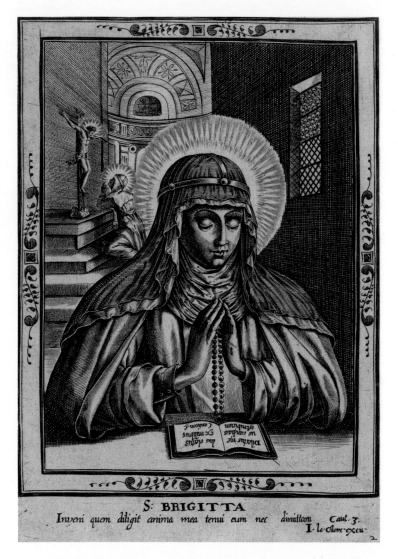

S: BRIGITTA

Inveni quem diligit anima mea tenui eum nec dimittam Caut. 3.
I. le Clerc excu.

LEFT

St Brigitta
Published by Jean Leclerc IV
(1560–1621/2)
After 1587
French
Engraving
H 18.7 cm, W 13 cm

OPPOSITE, LEFT

Figure of Sir John Langston
c. 1506
Made in London, England
Brass
H 69.5 cm

OPPOSITE, RIGHT

**Figure of the Prince Regent
Shōtoku Taishi as a two-year-
old child, kneeling in prayer
and reciting sutras in the
Namu Amida Butsu (Hail
to Buddha) form**
Edo period, 18th century
Japan
Wood
H 28.8 cm

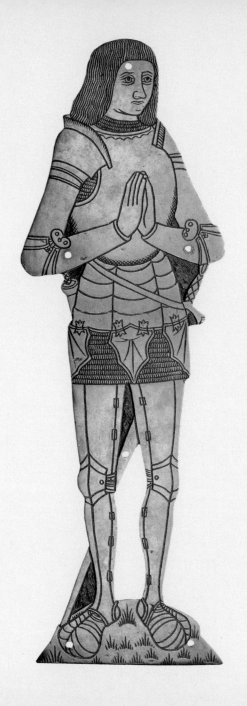

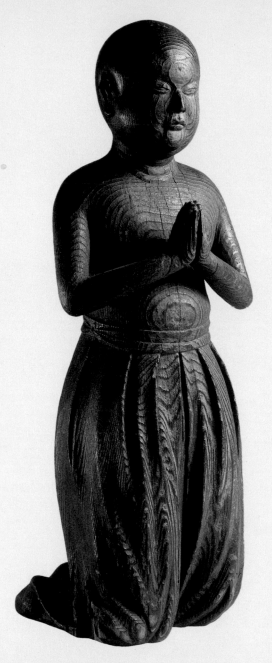

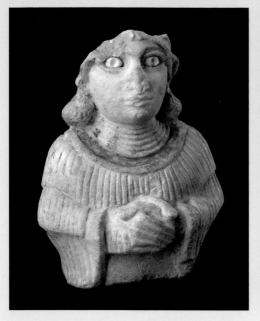

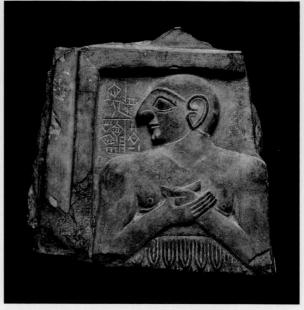

A votive figure remains dutifully at prayer in the absence of its donor. Like the Babylonian female figurine, the Sumerian stone-plaque depiction of Enannatum, king or governor of Lagash, clasps his hands in a worshipful gesture. With their raised arms and palms turned upwards towards the sky, the three figures on the Roman sarcophagus fragment present themselves as orants, or pious petitioners in a stance of prayer common to pagans, Jews and Early Christians at the turn of the first millennium AD.

ABOVE, LEFT
Painted statue of a female worshipper wearing a flounced robe
2000–1750 BC
Found at Ur, Iraq
White stone
H 14.5 cm, W 11.5 cm

ABOVE
Votive plaque showing Enannatum, ruler of Lagash, with hands clasped in an act of worship
2450 BC
Found at Tello, Iraq
Stone
H 19.1 cm, W 19.1 cm

OPPOSITE
Part of a sarcophagus depicting three votaries in Greek dress with forearms raised in gestures of prayer
Roman, AD 250–70
Marble
H 38.3 cm

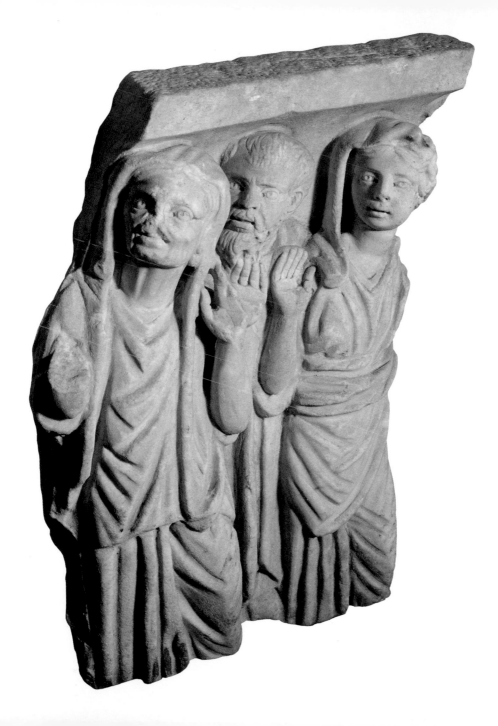

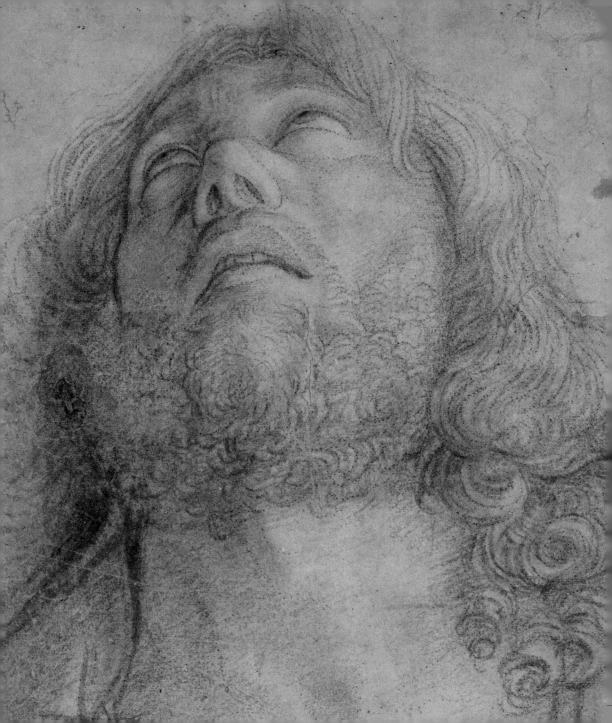

OPPOSITE

Head of a man looking up
Attributed to Giovanni Bellini
(*c.* 1431/6–1516)
After 1450
Italian
Black chalk
H 39 cm, W 26.2 cm

RIGHT

Mater Dolorosa
Print by Hermann Eichens
(1813–1886), after Ary Scheffer
(1795–1858)
c. 1880s
German
Engraving with etching and aquatint
H 44.5 cm, W 29.6 cm

The physical act of worship takes many forms. These ancient Mediterranean female votive figures present offerings. The figure on the left plays the lyre; the one on the right bears a plate of cakes and lifts her left hand in a devotional gesture. The Egyptian man in the photograph is engaged in *salah*, the Islamic practice of prayer. Five times a day, a devout Muslim demonstrates faith through a set cycle of postures and gestures, each accompanied by a recitation from the Qur'an.

BELOW, LEFT

Votive figurine of female playing a lyre

Cypro-Archaic II, 600–550 BC

From Lapithos, Cyprus

Terracotta

H 18.5 cm

BELOW, RIGHT

Votive female figurine holding a dish of cakes

Cypro-Archaic II, 600–550 BC

From Lapithos, Cyprus

Terracotta

H 20.5 cm

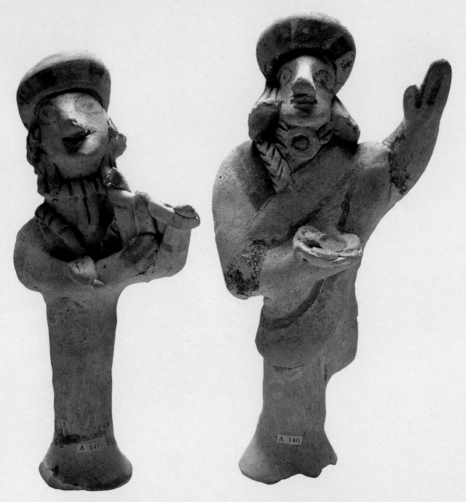

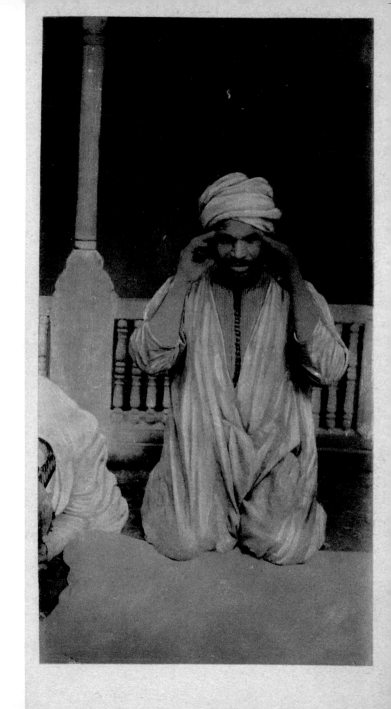

Printed postcard showing
Muslim man praying
c. 1900–30
Published by the Cairo Postcard
Trust, Egypt
H 15 cm, W 7.3 cm

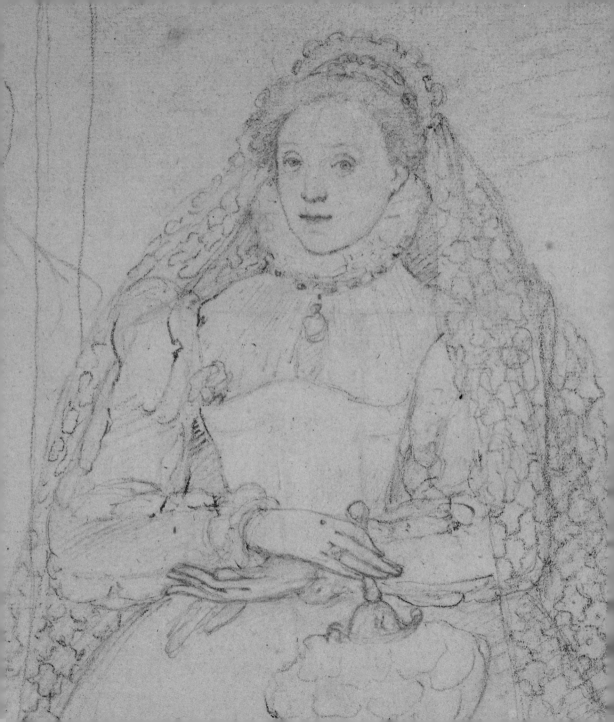

5 Rulers & Warfare

THROUGHOUT HISTORY, RULING power has tended to be entrusted to a distinct individual, whether as monarch, chieftain or elected official. When depicted, a ruler's image often acquires iconic significance, giving a face to the community that he or she rules. Indeed, the image of a ruler must convey more than likeness; it must also represent the vital ideas that shape and secure the ruled domain. Some portraits, for example, evoke an equitable system through the ruler's poise, enhanced by a kindly and confident gaze with just the hint of a smile (pages 168–9). Others assert the indomitability of the state through a stern glare, firm mouth and clenched jaw. The ruler's face distills the ideals of a nation and constructs its emblematic identity. It is the face that a nation broadcasts to the world, on monuments, on currency and, most significantly, in the popular imagination. Ultimately, the idea of rule transcends individual likeness, for the face of the ruler must project the essence of the rule.

In fact, pictorial likeness may be inconsequential or even irrelevant. The fatal beauty of Cleopatra is celebrated in the words of the Roman poets Horace and Lucan, but images of her vary from a bland ideal to hawkish severity. The enhanced visage of Alexander the Great – clean-shaven and ever young with a magnificent forelock gracing his broad, unlined brow – became the emblem of his empire (page 176). Rome's first emperor, Augustus, followed his example with an official countenance that contradicted descriptions of his ill-favoured appearance (page 177). Just as some rulers' faces are constructed, others are inherited. Throughout the more than five-century duration of the Old Kingdom in ancient Egypt (*c.* 2700 – *c.* 2200 BC), the image of each new pharaoh bore a striking resemblance to that of his predecessor. The Olmec mask, less than life-sized, may have portrayed an ancestor or a historic king (page 178). When facial features conform to a set of conventions, they have the same symbolic force as a headdress, a nimbus or a crown; the face itself serves as a representation of rule. And for modern rulers, whose features are as well-known as those of any celebrity, their public mien becomes their identity.

A regal demeanour is often the product of a calculated pose – head high, chin raised, eyes fixed on some distant goal – presenting a face to be admired, a face to inspire and a face that others will follow. And when those followers are defenders of the realm, their faces must return that look of steadfast determination. The warrior's impassive expression is a study in strength and readiness (pages 196–7). He tamps down emotion and wears a brave face; gaze unblinking, his attitude is one of alertness, ready for the orders that will trigger his actions. The warrior's helmet does more than shield his skull from damaging blows. Crowned with horns, crests or the snarling muzzle of a savage animal, it manifests his ferocity through intimidating association (pages 192–3, 198–9). A warrior may mark his face or stain his skin as a pre-battle ritual, giving him an unearthly and fearsome aspect, or he may cover his face with a metal visor, replacing his human countenance with an impenetrable visage of keen, fierce anonymity (pages 190–1).

Once in the thick of battle, the warrior's face maps his individual reactions to the fray. His gaze is now directed at the enemy; to look away is to give ground (page 194). Eyes narrow in concentration or widen with fear. Facial features contract and tighten, furrowing the brow and bracing the jaw, making a face like a clenched fist. Lips compress with the effort of suppressing a scream or they stretch open to frame a harrowing howl of agony. Complexions flush with effort – heart pounding, blood rushing – or blanch in terror. And, inevitably, the blows that are both given and received cause damage: whether bruised, bloodied or broken, a warrior's face bears witness to the conflict. He may carry the mark of battle in a permanent disfigurement – fractured bones, livid scars, a lost eye, missing teeth – borne as a debilitating burden or a badge of honour. Some scars lie deeper, affecting the warrior's mind, soul and memory long after the battle is over. These too leave their mark on a warrior's face (page 202). Whether hardened or brutalized, wary or despairing, an expression of authentic and individual experience replaces the impassive anonymity of the brave face.

Face of Authority

Portraits of rulers are often identified by attribute or
inscription, as well as by likeness. The enormous bust
of Ramesses II features the remains of the pharaonic
uraeus (stylized cobra symbolizing sovereignty, usually
worn on a headdress) and *nemes* headcloth; on the
back of the bust, hieroglyphs record the pharaoh's
name and accomplishments. Overleaf, the statue of
the Assyrian king Ashurnasirpal II is not crowned, but
carved text proclaims his titles and triumphs. A flowing
beard identifies Sojobo, mythical king of the *tengu*
(creatures of Japanese folk religion), as a *yamabushi*
(mountain hermit). No matter the iconographic
representation of power, all these rulers radiate
strength, resolve and confidence through their
dignified mien.

RIGHT
Statue of Gudea, ruler of Lagash
c. 2130 BC
Probably from Tello, Iraq
Dolerite
H 78 cm, W 50 cm

OPPOSITE
Colossal bust of Ramesses II
19th dynasty, *c.* 1250 BC
From the Ramesseum Temple
at Thebes
Red granite, granodiorite
H 267 cm

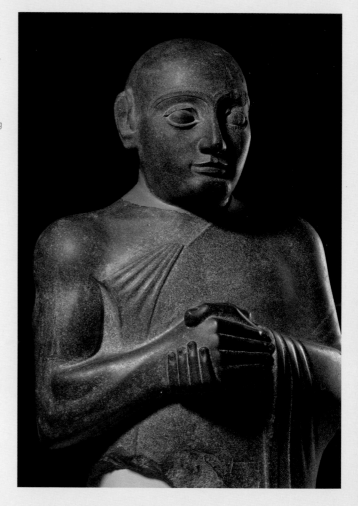

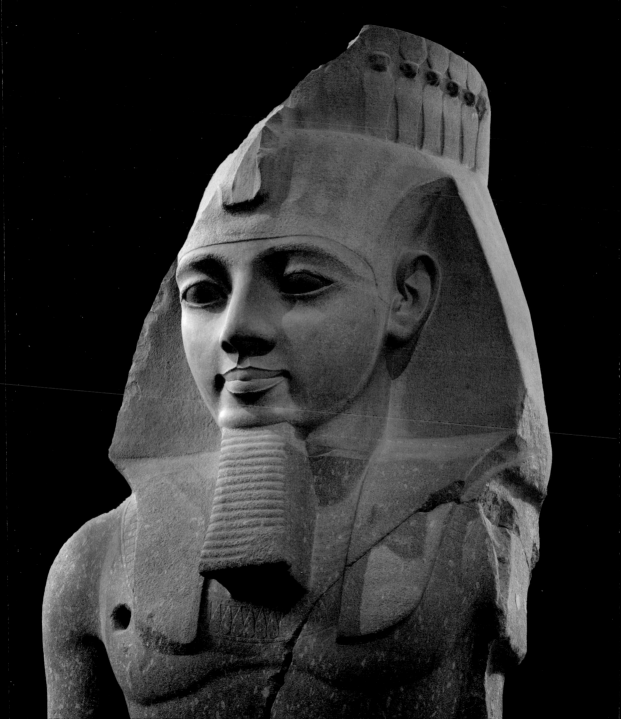

BELOW

The Lyte Jewel, open to show
portrait miniature of James VI and I
Painted by Nicholas Hilliard
(c. 1537–1619)
1610–11
Made in England
Portrait on vellum with a frame
of enamel, gold and diamonds
L 10.5 cm (open with pearl), W 4.8 cm

BELOW, RIGHT

Statue of Ashurnasirpal II,
king of Assyria
883–859 BC
From the Temple of Ishtar Belit
Mati, Nimrud, Iraq
Magnesite
H 113 cm, W 32 cm

OPPOSITE

Sojobo, the king of the *tengu*,
receiving his subjects at Mount
Kurama
Utagawa Kunitsuna (1805–1868)
1859
Japan
Woodblock print
H 35.3 cm, W 24.7 cm

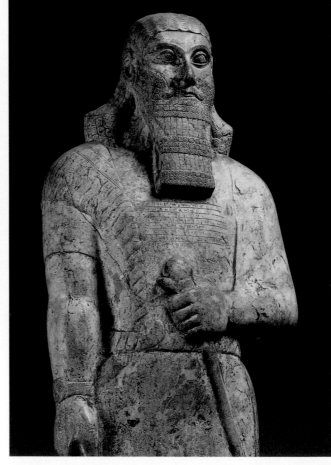

The Benin mask, representing Idia, mother of the
sixteenth-century *oba* (king) Esigie, would be worn
on the hip during important ceremonies. The mask is
crowned with a circlet of heads of Portuguese men,
symbolizing the importance of European trade to
Benin's wealth. The cameo of Elizabeth I of England
projects the queen's power through the material
display of her elaborate coiffure and precious
ornaments, as well as the beauty of the carved onyx.

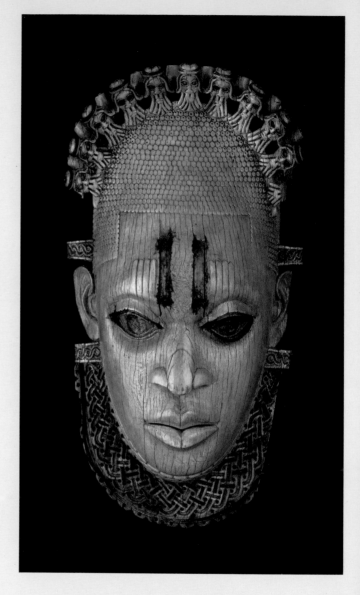

**Pendant mask associated
with Queen Idia**
16th century
Benin, Nigeria
Ivory with iron and copper inlays
H 24.5 cm, W 12.5 cm

Cameo bust of Elizabeth I
16th century
Made in England
Onyx, gold
L 2.4 cm, W 2 cm

OPPOSITE

**Portrait of the Qianlong
Emperor based on a
Chinese prototype**
Print by Mariano Bovi
(1757–1813)
1795
British
Aquatint and etching, printed
in colour
H 51.7 cm, W 30.2 cm

BELOW

The Statue of Idrimi
16th century BC
Tell Atchana, Turkey
Magnesite
H 104.1 cm, W 48.3 cm

BELOW, RIGHT

**Figurative carving (*ndop*)
associated with King Shyaam
aMbul Ngwoong**
Probably late 18th century
Kuba-Bushoong people,
Democratic Republic of Congo
Wood
H 55 cm, W 22 cm

Just as the likeness of a ruler gives meaning to an object, the nature of that object articulates the ruler's authority. The stone carving of Idrimi, ruler of the ancient Syrian city-state of Alalakh, survives from the sixteenth century BC. The paper on which the image of the Qianlong Emperor is printed enabled it to be easily and widely circulated. The game board at the base of the *ndop* identifies it as a representation of King Shyaam aMbul Ngwoong, the founding father of Kuba society. One of a series of idealized representations of Kuba rulers, the *ndop* would secure sovereignty in the king's absence.

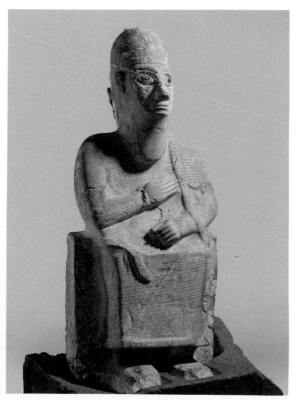

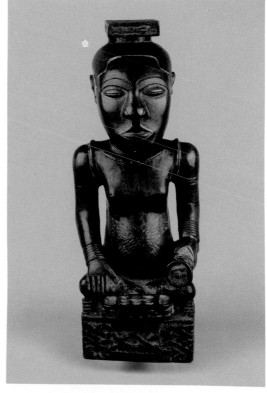

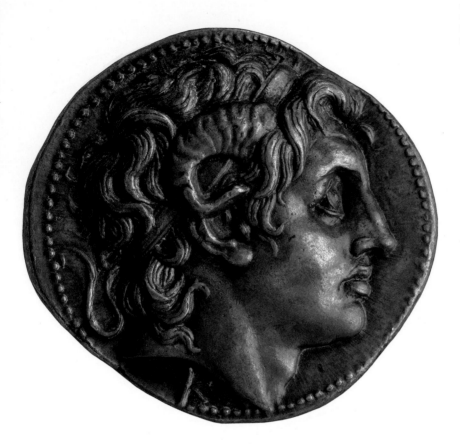

Silver tetradrachm showing
Alexander the Great (obverse)
c. 305–281 BC
Minted in Lampsacus, Turkey
Diam. approx. 3 cm

'I have seen the king with a face of Glory. He who is the eye
and the sun of heaven. He who is the companion and healer of
all beings. He who is the soul and the universe that births souls.'

Rumi, *ghazal* (ode) from *Divan-e Shams-e Tabrizi*, 13th century

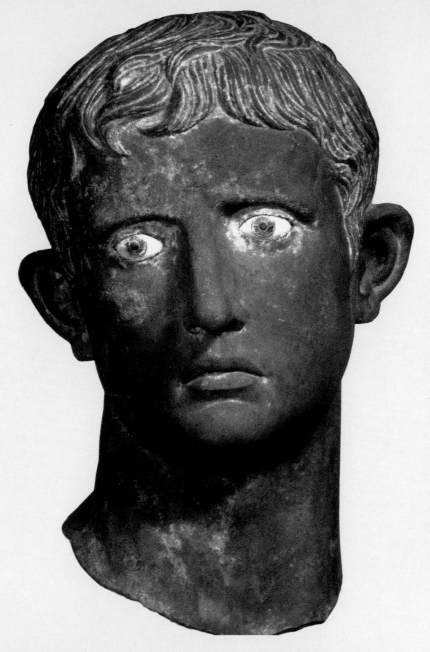

The Meroë Head
Bronze head from an over-
life-sized statue of Augustus
Roman, 27–25 BC
From Meroë, Sudan, excavated
beneath the steps leading into
a shrine of Victory
Bronze
H 46.2 cm

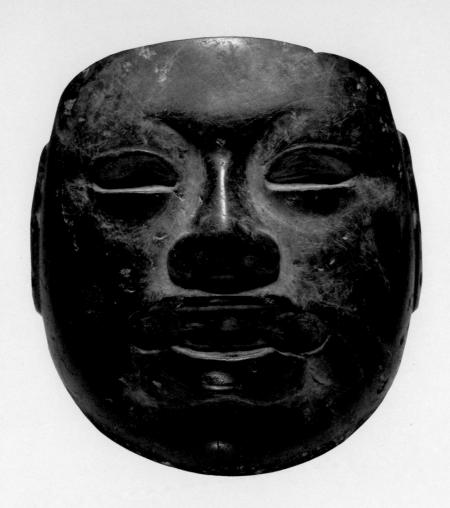

Model mask, possibly worn
round the neck as a pendant
Olmec, 900–400 BC
Petén, Guatemala
Serpentinite
H 13 cm, W 11.3 cm

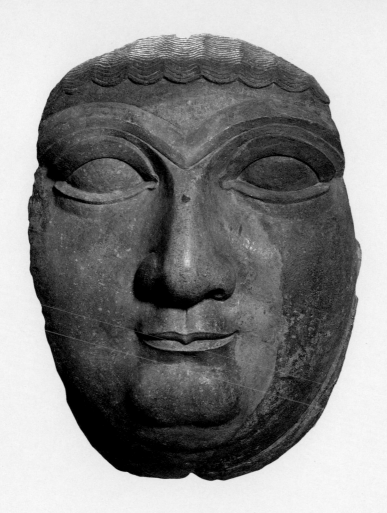

Sculpture of a face probably
belonging to the head of a
colossal sphinx
700–695 BC
From the South-West Palace
at Nineveh, Iraq
Stone
H 60 cm, W 40 cm

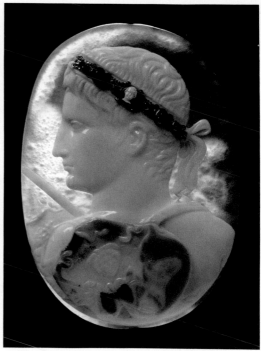

Crowned Heads

As much a fashion accessory as a royal symbol, the crown worn by Elizabeth I of England anchors a magnificent veil of lace. The Ptolemaic queen wears a floral wreath; the yellow glaze of the blossoms, also seen on her earrings, simulated gold. In its original state, the Blacas Cameo showed Augustus, the first emperor of Rome, wearing a champion's laurel wreath; at some time in the Middle Ages, the wreath was replaced with a jeweled diadem. The ties of the wreath remain, recalling the diadem's ancestry in the headband of fabric or leather worn by Alexander the Great.

OPPOSITE
Portrait of Queen Elizabeth I
Federico Zuccaro (c. 1542–1609)
1575
Italian
Black and red chalk
H 30.7 cm, W 22.2 cm

ABOVE, LEFT
Head of a Ptolemaic queen, possibly Arsinoe II
Hellenistic, 300–270 BC
From Naukratis, Egypt
Glazed composition
H 5.8 cm

ABOVE
The Blacas Cameo
Three-layered sardonyx cameo engraved with a portrait of Augustus wearing the aegis of Minerva and a sword belt
Roman, AD 14–20
Sardonyx
H 12.8 cm

While symbolic headwear – a wreath, a coronet or even an ornamented hat – indicates that the wearer holds a special place in society, a monarch's crown denotes his or her legitimate dominion. Based on a circlet, recalling its origins in the diadem of the ancient world, the prevailing form of the European crown encircles the monarch's head with a ring of arches crafted of precious metal and embellished with jewels that hold iconic significance for the nation. This form was so strongly rooted in the European imagination that when artists portrayed rulers of other parts of the world, their crowns, no matter the material, were rendered according to the familiar convention.

Two playing cards, a king of spades and a king of hearts
Anonymous
Early 19th century
French
Hand-coloured etching
H 8.3 cm, W 5.4 cm

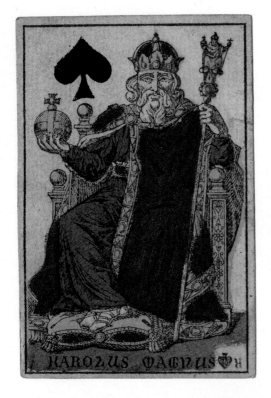

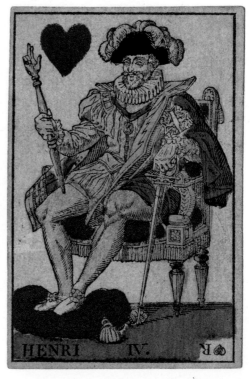

Nicaragua from 'Jeu de la Géographie' (a complete set of 52 playing cards plus a title card)
Print by Stefano della Bella
(1610–1664)
1644
Italian
Etching
H 8.8 cm, W 5.4 cm

A headdress, accentuating height and bearing, sets
a ruler at one remove from others in the community.
As part of the royal regalia, it may bear a national
emblem or proclaim the powers of the sovereign.
In ancient Egypt, the pharaoh had several crowns;
here, Amenhotep III wears the *khepresh*, or 'blue
crown', which was associated with war. A tall, pointed
headdress, covered with a net of beadwork, distinguishes
a brass portrait believed to commemorate Queen Idia
of Benin. The kingdom's first *Iyoba* (Queen Mother),
Idia used her prowess in military strategy to help her son
Esigie defeat his brother in battle and unify the realm.

Commemorative head of
an *Iyoba* (Queen Mother)
16th century
Benin, Nigeria
Brass
H 41 cm, W 15.5 cm

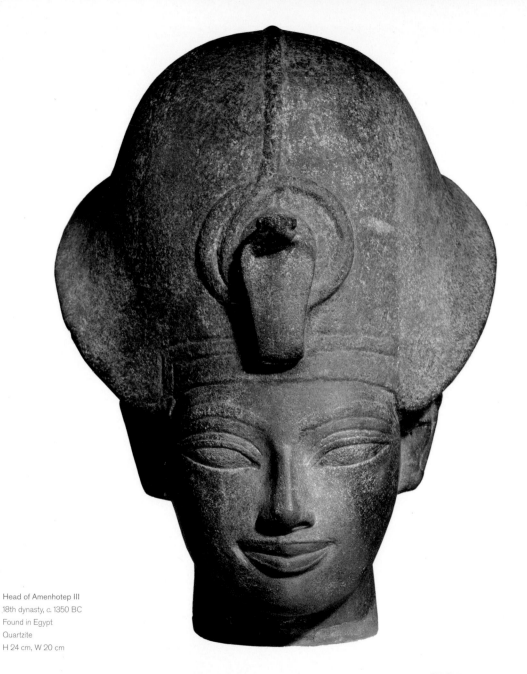

Head of Amenhotep III
18th dynasty, c. 1350 BC
Found in Egypt
Quartzite
H 24 cm, W 20 cm

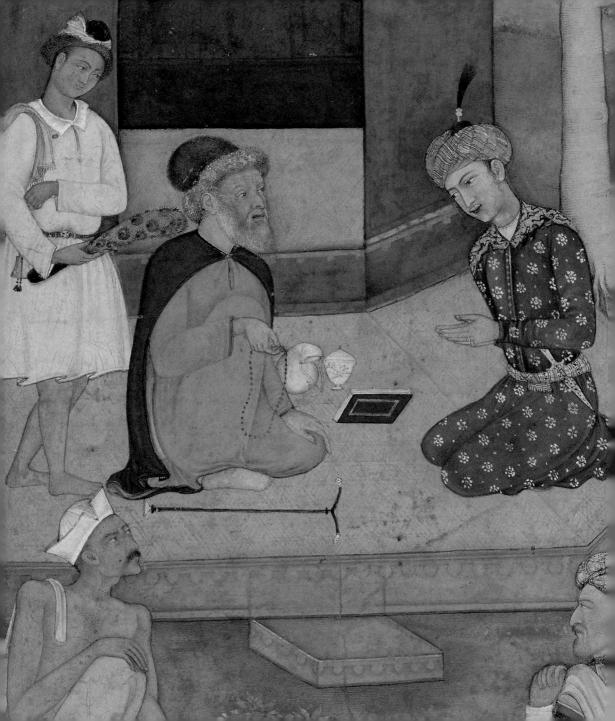

Although the name of the elegant young man dressed in violet is not known, the golden dagger tucked into his belt identifies him as a nobleman. His turban, with its amply rounded silhouette, similarly proclaims his elevated status. During the reign of Shah 'Abbas (1588–1629), men of royal rank adopted a lower, fuller form of the traditional turban, wound from a length of richly coloured silk – here, a vibrant green embellished with gold – and crowned with a plumed aigrette. More than a fashionable ornament, headwear in Safavid society indicated a man's position, from the courtier's pale-green turban with a feather tucked in the fold (bottom right) and the simple, brown turban worn by the holy man to the array of caps worn by the visitors, the horseman and the mendicant (lower left, kneeling).

Prince Visiting a Holy Man
Single-page painting mounted
on a detached album folio
c. 1610
India
Ink, opaque watercolour and gold
on paper
H 25.4 cm, W 12 cm

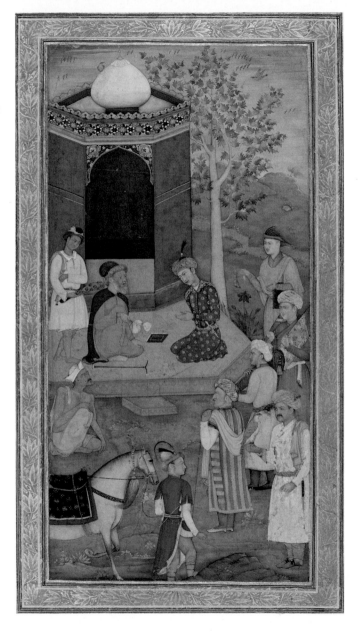

Brave Faces

'I love the man that can smile in trouble, that can gather
strength from distress, and grow brave by reflection.'

Thomas Paine, *Rights of Man*, 1791

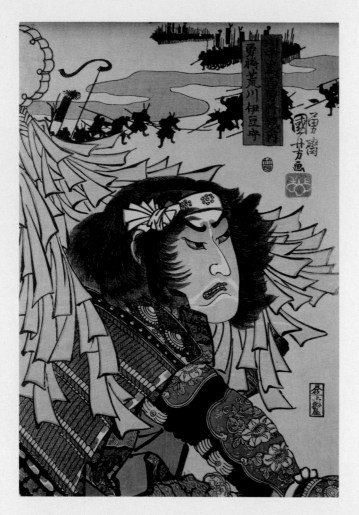

LEFT

*Heroic General Arakawa
Izu-no-kami*, from the series
'One Hundred Heroic Generals
in Battle at Kawanakajima,
Shinano Province'
Utagawa Kuniyoshi (1797–1861)
1845–6
Edo, Japan
Woodblock print
H 36.9 cm, W 25 cm

OPPOSITE

The Highlander
Print by Joseph Simpson
(1879–1939)
1925
British
Etching
H 19.7 cm, W 15.6 cm

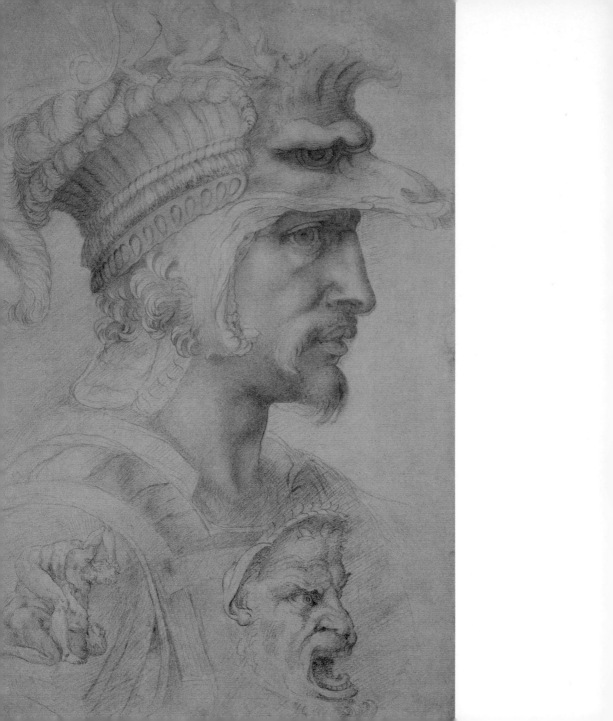

In the sketch of the head of an ideal warrior, a snarling canine muzzle embellishes the man's helmet, seeming to double his ferocity. The print on the right portrays the renowned kabuki actor Ichikawa Ebizō wearing a 'five-spoke wheel' wig and spine-chilling red face paint, part of the traditional costume for the theatrical *shibaraku* (wait a moment) scene, when the hero arrives to rescue victims from certain death.

OPPOSITE
**Head of a warrior (the Count
of Canossa)**
After Michelangelo (1475–1564)
1550–1600
Italian
Black chalk
H 41.2 cm, W 26.3 cm

RIGHT
**Kabuki actor Ichikawa Ebizō
as Usui no Aratarō Sadamitsu
in a *shibaraku* scene**
Utagawa Kunimasa (1773–1810)
1796
Edo, Japan
Woodblock print
H 38.5 cm, W 25 cm

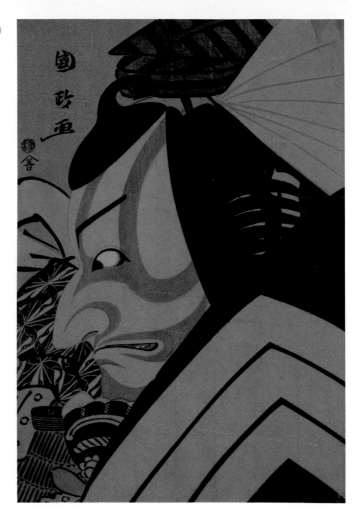

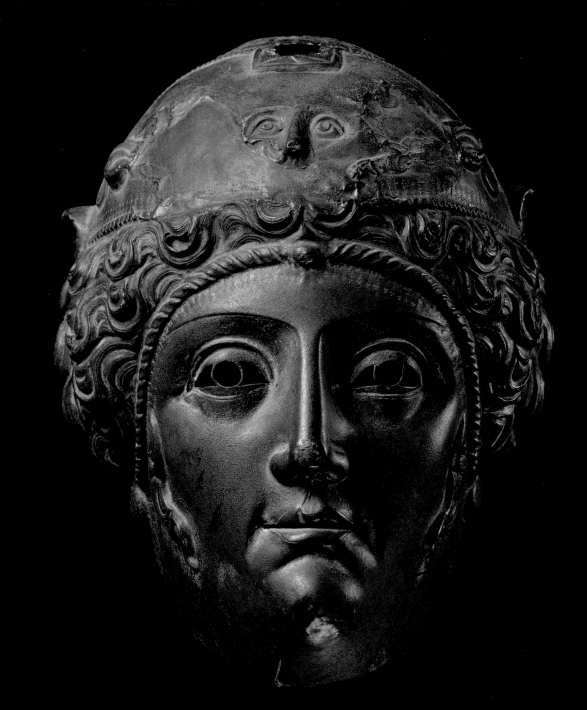

'To guard his head he had a glittering helmet … It was of beaten gold, princely headgear hooped and hasped by a weapon-smith who had worked wonders.'

Seamus Heaney, *Beowulf*, 1999

OPPOSITE
Bronze cavalry parade mask depicting a woman's face, perhaps worn by soldiers representing Amazons
Roman, AD 100–200
From Nola, Italy
Bronze
H 25.4 cm

RIGHT
Gold finger ring with a cornelian intaglio of the head of a warrior
Made by Luigi Pichler (1773–1854)
19th century
Made in Rome
Gold, cornelian
H 3.1 cm

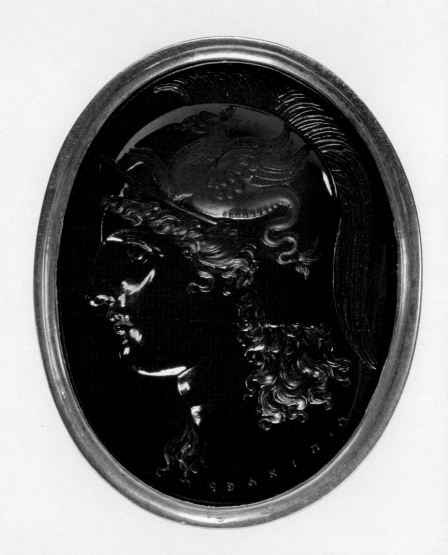

Ready for Battle

The widened eyes and fierce expression of the kneeling warrior figure made by the Moche people of South America reveal that his physical readiness is matched by a vigilant state of mind. Popping his eyes and biting his shield, the ivory rook from the Lewis Chessmen epitomizes the furious nature of the legendary Norse fighters, the berserkers. The Picts stained their skin with woad, giving them a fearsome blue aspect that, according to Roman accounts, unnerved their enemies.

BELOW, LEFT
Vase in the form of a kneeling warrior, with club and shield, appearing poised for impending action
Moche, 100 BC – AD 700
Peru
Painted pottery
H 22.5 cm, W 13.6 cm

BELOW
Ivory chess piece in the shape of a berserker from the Lewis Chessmen
c. 1150–75
Found in Uig, Scotland
Ivory
H 8.5 cm

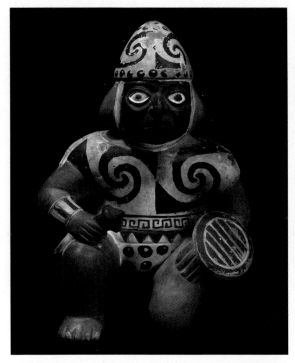

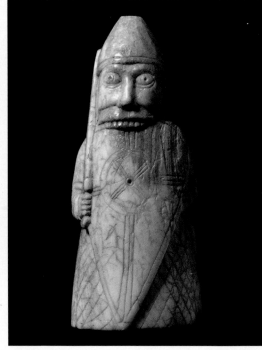

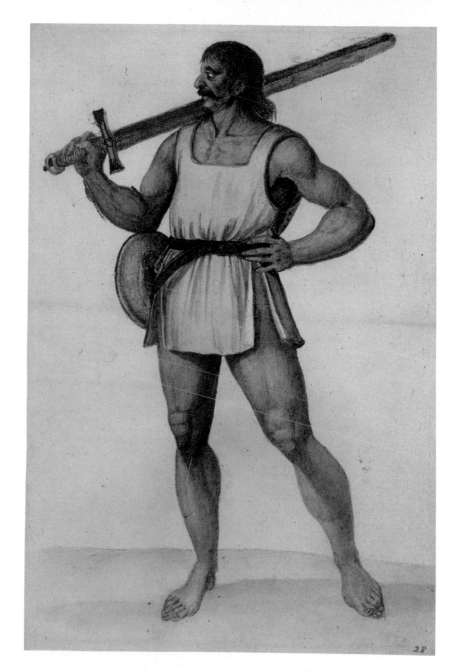

A warrior neighbour of the Picts
John White (*fl.* 1585–93)
Production date unknown
British
Pen and brown ink and
watercolour over graphite
H 23.6 cm, W 15.4 cm

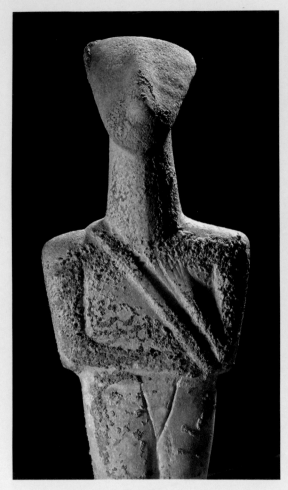

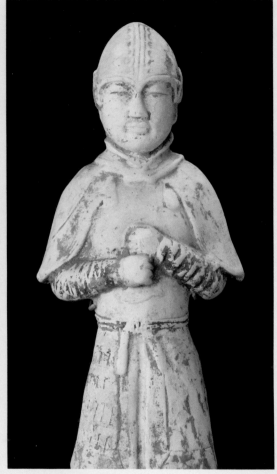

ABOVE

Figurine of a man of the
'hunter-warrior' type
Early Cycladic, 2300–2200 BC
Made in the Cyclades, Greece
Marble
H 21.6 cm

ABOVE, RIGHT

Figure of a soldier
Tang dynasty, AD 618–906
China
Earthenware
H 36.8 cm

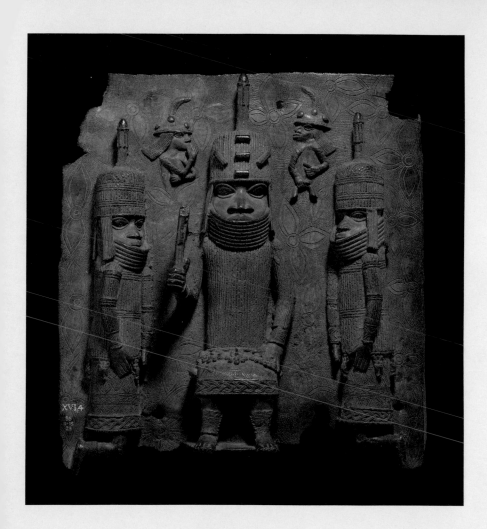

The arrangement of the figures in the Benin plaque
reflects the hierarchy of authority in Benin society.
In the centre, the *oba* (king) wears a towering
headpiece, elaborate coral-bead regalia and pendant
masks attached to his skirt; his attendants wear
multi-strand coral-bead collars and smaller, cylindrical
helmets. The truncated European figures that flank
the *oba*'s head are identified by their long hair and the
three bosses on their feathered helmets.

Cast brass plaque showing
the *oba* (centre) with attendants,
and with small European figures
in the background
16th–17th century
Benin City, Nigeria
Brass
H 43.5cm, W 41 cm

Worn for physical protection, a warrior's helmet also
presents the enemy with an idealized representation
of a brave face. The mask-like Corinthian helmet
encloses the brows, cheeks and jaw in a shield of
cast bronze, while the aquiline nose guard and wide
eyeholes create an impression of anonymity. The
Roman gladiator's helmet offers similar, full protection,
but a grill of linked circles blanks out any facial
reference. Abstracted imagery – a stylized heroic
visage or a mythical flying creature, as seen on the
horned and crested Japanese samurai helmet or the
nosepiece of the Anglo-Saxon helmet found in the
ship burial at Sutton Hoo – replaces the warrior's face
with an emblem of ferocity.

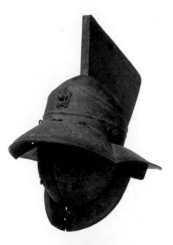

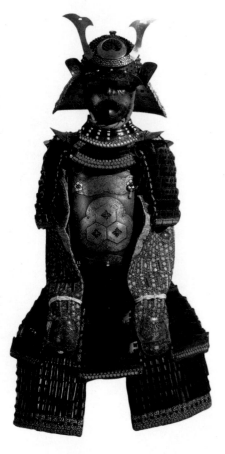

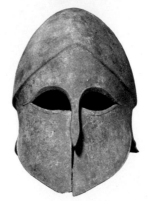

BELOW, FAR LEFT
**Set of samurai armour made up
of a helmet (*kabuto*), cuirass (*do*),
shoulder-piece (*sode*) and
protector (*tare*)**
Momoyama period, late 16th
century (cuirass and sleeves);
Edo period, 17th century (helmet),
18th–19th century (remainder)
Japan
Textile, steel, leather, lacquer, iron
and gold
H 125 cm (mounted)

LEFT
**Bronze gladiator's helmet with
a medallion of Hercules**
Roman, 1st century AD
Found at Pompeii, Italy, said to
have been found in the gladiators'
barracks
Bronze
H 48.3 cm

LEFT, BOTTOM
Helmet of Corinthian type
Corinthian, c. 500 BC
From Corinth, Greece
Bronze
H 22.9 cm

OPPOSITE
**Iron helmet from the ship burial
at Sutton Hoo**
Late 6th – early 7th century AD
Found in Mound 1, Sutton Hoo,
Suffolk, England
Iron with silver, gold, copper alloy
and garnets
H 31.8 cm, W 21.5 cm

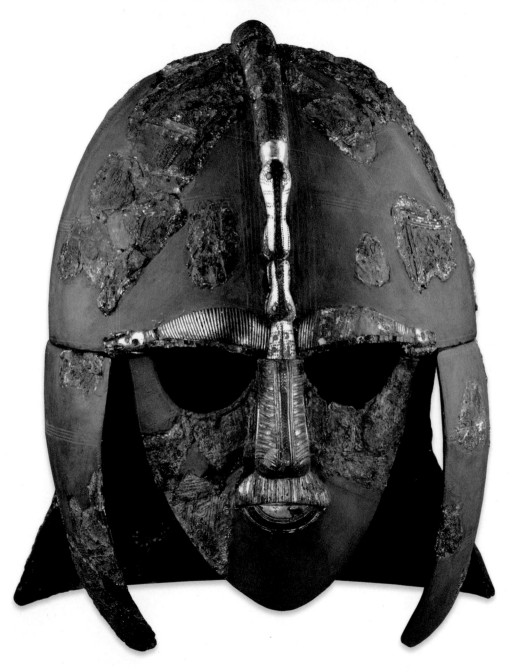

In the Thick of It

In the work seen opposite, the widened eyes and small, tightly closed mouths, which are characteristic of paintings in the Shewan style, are meant to express a mystical state of trance-like concentration. The featured saints – Michael (top left), Gabriel (top right) and George (bottom, centre) – also carry a warrior's identity: vigilant, armed and ready for action, they surround the Virgin Mary and infant Jesus in holy protection.

RIGHT, TOP
Relief depicting a scene from
the Battle of Til-Tuba, fought
between the Assyrian and
Elamite armies
660–650 BC
From the South-West Palace
at Nineveh, Iraq
Gypsum
H 204 cm, W 175 cm

RIGHT, BOTTOM
Part of a colossal statue
depicting a barbarian crouching
by the side of a Roman emperor
Roman, c. AD 160–170
From the Palace of Trajan,
Ramleh, Egypt
Marble
H 86.4 cm

OPPOSITE
Painting depicting the Virgin
Mary holding the infant Christ
19th century
Shewa, Ethiopia
Painting on parchment
H 80 cm, W 79 cm

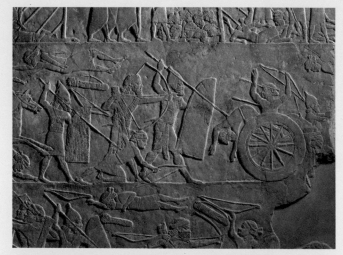

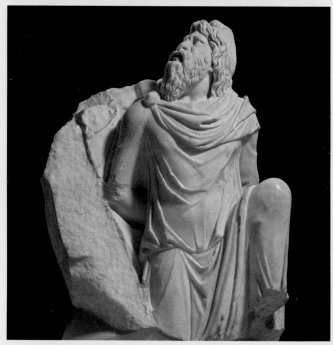

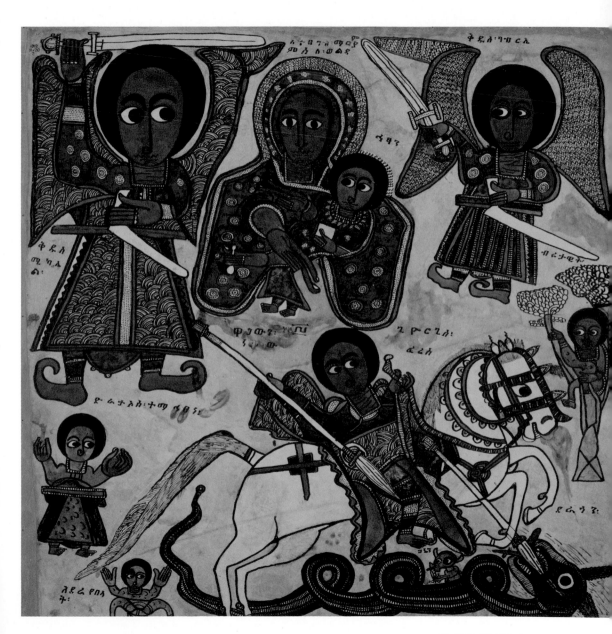

War and Sacrifice

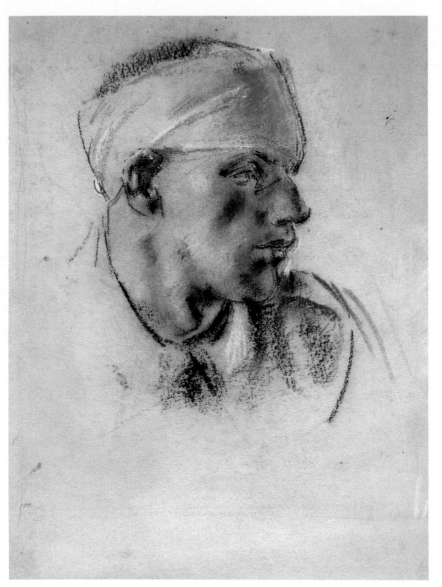

LEFT
Head of a soldier with bandaged forehead
Henry Tonks (1862–1937)
Production date unknown
British
Coloured chalks
H 38.1 cm, W 28.1 cm

OPPOSITE
Poster with the inscription 'Subscribe to the Fourth War Loan'
Designed by Alexei Kokorekin
1945
Issued in Latvia
Paper
H 88 cm, W 64.6 cm

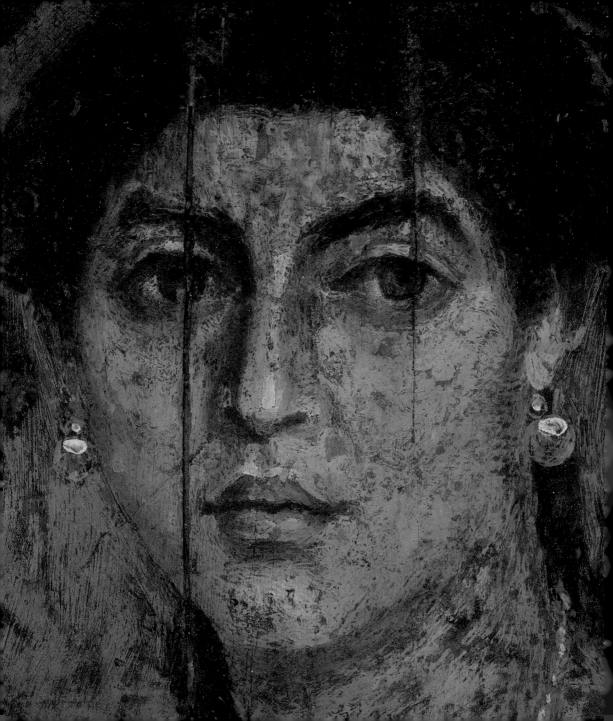

6 Identity & Disguise

WE CAN IDENTIFY SOMEONE by the way they walk, through a characteristic gesture or from a distinctive silhouette. To be certain of who they are, however, we look at their face. In a global population of more than 7.5 billion, no two individuals look exactly the same. Resemblances may be striking, but there are always fundamental differences, even between identical twins. Our features, imprinted through genetic heritage, are further shaped by our unique physical and emotional experiences, prompting us to view every face as a symbol of identity: a record of who we are, what we know and how we feel. But, despite the commonplace that after a certain age we will all have the face we deserve, facial appearance derives from the complex interaction of the intentional and the inescapable. The selfhood that we portray through facial expression is both personal and communal, and through the subtle set and play of our features, we disguise as much as we reveal in a complex and ever-changing performance of identity.

The English painter Thomas Gainsborough found it difficult to capture the likeness of skilled actors, claiming that 'they have everybody's faces but their own'. To convey mood and establish character, actors master facial expression; but whether on stage or off, we are all practised in the art of making a face. With a focused gaze we project confidence; with a raised eyebrow we communicate humour or scepticism; with a set jaw we broadcast resolve (pages 214–15). We put on a brave face, assume a poker face or a game face, seeking to embody the quality we portray. Grooming and cosmetics enhance our features and augment our construction of identity. A boyish man grows a beard to add gravitas; a pallid woman dusts her cheeks with rosy powder to add a healthful glow. Cosmetics can conceal character as well as hide flaws. Hamlet taunts Ophelia about women's 'paintings': 'God has given you one face and you make another.' Throughout history, culturally specific facial decoration has been used to signify age, power and social status. Such indelible marks as tattoos, piercings, tooth filings and scarification communicate profound changes – passage from childhood to maturity, a new status, a tragic

loss – and situate the individual within the community (pages 216–17). More than mere decoration, facial enhancement and alteration inscribes identity.

A mask can identify as well as disguise. The word's origin is elusive, traced to the post-classical Latin word *mascara*, meaning a spirit or spectre, as well as the Arabic *mashara*, meaning to falsify or transform. A mask may be worn for playful deception, such as the eye-covering domino or the Mardi Gras mask supported on a stick. Masks have a long tradition in the theatre, as devices for identifying actors as specific characters; the classical Latin word *persona* means not only the character played by an actor but also 'mask'. Hidden behind an assumed identity, the actor's own individuality is subsumed into the dramatis personae's age, gender and destiny. Masking is a social act, requiring a knowledgeable audience that can recognize the character and understand its purpose. Nowhere is this as significant as in ritual masking, wherein select members of a community are transfigured by a special mask into another, more powerful entity: a mythic hero, a revered ancestor, a deity. Along with costume, body decoration and movement, the mask becomes a conduit for channeling those forces that appease the spirits and sustain the community (pages 228–9). Veiling also merges identity and disguise, defining a border between what can and cannot be seen, hiding the individual's face, but evoking the power of its presence.

Famous faces are constructed out of an individual's appearance, their reputation and the ideas and desires we project upon them. False or true, their public image is regarded as their actual identity. Our own identity is harder fully to comprehend; our perception of self-image, of our own appearance, is shaded by our inner life, our tally of flaws and faults, and our aspirations. In art, a selective portrayal, emphasizing one feature over all others, may better represent an individual's identity than a straightforward likeness (pages 238–9). And when artists depict their own image, they often do so to hone their observational skills, donning costumes and making faces to create a character. But in the best portraits, whether of sitter or self, artists sharpen observation with insight, looking through the lens of appearance to discover the essential elements of identity.

Masking Identities

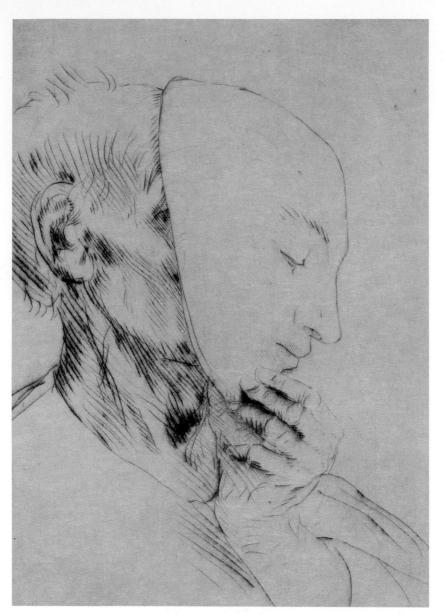

LEFT
L'Homme au masque
Alphonse Legros (1837–1911)
1882
French
Drypoint
H 17.7 cm, W 12.6 cm

OPPOSITE
The Beauty Unmask'd
Anonymous, after Henry Morland
(*c.* 1719–1797)
1770
British
Hand-coloured mezzotint
H 35.3 cm, W 25 cm

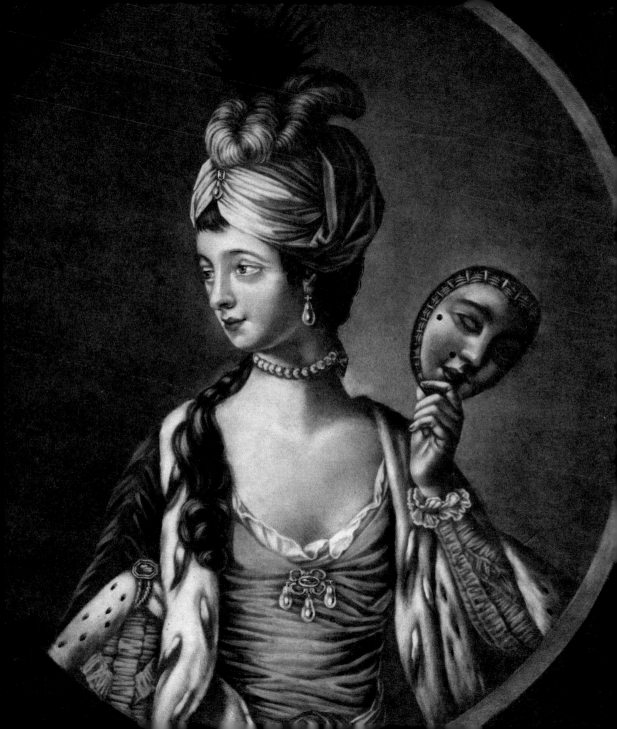

No Two Alike

A general description of any one of these women would serve to describe them all. Each has a heart-shaped face with high cheekbones and a broad brow. Their eyes are large, crowned by well-defined and expressive brows. Look closer, however, and the similarities fade. Each woman is striking in her own way, whether for her serene demeanour, her wry smile, her soulful eyes or her turned-up nose. Facial appearance reflects gender, age, ethnicity and even cosmetic enhancement, but no matter how close the resemblance, no two faces are exactly alike.

ABOVE, LEFT

Portrait-head of a woman
c. AD 90–100
Found in Egypt
Painted plaster
H 34 cm, D 32 cm

ABOVE

Red brick with female head with veil headdress
15th century
Found in Wingfield Church, Suffolk, England
Clay
H 14 cm, W 14 cm

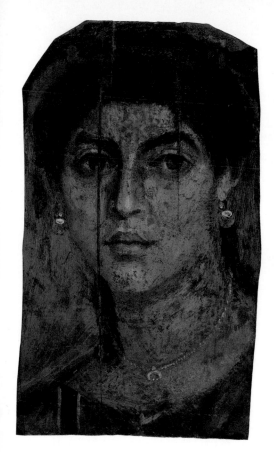

ABOVE
Mummy portrait of a woman
AD 55–70
Found in Hawara, Egypt
Encaustic on limewood
L 35.8 cm, W 20.2 cm

ABOVE, RIGHT
Studies of Three Women
Paul Helleu (1859–1927)
After 1874
French
Drypoint
H 28 cm, W 19.7 cm

'It is the common wonder of all men, how among so many
millions of faces, there should be none alike.'

Thomas Browne, *Religio Medici*, 1643

LEFT
Stirrup-spout vessel in the form
of a human head
Moche, AD 300–600
Peru
Pottery
H 26.5 cm, W 15 cm

OPPOSITE, TOP LEFT
Votive head of a man with short
hair falling in curls and a wart
on his upper lip
Etruscan, *c.* 300–200 BC
Terracotta
H 30.5 cm

OPPOSITE, TOP RIGHT
Head from a portrait statue
of a North African
Hellenistic, *c.* 300 BC
From the Temple of Apollo
at Cyrene, Cyrenaica (Libya)
Bronze
H 26 cm

OPPOSITE, BOTTOM LEFT
The Arundel Head
Head from a statue, perhaps
of Sophocles
Greek, 200–100 BC
From Smyrna, Turkey
Bronze
H 29.2 cm

OPPOSITE, BOTTOM RIGHT
Portrait of a Confucian Scholar
Attributed to Yi Che-gwan
(1738–1837)
Choson dynasty, late 18th – early
19th century
Korea
Ink and colour on paper
H 54.4 cm, W 45 cm

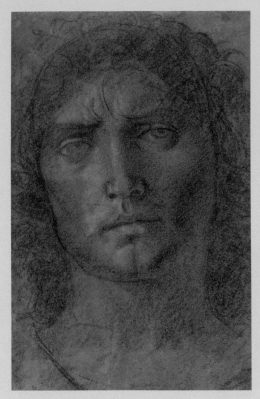

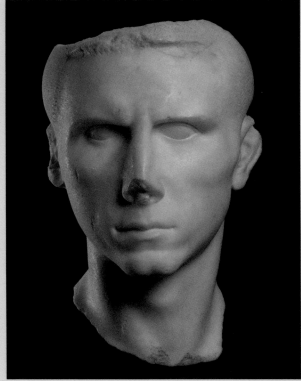

Making a Face

The eyes, as the familiar saying goes, provide a window to the soul, but the way our other features frame our eyes adds nuance to any perceived insight. We direct our gaze to look another straight in the eye, or tense our eyelids to convey anger or scepticism. We may even glare with wide eyes and a furrowed brow, presenting a fierce and aggressive expression. With every shift of feature, we make a face to send a message.

ABOVE, LEFT

Head of a man
Bartolomeo Montagna
(1450–1523)
Production date unknown
Italian
Black chalk
H 24.8 cm, W 15.5 cm

ABOVE

Portrait head from a statue of a Roman
Roman, c. 40 BC
Made in Alexandria, Egypt
Found in Cyprus
Parian marble
H 31 cm, W 20.5 cm

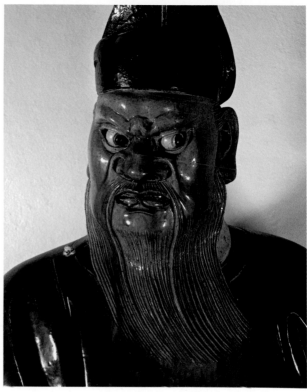

ABOVE, LEFT

Head of a weeping, bearded man
Peter Paul Rubens (1577–1640)
c. 1603
Flemish
Pen and brown ink
H 32 cm, W 19.2 cm

ABOVE

**Figure of an assistant to the
Judge of Hell**
Ming dynasty, c. 1522–1620
Northern China
Earthenware decorated in
polychrome enamels with
cold-painted details
H 136 cm, W 39 cm, D 31 cm

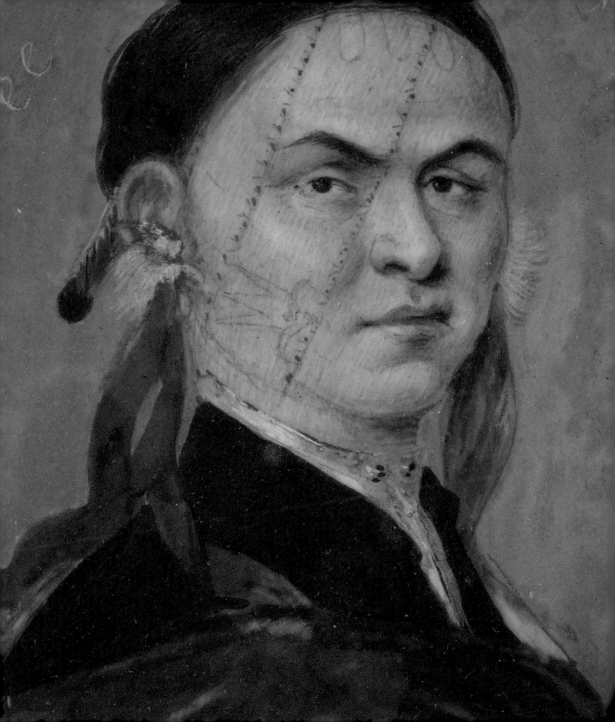

OPPOSITE

Miniature portrait of
Ganajoh-Hare
Bernard Lens III (1682–1740)
1710
British
Watercolour and bodycolour
with graphite
H 9 cm, W 7 cm

ABOVE

Profile-portrait drawing of a man,
and a woman, both with tattoos
on their faces
Early 20th century
Made in New Zealand
Pigment ink and watercolour
H 8.7 cm, W 13.7 cm

ABOVE, RIGHT

Full face and profile of a tattooed
Maori man
Charles Rodius (1802–1860)
1834–5
German
Pencil and black chalk
H 23 cm, W 15.5 cm

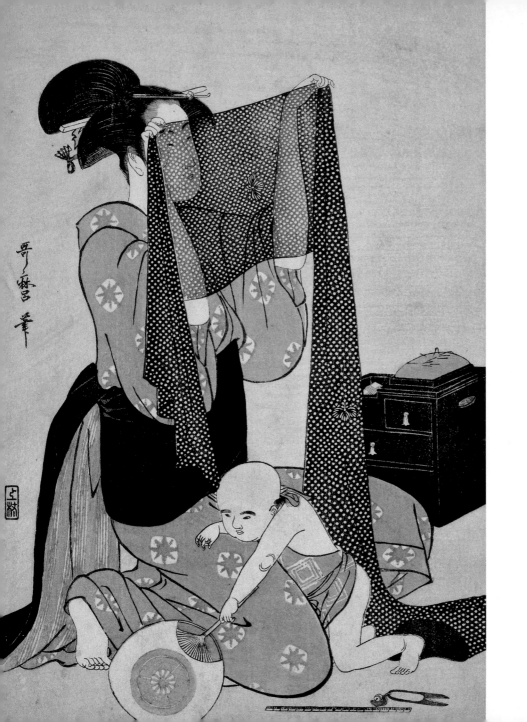

Hide and Reveal

The veil's long history, traced back to the ancient cultures of Asia, Africa and Europe, is threaded with fluid yet significant meaning. It is ceremonial: a nun, on entering a convent, 'takes the veil'. A bride wears a veil at her wedding. A mourning veil provides the privacy to grieve, while telling the world of a widow's loss. A veil can be plain and practical, or it can be made of magnificent lace and embellished with embroidery or jewels. It can be alluring, evoking the beauty hidden behind a gossamer curtain. Or it can signify principles of modesty, as in the Muslim practice of partial and full veiling. Few articles of clothing are as simple while simultaneously so complex. No matter the meaning, the veil demarcates a boundary that both hides and reveals.

OPPOSITE

Left-hand sheet from a triptych
print showing women seated,
sorting and sewing fabrics
Kitagawa Utamaro (died 1806)
1794–5
Edo, Japan
Woodblock print
H 37.2 cm, W 24.7 cm

RIGHT

Constanta Charming
Print by Elias Martin (1739–1818)
1778
British
Stipple printed in red-brown ink
H 21.4 cm, W 16.2 cm

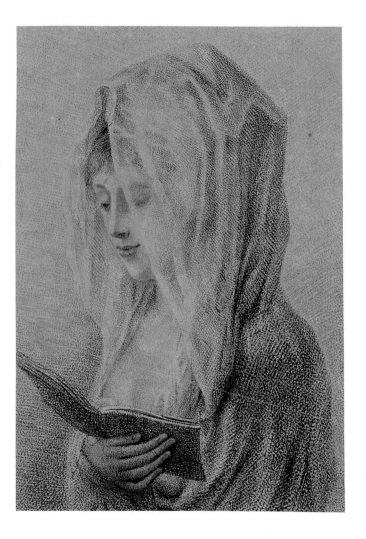

LEFT
Noh mask of Nakizō, a female
deity or woman of high rank
18th–19th century
Japan
Wood and lacquer
H 21.2 cm

OPPOSITE
Contemporary Noh mask
of Okina, an old man
Nagasawa Ujiharu (1912–2003)
c. 1981
Japan
Wood and hair
H 18.3 cm

Masking

Masking plays an essential role in the centuries-old
traditions of Japanese Noh theatre. Classic dramas
involve a repertoire of standard characters: ghosts,
women, children, the elderly. The mask shown above
represented an innocent young girl. Her shaved brows,
blackened teeth and opaquely painted complexion
reflected the refined elements of contemporary beauty.
Skilfully carved, the rigid features would have appeared
to shift with the actor's movements. With a furrowed
brow, eyes closed in laughter and a stub-toothed grin,
the mask opposite signified a happy old man. The hinged
lower jaw allowed the actor to manipulate the mouth
and wag the trailing beard.

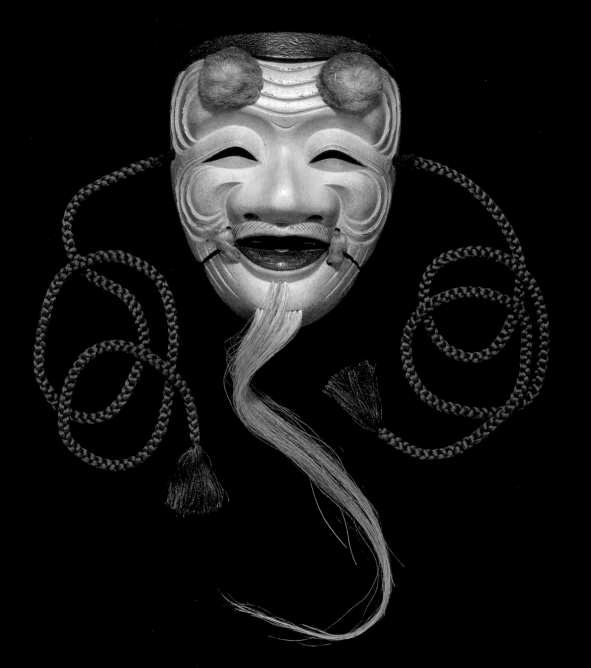

The Nyau, a semi-secret society of the Cewa people of Malawi, organizes masquerades for such significant community events as funerals, initiations and coronations. The masks, worn by male dancers garbed in shredded textiles, plastic and leather strips, portray traditional figures – an old man, a female ancestor, an English colonist – as well as contemporary celebrities. Inventive and evocative, the masks embody telling character traits and contain the spirits of those who have died.

BELOW, LEFT

Human face-shaped mask (*makanja*) used in the Nyau masquerade
1986
Cewa people, Malawi
Painted wood, fabric and ostrich feathers
H 76 cm, W 44 cm

BELOW

Human face-shaped mask (*simoni*) used in the Nyau masquerade
1986
Cewa people, Malawi
Painted wood, fabric and ostrich feathers
H 74 cm, W 51 cm

OPPOSITE

Human face-shaped mask (*simoni* or *mbalangwe*) used in the Nyau masquerade
Late 20th century
Cewa people, Malawi
Painted wood, fibre, feathers, plastic and cotton
H 68 cm, W 57 cm

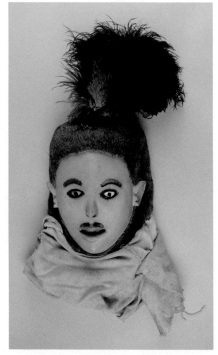

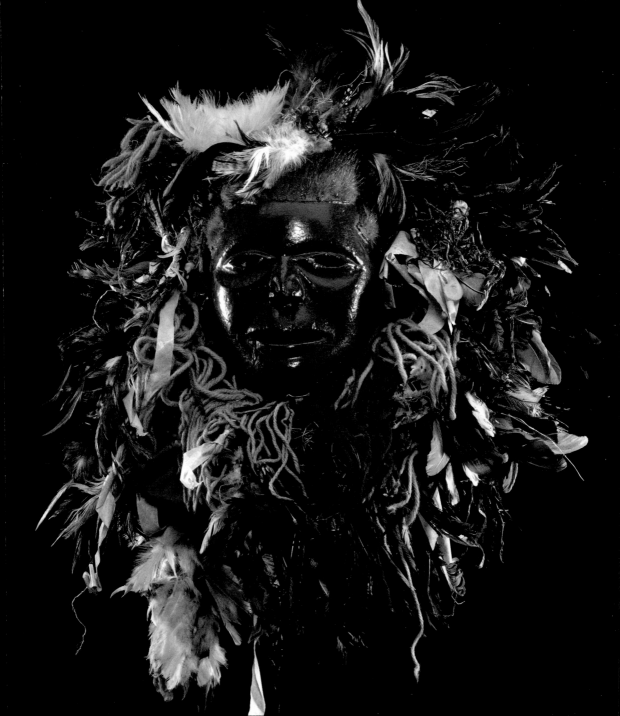

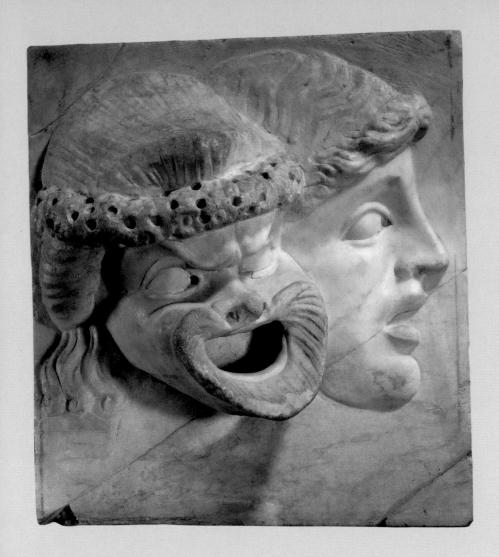

Relief with tragic and comic
masks
Roman, AD 100–200
Marble
H 23.9 cm

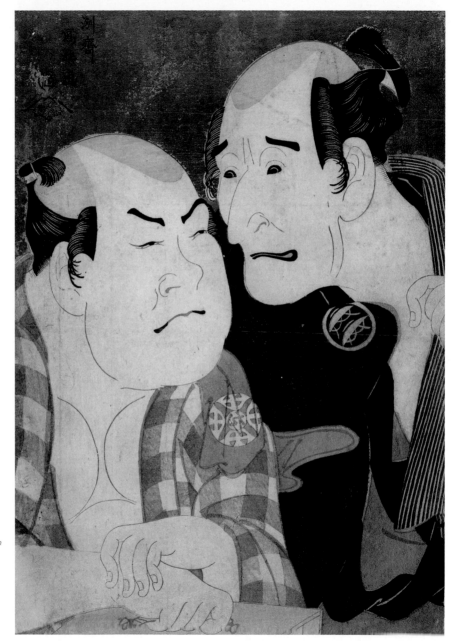

The Actors Nakajima Wadaemon
and Nakamura Konozō in
'A Medley of Tales of Revenge'
Tōshūsai Sharaku (*fl.* 1794–5)
1794
Edo, Japan
Woodblock print
H 35 cm, W 24.2 cm

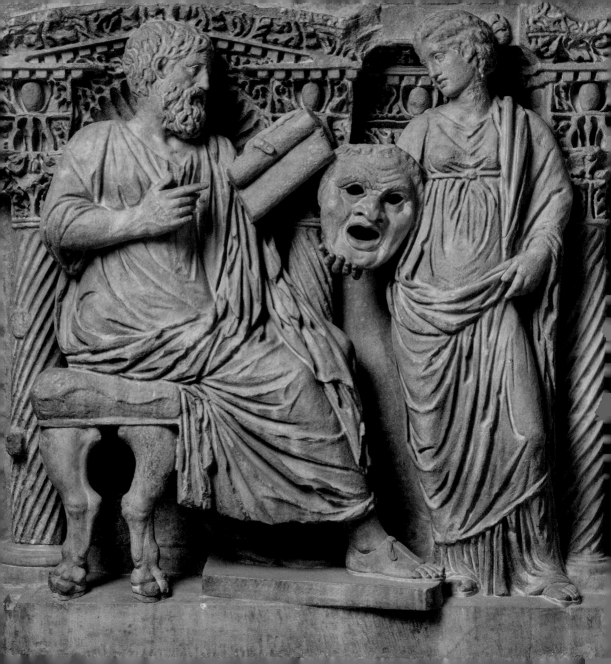

OPPOSITE
Part of the front of a columnar
sarcophagus depicting a seated
man reading from a scroll to
Thalia, the muse of comedy
Roman, AD 180–200
From Phrygia, Turkey
Phrygian marble
H 106 cm, L 117.6 cm

ABOVE
Theatrical mask of a female
character
Hellenistic, 300–50 BC
From Salamis, Cyprus
Terracotta
H 9.2 cm

ABOVE, RIGHT
Tragic mask with beard
Roman, production date unknown
Marble
H 21.5 cm

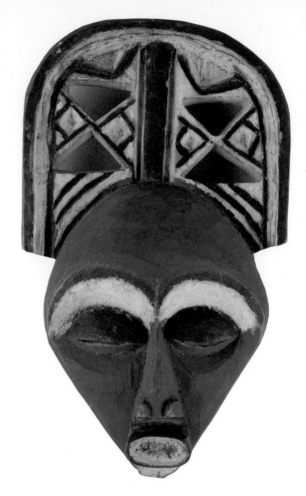

ABOVE

**Human face-shaped mask
with horns**
Early 20th century
Senufo people, Côte d'Ivoire
Wood
H 32 cm, W 16 cm

ABOVE, RIGHT

Human face-shaped mask
Late 19th – early 20th century
Pende people, Democratic
Republic of Congo
Wood and pigment
H 28.5 cm, W 17 cm

Ceremonial masks empower the wearer through transformation. The bearded and horned mask made by the Senufo people of the Côte d'Ivoire was used in society and funerary rites, initiation ceremonies and harvest festivals. The Pende mask illustrates the traditional form for masquerade ceremonies; its pristine condition suggests that it was made for commercial sale or on commission. The Krishna mask, with its wide eyes and subtle smile, resembles those worn to re-enact stories from the great Sanskrit epics – the *Ramayana* and the *Mahabharata* – as part of the Chhau dance in Bengal. Rich with gilt and lacquer, the Japanese bodhisattva mask would be worn by a Buddhist priest for a *gyōdō* ceremony of inauguration or dedication.

ABOVE, LEFT
Krishna mask
20th century
Made in West Bengal, India
Papier mâché
H 19 cm, W 17 cm

ABOVE
Buddhist bodhisattva mask for a *gyōdō* ceremony
13th century
Japan
Painted, lacquered and gilded wood
H 30 cm, W 22.5 cm

Famous Faces

In our global culture, faces of celebrities transcend geographic borders. Queen Victoria's image circulated throughout her empire; local artists, such as the Yoruba wood carver whose work is shown overleaf, responded in their own distinctive style. The Cuban revolutionary leader Fidel Castro appears on a Peruvian dance-bib, made to be worn by a male participant in La Negrería, a social-bonding festival honouring collective identity. A photograph of Barack Obama, the first African-American president of the United States, flanked by two maps of Africa, is the centrepiece of a Tanzanian *kanga*, a printed cotton panel generally worn by women.

Printed cloth (*kanga*) with a photographic image of Barack Obama and the inscription 'Congratulations Barack Obama – God has granted us Love and Peace'
2008
Tanzania
Cotton
H 107 cm, W 315 cm

BELOW, LEFT
Dance-bib with portrait of
Fidel Castro
c. 1968
Junín, Peru
Cotton, velvet, mirror glass and
sequins
L 80 cm, W 48 cm

BELOW
Badge with portrait of
Jacqueline Kennedy
2001
Issued by the Metropolitan
Museum of Art, New York,
United States
Diam. 3.7 cm

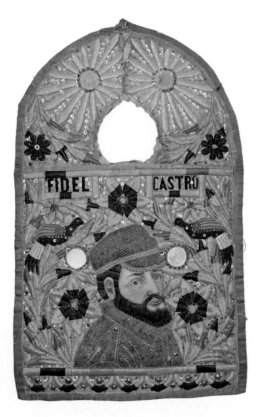

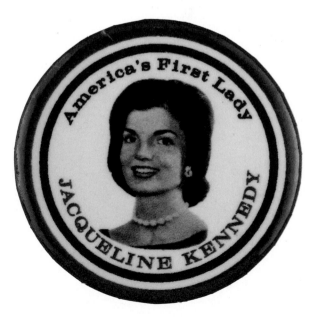

BELOW

Our Sovereign Lady the Queen
Print by Faustin (c. 1847–1914)
c. 1874–80
French
Chromolithograph
H 14.6 cm, W 6.6 cm

BELOW, RIGHT

Statuette of Queen Victoria in
ceremonial robes, crowned and
holding a fan
19th century
Yoruba people, Nigeria
Wood
H 37 cm, W 12 cm

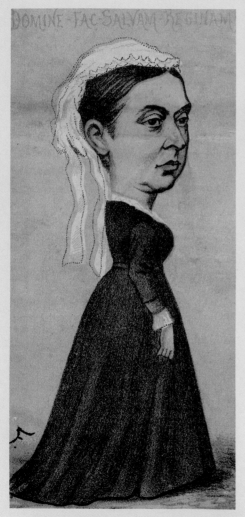

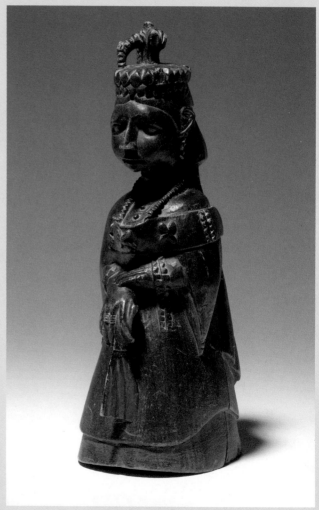

Portrait of Queen Victoria from
the Cabinet Portrait Gallery
Photographed by W. & D. Downey
(*fl.* 1860s – *c.* 1910)
1890–4
British
Woodburytype photograph
H 13.9 cm, W 9.3 cm

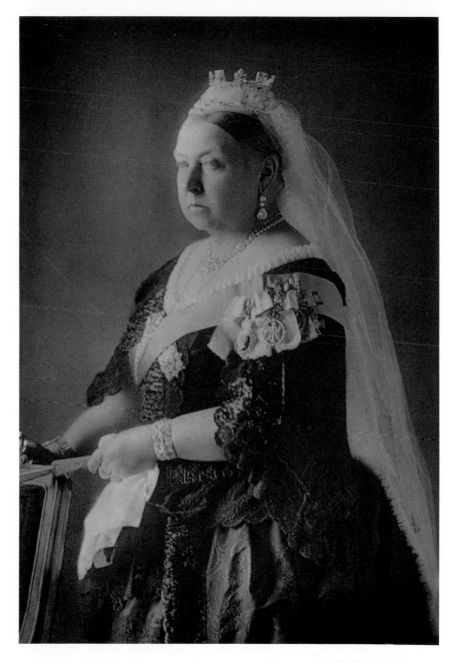

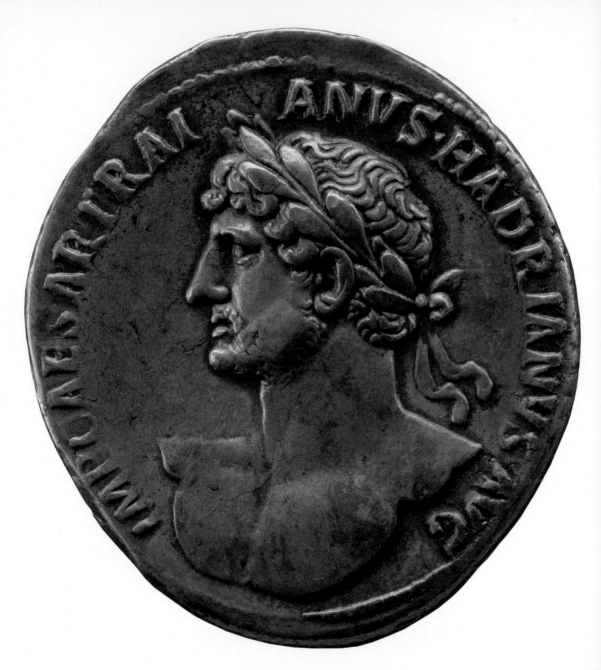

OPPOSITE
Silver medallion showing Hadrian
(obverse)
c. AD 119–122
Minted in Rome, Italy
Diam. 3.8 cm

ABOVE
Medal illustrated with the heads
of Ronald Reagan and Mikhail
Gorbachev
c. 1991
Made in Russia
White metal (supposedly made
from melted-down weaponry)
H 3.4 cm, W 5 cm

Caricature

The best of caricature strikes a resonant balance between keen observation and expressive exaggeration. Through emphasis and embellishment, the artist transforms distinctive facial features into a satiric likeness that reveals as much about the sitter's character as about his or her appearance. Leonardo da Vinci's caricatures developed out of his lifelong study of nature. Defects – a hooked or bulbous or broken nose, lips pressed tight over toothless jaws – fascinated him as much as, if not more than, perfection. More grotesque than comic, Leonardo's caricatures present a brutally honest view of what it looks like to be human.

BELOW, LEFT
Head of a balding man in profile
Leonardo da Vinci (1452–1519)
After 1467
Italian
Red chalk
H 10.1 cm, W 7.3 cm

BELOW, CENTRE
A caricature of an old woman
Leonardo da Vinci (1452–1519)
After 1467
Italian
Pen and brown ink
H 5.7 cm, W 4.2 cm

BELOW, RIGHT
A caricature of a bald-headed old man
Leonardo da Vinci (1452–1519)
After 1467
Italian
Pen and brown ink
H 5.7 cm, W 4 cm

OPPOSITE
Five caricature male heads
Circle/school of Leonardo da Vinci (1452–1519), attributed to Aurelio Luini (1530–1593)
1467–1519
Italian
Pen and brown ink
H 18.2 cm, W 17.6 cm

LEFT

Portrait of George Humphrey II
James Gillray (1756–1815)
1811
British
Pen and brown ink
H 37.2 cm, W 49.2 cm

LEFT, BOTTOM

**Self-portrait with a massive
spectacled lady**
Richard Doyle (1824–1883)
Production date unknown
British
Pen and black ink over graphite
H 7.7 cm, W 6.8 cm

Oddities
Print by Thomas Rowlandson
(1757–1827), after Henry
Wigstead (c. 1745–1800)
1792–4
British
Hand-coloured etching
H 17.7 cm, W 26.2 cm

More than a Likeness

OPPOSITE

Self-Portrait
Eric Gill (1882–1940)
1927
British
Wood engraving
H 18 cm, W 12.5 cm

LEFT

Self-portrait
Aubrey Beardsley (1872–1898)
Production date unknown
British
Pen and black ink with black wash
H 25.2 cm, W 9.5 cm

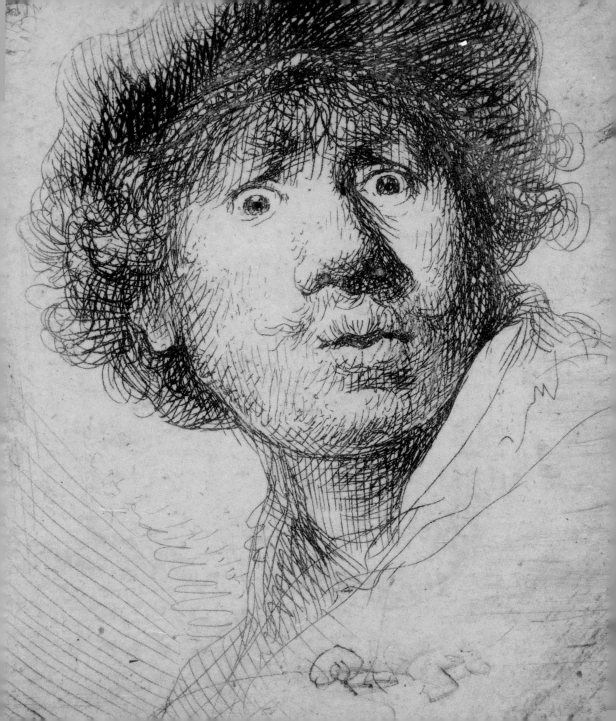

OPPOSITE
Self-portrait in a cap
Rembrandt van Rijn (1606–1669)
1630
Dutch
Etching and drypoint
H 5.2 cm, W 4.6 cm

ABOVE
Self-portrait
Rembrandt van Rijn (1606–1669)
1630
Dutch
Etching
H 7.3 cm, W 6.2 cm

ABOVE, RIGHT
Self-portrait
Rembrandt van Rijn (1606–1669)
1628–9
Dutch
Pen and brown ink
H 12.7 cm, W 9.5 cm

Few artists portrayed themselves as often as Rembrandt van Rijn; he depicted his own face more than a hundred times over the course of his long career. As well as forming a pictorial autobiography, Rembrandt's self-portraits present an intimate record of an artist honing his craft. As a means of experimenting with facial expressions, he depicted himself with narrowed eyes or puckered lips. He ruffled his hair for a dishevelled effect, or used such props as a cap or a crown to play a character. Always available and ready to pose, Rembrandt became his own most expressive sitter.

BELOW

Self-portrait
Rembrandt van Rijn (1606–1669)
1634
Dutch
Etching
H 12.5 cm, W 10.3 cm

OPPOSITE

Self-portrait in character
Print by Robert Blyth
(c. 1750–1784), after John
Hamilton Mortimer (1740–1779)
1782
British
Etching
H 39.5 cm, W 31 cm

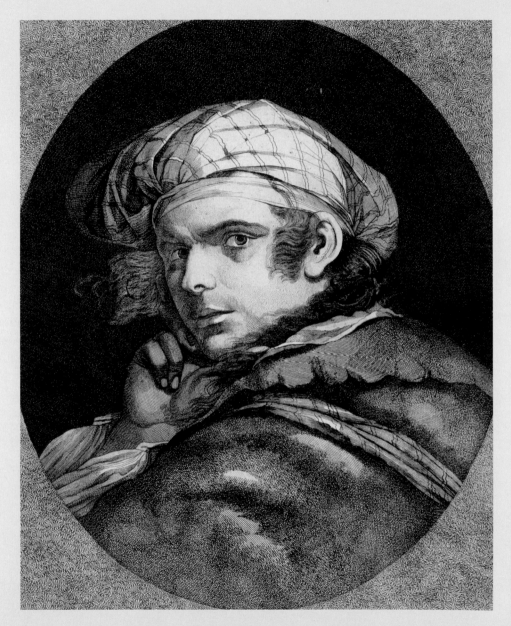

'No man for any considerable period can wear one face to himself and another to the multitude without finally getting bewildered as to which may be the true.'

Nathaniel Hawthorne, *The Scarlet Letter*, 1850

LEFT

Beethoven, or *Kiss of the Whole World*
Print by Alois Kolb (1875–1942)
c. 1900
Austrian-German
Etching
H 41 cm, W 41.5 cm

OPPOSITE

The Artist and His Tools
Print by Louis Kahan
(1905–2002)
1947
Australian
Woodcut
H 45.8 cm, W 34.5 cm

37/80 cecil kahau 47

The American photographer Paul Strand regarded the
portrait as the most challenging subject; to compel the
viewer, the image must transform an unfamiliar face
into one both familiar and unforgettable. Artists from
the time of Hans Holbein the Younger to Celia Paul
sought to elicit a similar empathy between viewer and
subject, presenting the appearance of an individual's
face – whether an unknown sitter's or the artist's own
– as a window into their unique existence.

Self-Portrait
Celia Paul (born 1959)
2007
British
Watercolour
H 39.4 cm, W 39.3 cm

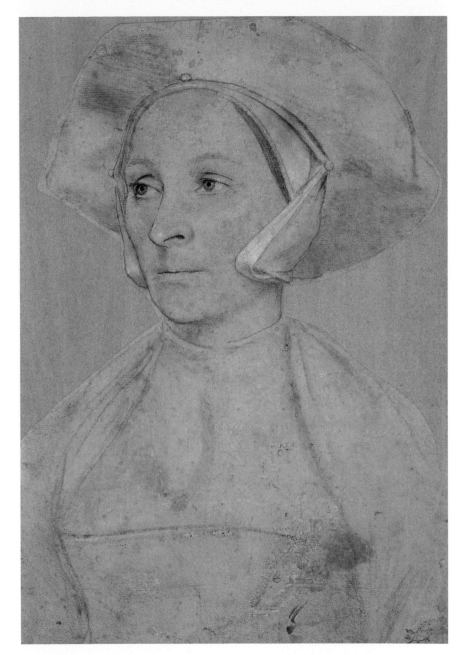

Portrait of an unknown English
woman
Hans Holbein the Younger
(1497/8–1543)
c. 1532–5
Swiss-German
Black and red chalk
H 27.6 cm, W 19.2 cm

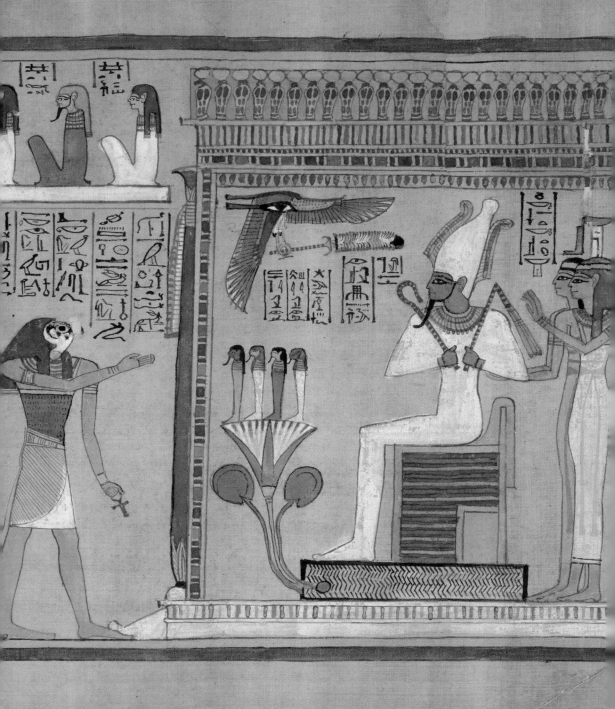

7 Death & the Afterlife

THE DAUNTING MYSTERY of death is not in the cessation of our body's vitality, but in the question of what, if anything, will follow. To counter this uncertainty, cultures throughout the world have personified death, giving it a form and a face that is familiar. According to the earliest body of Indian scripture, the Vedas, Yama, the first mortal to die, has a human visage, despite his red eyes and green skin; he rides a buffalo in his underworld domain. The ancient Greek deity Thanatos is handsome and youthful, but carries an extinguished torch. With his terrifying rictus and sharp scythe, the Grim Reaper rose out of medieval Europe's plague years when skeletal bodies of the stricken were all too commonplace. Each possesses an element of known life to help us turn a brave face to what we cannot know.

As life flows out of the body the face transforms. Blood circulation diminishes, turning skin ashen and pale. Eyes lose focus, cheeks hollow, and the mouth gapes open as the jaws grow slack. The head may droop to one side or loll back as muscular control diminishes. But as in life, every face in death is different, telling the story of each demise. The ravages of illness or the ruin of age leave their mark. A painful death contorts our features; we react to a violent death with panic and shock. For some, death offers a release from earthly tribulations; such release is welcomed with an expression of submissive repose.

Death robs the face of its animation, but not of its significance. In most cultures, the face is given special regard when the body is prepared for burial. Lifeless lids are closed over sightless eyes. Jaws are pressed back together, sealing a gaping mouth. Like the body, the face is dressed: hair smoothed, skin washed, and cosmetics applied to disguise a pallid complexion. In the ancient world, from the Mediterranean to the Americas, burial masks crafted from beaten gold, silver or precious stones paid tribute to royalty. Tomb portraits give the dead a presence in the living world for generations to come. But a likeness may have a greater purpose than simply reminding the living of the departed. The ancient Egyptians crowned the elaborate sarcophagi of high-status individuals with an idealized yet lifelike mask to guarantee that the *ka* – the vital spark released at the moment of death – would recognize

and return to the correct body in the afterlife. Burial masks often feature closed eyes that prevent evil spirits from entering or exiting the corpse. Others have inserts that simulate alert and focused eyes, ready to gaze on the revelations that come after death.

For the living, the mystery of death is compounded by grief. They search the face of the newly deceased for some final message or a flicker of life. Mourning casts a pall of sorrow. The mourner might openly weep, cover her face, or cast his eyes to the heavens (pages 276–7). But the mourner may also face the loss with a look of stoic fortitude or poignant forbearance. And the living cherish a token of the dead: a lock of hair or a lifelike image. A death mask, cast directly from the corpse, produces an exact representation that may be used in burial or commemorative rituals. Deathbed portraits – whether painted, drawn or photographed – soften the harsh reality and present a peaceful countenance, as though the subject were merely asleep (pages 266–7). The skull endures as a potent symbol, whether as the housing for a timepiece to remind the owner of the inevitability of death, or as a mosaic-embellished evocation of a powerful deity, such as Mictlantecuhtli, the Aztec lord of death (pages 296–7).

In many cultures, the transformation from life to death is conceived of as a journey. Coins placed on the eyes or in the mouth of the deceased pay for the passage. Spirits unable to reach their destination become restless; with a ghostly and often hideous visage, they remind the living of their own inevitable demise. Most concepts of the afterlife include a presiding authority – the formidable Hades of ancient Greek mythology, the skull-faced and blood spattered Mictlantecuhtli, an impassive Christ or fatherly Abraham – who doles out reward or punishment with a stern or kindly countenance. As a result, the dead may spend their eternity in a state of bliss or in hideous torment. Some cultures conceive of an afterlife in terrestrial terms, filled with familiar labour and leisure. Other promise that beloved faces, vanished from the mortal world, will be seen again. Still others envision inescapable decay, leaving only the skeleton and its grinning skull as the enduring testament to our human story.

When Death Calls

During the Middle Ages, the Grim Reaper, with his fixed grin and bony physique, reminded all men and women of their inevitable mortality. In the ancient Vedas, Yama reigned over the dead in the region of the south. A formidable figure with blue-green skin and fire-red eyes, he rode a massive buffalo and carried a skull-topped mace. Over the centuries, he was also known as King Emma, the arbiter of judgment and retribution.

Netsuke of King Emma
18th–19th century
Japan
Bronze, copper
Diam. 2.9 cm

RIGHT

Death riding
Albrecht Dürer (1471–1528)
1505
German
Charcoal
H 21.1 cm, W 26.5 cm

RIGHT, BOTTOM

Painting of the Hindu deity Yama,
the god of death, on his buffalo
mount
1800–5
Painted in Pune, India
Gouache on paper
H 26.4 cm, W 37.6 cm

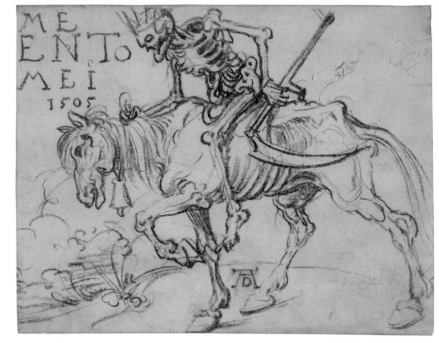

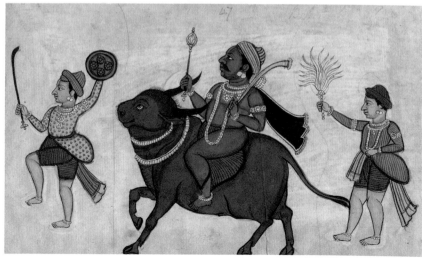

The identity of the Queen of the Night, subject of
the clay relief, is likely the comely, winged Babylonian
goddess Ereshkigal, who ruled over the dead in a
vast realm beneath the eastern mountains. Towering,
skull-faced and blood-spattered, the Aztec deity
Mictlantecuhtli also led a subterranean existence,
living with his wife, Mictécacihuatl, in Mictlan (the
underworld of Aztec mythology), where he watched
over the bones of the dead. His realm – the lowest
of the nine levels of Mictlan – received those who died
a natural death, but only after they had negotiated
many treacherous obstacles.

OPPOSITE
The Queen of the Night
Painted clay relief depicting
a Mesopotamian goddess with
feathered wings and talons
1800–1750 BC
From southern Iraq
Fired clay
H 49.5 cm, W 37 cm

RIGHT
Seated figure of Mictlantecuhtli,
the Aztec god of death
1325 -1521
Mexico
Sandstone
H 60 cm, W 27 cm

Facing Death

'Death, in itself, is nothing; but we fear
To be we know not what, we know not where.'

John Dryden, *Arueng-Zebe*, 1675

A lady on her deathbed with
a gentlemen standing by
Jacques de Gheyn II (1565–1629)
1601
Dutch
Bodycolour and grey wash
H 20.7 cm, W 28.6 cm

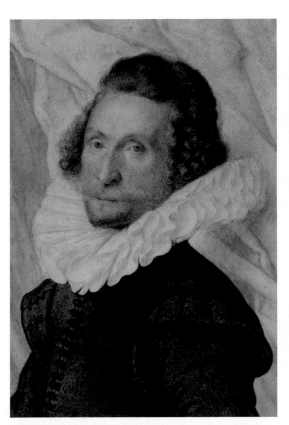

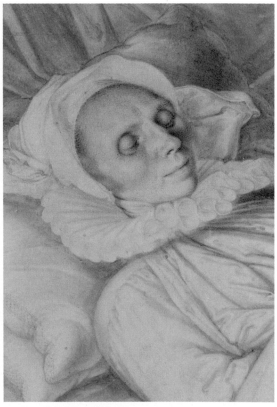

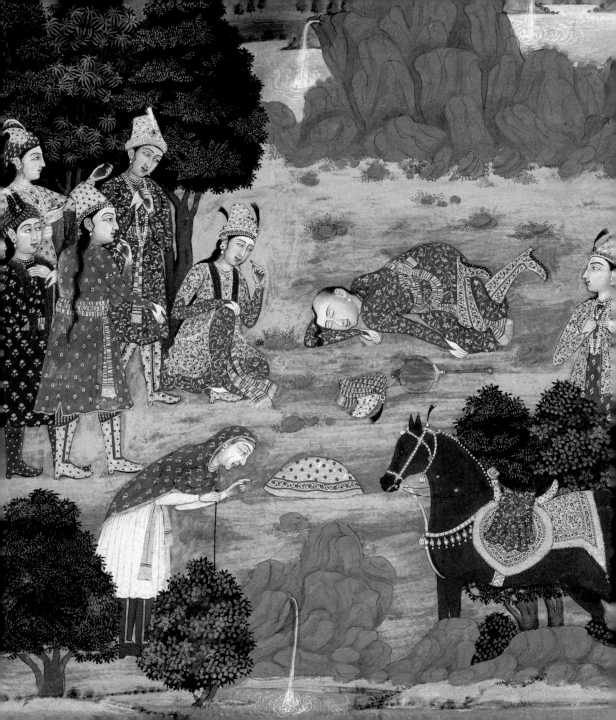

In cultural and faith-based narratives, the way in which an individual faces death is a testament to character. Farhad, the love-struck sculptor of Nizami's *Khamsah* (Five Poems), agreed to dig a roadway through Mount Bisotun to win the hand of Shirin, but a false report of her death drove him to take his own life by hurtling over the rocky cliffs. According to the book of Genesis, God ordered the patriarch Abraham to sacrifice his dearest son, Isaac, to test his faith. Reluctant but obedient, Abraham bound his son as God had instructed, but, as he raised his knife, a holy messenger stayed his hand.

OPPOSITE
The Death of Farhad
A single-page painting mounted
on a detached album folio
c. 1770
India
Ink, opaque watercolour and gold
on paper
H 40 cm, W 22.5 cm

BELOW
Maiolica dish depicting Abraham
being prevented from killing
Isaac by an angel
c. 1525–30
Made in Castel Durante, Italy
Earthenware
Diam. 26.7 cm

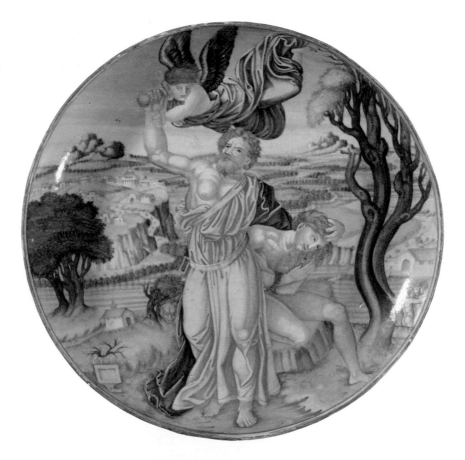

'Because I could not stop for Death
He kindly stopped for me'

Emily Dickinson 'The Chariot', 1890

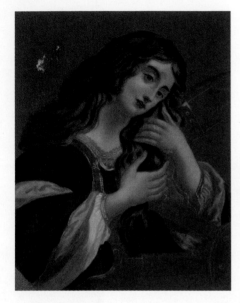

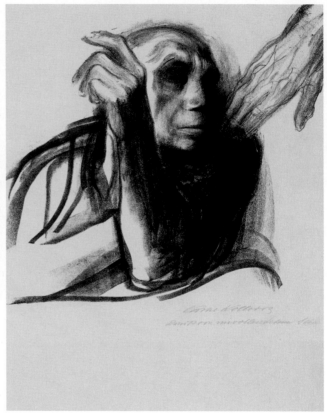

ABOVE

St Catherine of Alexandria
Anonymous, after Carlo Dolci
(1616–1686)
c. 1830s
British
Colour mezzotint
H 12 cm, W 9.6 cm

ABOVE, RIGHT

Ruf des Todes (Call of Death)
Käthe Kollwitz (1867–1945)
1934–5
German
Lithograph
H 40.5 cm, W 40.5 cm

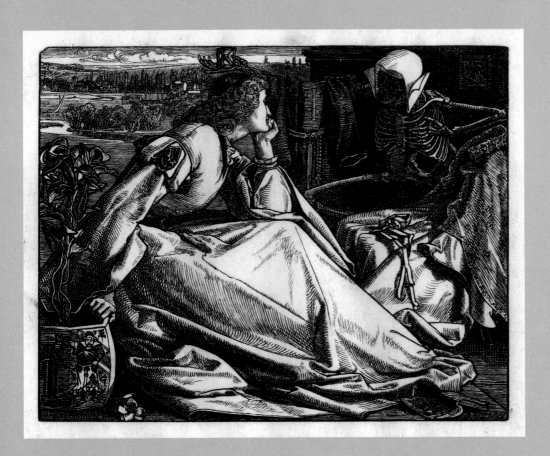

Until Her Death
Dalziel Brothers (1839–1905),
after Frederick Sandys
(1829–1904)
1862
British
Engraving
H 10.1 cm, W 12.5 cm

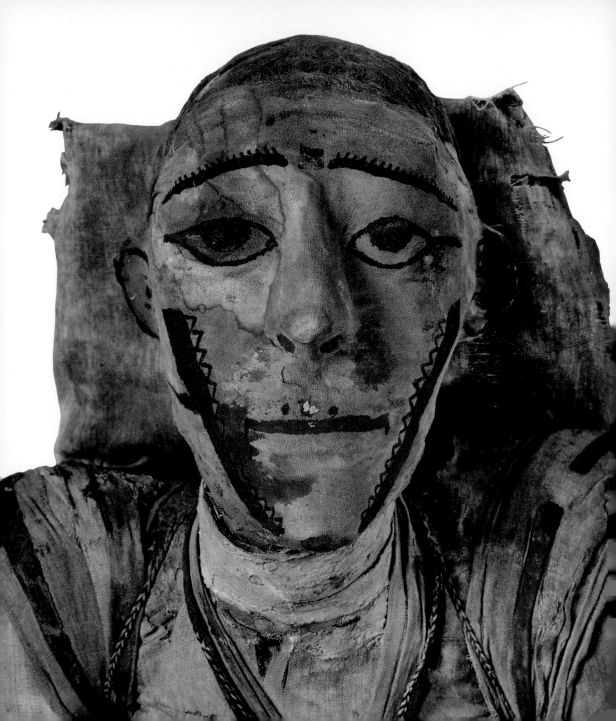

Deathly Countenance

OPPOSITE
Head of a mummy of an
adult man
Roman period,
1st–3rd century AD
Found in Egypt
H 41.5 cm, L 170.2 cm

BELOW
Fragment of a crucifix showing
the head of Christ
c. 1130
Found in All Hallows Church,
England
Wood and gesso
L 15.5 cm, W 7.2 cm

BELOW, RIGHT
Head of the Dead Christ
Albrecht Dürer (1471–1528)
1503
German
Charcoal
H 31 cm, W 22.1 cm

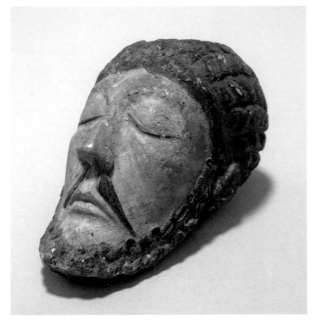

May 4th 1896.

Throughout history, the face of a corpse has been treated with special concern. Staring, sightless eyes are veiled with lowered lids or covered with coins to pay for transport to the next life. Gaping jaws are manoeuvred shut, erasing the memory of a last gasp of air or a cry for mercy. Cosmetics might be used to hide an ashen pallor. The practice of taking a mould from the deceased's face to create an accurate record of their features is seen in many cultures; drawings and photographs of the dead in repose were popular in nineteenth- and early twentieth-century Europe and America. While each crafted image had a culturally specific purpose – whether ceremonial, memorial or a souvenir of remembrance – most supplanted any traces of final agony with a serene aspect to bear witness to a peaceful death.

Portrait head of Alfred Hunt, deceased
Henry Tanworth Wells
(1828–1903)
1896
British
Black chalk
H 26.1 cm, W 36.1 cm

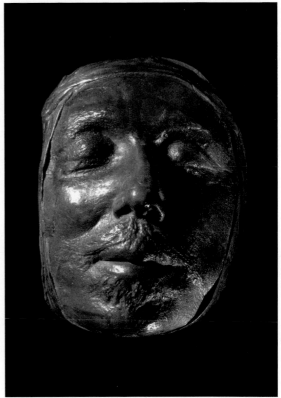

Portrait of a dead child
John Everett Millais (1829–1896)
Production date unknown
British
Graphite and black chalk
H 20.9 cm, W 15.5 cm

ABOVE, RIGHT
Wax death mask of Oliver
Cromwell
1658–1753
From England
Wax, metal
L 21.5 cm, W 10.2 cm

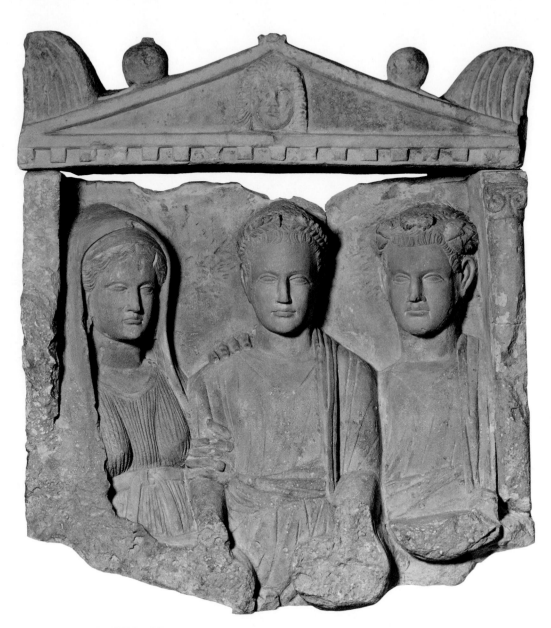

Laid to Rest

The ancient Romans crafted naturalistic wax masks to commemorate their distinguished ancestors. This practice led to the distinctive portraits mounted on tombs to memorialize the dead. Although their names are not known, the figures opposite infer by gesture that the decedent is flanked by his mother and brother. The inscription on the funerary relief below identifies Lucius Antistius Sarculo, once a master of the Alban college of Salian priests, and his wife, the former slave Antistia Plutia. The tomb was dedicated by two freedmen – Rufus and Anthus – to honour their patron.

OPPOSITE

Grave relief decorated in high relief with three figures
Roman Imperial period,
1st century AD
From Tremithusa, Cyprus
Limestone
H 98.5 cm

BELOW

Funerary relief of Lucius Antistius Sarculo and his wife and freedwoman (former slave) Antistia Plutia
Roman, 30–10 BC
From Rome, Italy
Marble
H 64.8 cm, L 95.3 cm

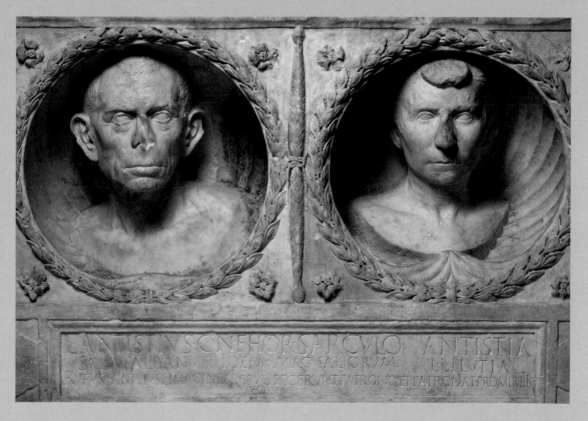

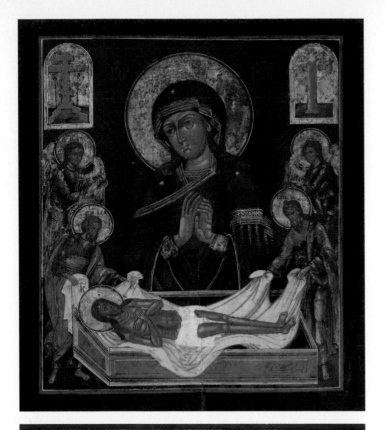

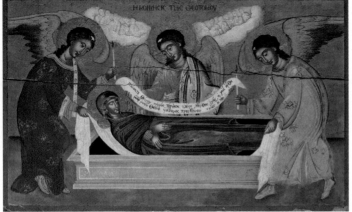

LEFT

Painted icon depicting the
Lamentation combined with
the Entombment of Christ
1750–1800
Made in Russia
Egg tempera, silver and gesso
on wood
L 51.5 cm, W 44.2 cm

LEFT, BOTTOM (DETAIL OPPOSITE)

Painted icon of the Entombment
of the Virgin Mary
17th century
Made in Greece
Egg tempera and gold leaf on
wood, primed with cloth and gesso
H 44.5 cm, W 70.7 cm

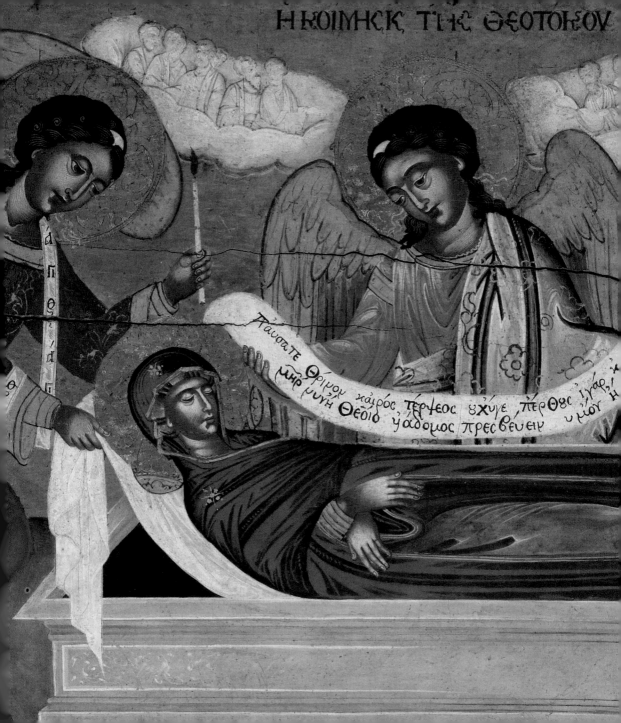

According to ancient Egyptian belief, bodies of
the dead were preserved to provide the spirit with
a means of transport on its journey to the afterlife.
If mummification failed and the mummy perished, an
elaborate coffin served as an apt substitute. Idealized
portraits and detailed inscriptions identified the coffins
and masks of high-ranking individuals; the mask
of Satdjehuty, a woman who may have been a senior
member of the court of Queen Ahmose Nefertary, is
embellished with gold leaf and blue paint to simulate
lapis lazuli. A generic, wooden coffin mask features
a lively expression and wide-open obsidian and ivory
eyes. The Canopic jars, with stoppers in the form of
human heads, stored viscera that had been removed
from the embalmed body.

RIGHT, TOP
Wooden Canopic chest of Gua
and four Canopic jars, each in
the form of a human-headed
deity
12th dynasty
Found at Deir el-Bersha, Egypt
Wood, linen and calcite
Chest: H 53 cm, D 55 cm

RIGHT
Wooden face of a coffin
18th dynasty, 1400 BC
Found in Egypt
Wood, ivory and obsidian
L 18 cm, W 14 cm

Cartonnage mummy-mask
of Satdjehuty
18th dynasty, c. 1500 BC
Found in Egypt
Plaster, linen, gold
H 61 cm, W 35.2 cm

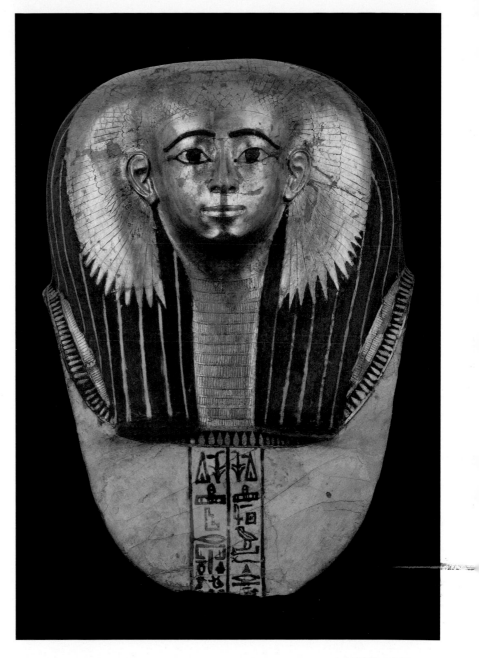

Funerary stela showing the
upper torso of a female figure
1st century BC
Found at Timna, Yemen
Calcite
H 30 cm, W 19 cm

Painted terracotta sarcophagus
of Seianti Hanunia Tlesnasa
Etruscan, c. 250–200 BC
From Poggio Cantarello,
near Chiusi, Tuscany, Italy
Terracotta
H 129.5 cm, L 180 cm

Mourning the Loss

'Our dead are never dead to us until
we have forgotten them.'

George Eliot, *Adam Bede*, 1859

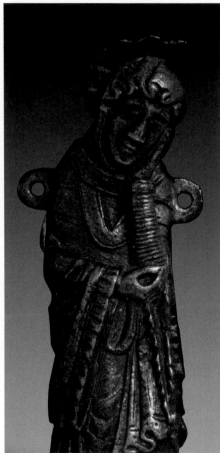

FAR LEFT
Wooden figure of Nephthys
kneeling, her hands raised
to her face in mourning
4th–3rd century BC
Found in Egypt
Wood, gesso
H 59 cm, W 14 cm

LEFT
Figure of the Virgin from a shrine,
in the traditional gesture of
mourning
1100–1150
Found in Durham, England
Bronze
H 10.8 cm, W 4 cm

OPPOSITE
Carved pietà (the Virgin holding
the dead body of Christ)
c. 1420
Made in Germany
Ivory
H 6.6 cm

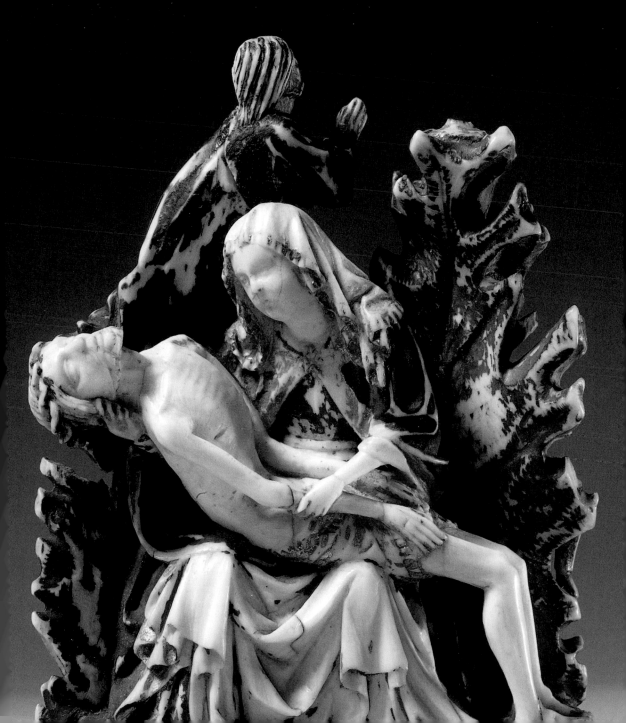

Mourning mask featuring a
human face carved in wood and
adorned with human hair made
by the Kanak
Before 1853
Made in New Caledonia
Wood, human hair, fibre, feathers
and bamboo
H 66 cm, W 45 cm, D 36 cm

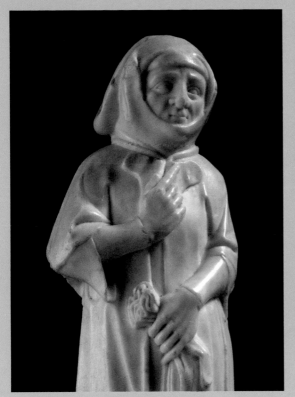

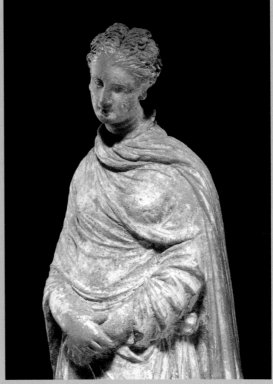

Mourners pay respect to the deceased through gesture, garb and expression. The voluminous hood of the late-medieval 'weeper' (a small image of a mourner set around a tomb-chest) almost hides his doleful face, but he has removed his gloves to place his hand upon his heart. The sorrowful expression of the Greek female statuette gains meaning from crossed hands held below the waist, indicative of sadness or loss. Carved in wood, crowned with human hair and worn with a black feather cloak, the mourning mask from New Caledonia represented the abiding power and ongoing presence of a deceased chief or community leader. Because the eyes of the mask are shut, the wearer would look out through the open mouth.

ABOVE, LEFT
Figure of a sergeant-at-law
15th century
Made in France
Found in Angers
Alabaster
H 33.3 cm, W 10 cm

ABOVE
Figure of a woman standing
Hellenistic, c. 300–275 BC
From Tanagra, Boeotia, Greece
Terracotta
H 19.7 cm

Memento Mori

The European concept of memento mori – literally, 'remember you must die' – is a grim warning, often in the form of a skull. But skulls take on a very different aspect in association with the Mexican holiday Día de los Muertos, or 'Day of the Dead', held between 31 October and 2 November (overleaf). Merging Catholic and Aztec traditions, families and friends welcome the return of the souls of lost loved ones by decorating graves and building altars of remembrance laden with tempting food and drink. The central symbol is the smiling *calavera*, a skull of cut paper (*papel picado*), or of moulded papier mâché or sugar, depicting the dead as happy and engaged in favourite activities, rather than as spectres to be feared.

OPPOSITE, TOP
Memento mori depicting a
woman wearing a headdress
and a skeleton
16th century
Made in France
Ivory
H 6.1 cm, W 3.1 cm

OPPOSITE, BOTTOM
A skull (memento mori) balancing
on a recessed ledge
Print by Andrea Andreani
(1540–1623)
1586–1610
Italian
Chiaroscuro woodcut
H 28.1 cm, W 33.7 cm

Cameo of a skull
and crossbones
17th century
Made in Europe
Glass
Diam. 1.2 cm

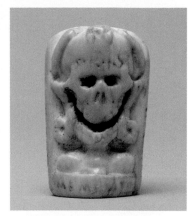

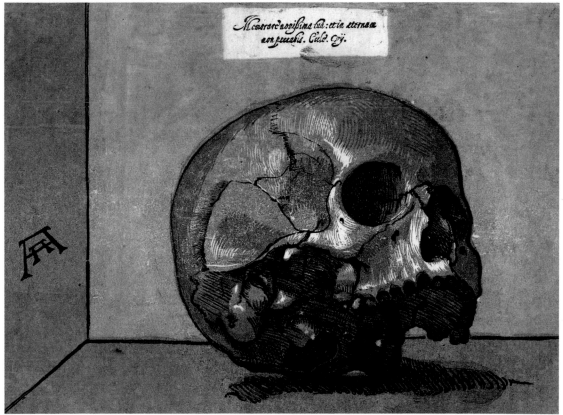

Paper-cut of a dancing skeleton
with hat in right hand, cane in left
hand, wearing bow tie and shoes
Made by Maurilio Rojas (born 1967)
1980s
San Salvador Huixcolotla, Mexico
Paper
H 74 cm, W 47.5 cm

Paper-cut of a skull and
crossbones with hat
Made by Maurilio Rojas (born 1967)
1980s
San Salvador Huixcolotla, Mexico
Paper
H 48.5 cm, W 36.5 cm

Afterlife and Paradise

Life after death may be conceived of as a paradise, where the worthy will mingle with the divine and enjoy eternal salvation and rest. Other concepts suggest that the deceased will reside in a familiar world. Elaborately furnished tombs in Egypt and China (pages 286–9) reflect this belief, providing the dead with everything from their old life – emblems of rank; domestic objects; even figurines of guardians, servants and animals – that they will need in their new one.

ABOVE
Figure of Garuda, Vishnu's
vahana (mount)
18th century
Made in India
Brass
H 5.5 cm, W 5.5 cm

ABOVE, RIGHT
The Guardian Angel
Jane E. Cook (*fl.* 1860)
1860
British
Pen and black ink with gold
H 13.1 cm , W 7.8 cm

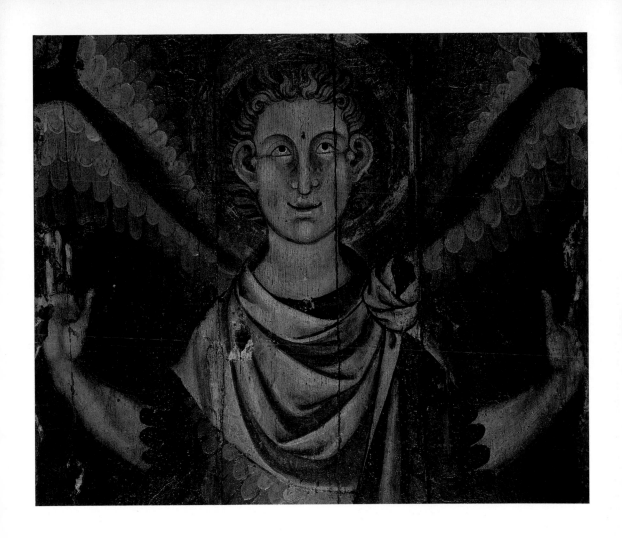

Panel painting from the
Palace of Westminster
c. 1263–6
Made in England
Oil and gesso on oak
H 45.6 cm, W 43.2 cm

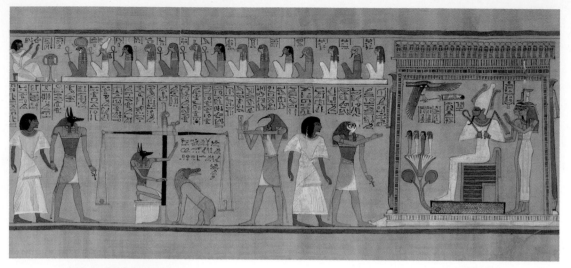

ABOVE

Book of the Dead of Hunefer
19th dynasty, *c.* 1290 BC
Found in Egypt
Painted papyrus
H 40 cm, L 87.5 cm

LEFT

Tomb painting of seated
Nebamun
18th dynasty, *c.* 1350 BC
From Thebes, Egypt
Polychrome painted plaster
H 67.5 cm

OPPOSITE

Blue glazed-composition shabti
(funerary figurine) of Sety I
19th dynasty, *c.* 1290 BC
Found in the Valley of the Kings,
Egypt
Glazed composition
H 22.8 cm, W 9.6 cm

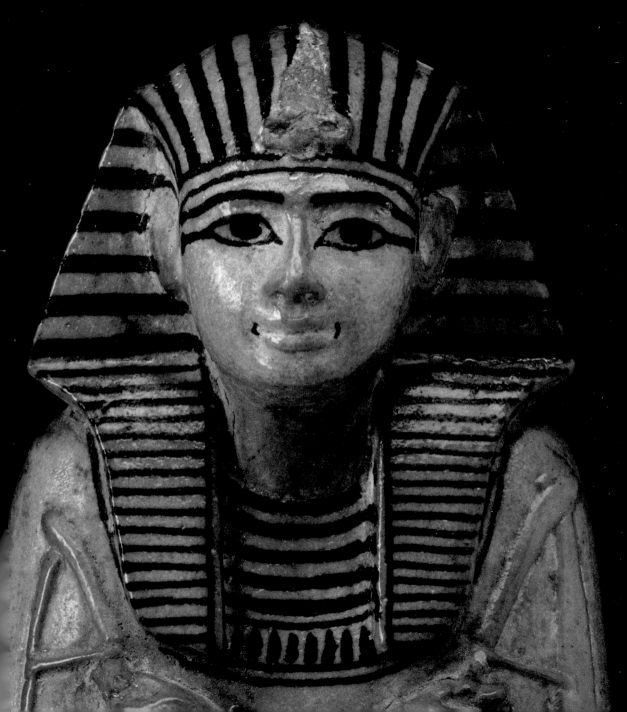

'The living is a passing traveller;
The dead, a man come home.'

Li Bai, 'The Old Dust', 8th century

BELOW (DETAIL OPPOSITE)
Part of a procession of ceramic
tomb figures of guardians
and officials
Tang dynasty, c. AD 728
Luoyang, China
Sancai ware
Max. H 109 cm

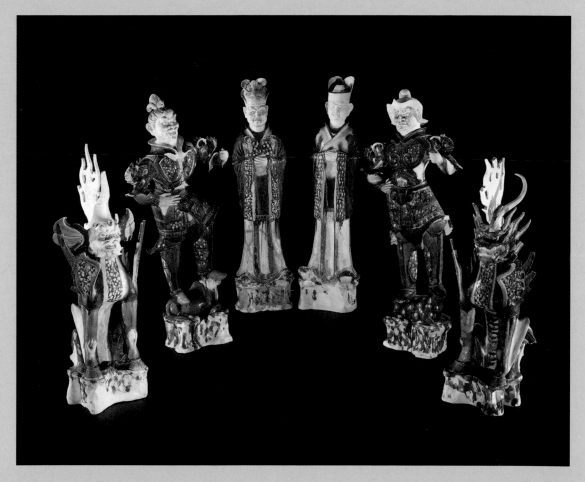

This magnificent illumination, rendered in gold on indigo-dyed paper, depicts Shakyamuni ('Sage of the Shakyas', one of the Buddha's descriptive names) delivering a sutra (sermon) to a circle of surrounding deities while the bodhisattvas that flank him welcome souls into paradise. The *Amitabha Sutra* is the foundational text of Pure Land Buddhism, and the arduous task of producing a *sagyeong* (Korean for 'hand-written copy') such as this one helped a soul to reach Sukhavati (Pure Land of Bliss). There, it would be released from the endless cycle of rebirth and the burden of worldly suffering.

Frontispiece from a hand-written copy of the *Amitabha Sutra*
Goryeo dynasty, 1341
Korea
Gold and silver on indigo-dyed paper
H 21.7 cm, W 17.6 cm (when open)

Beyond the Known World

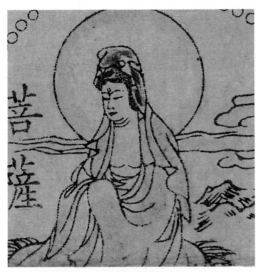

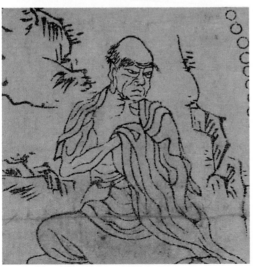

This print – *Picture of the Ten Directional Realms for Contemplating the Mind*, an interpretation of the *Avatamsaka Sutra* – illustrates the existential cycles of rebirth and escape for the Buddhist layman. The realms of the title include six that lead to rebirth and four that offer release, including the realm of the bodhisattvas (upper detail) and that of enlightened beings (*pratyekabuddha*; lower detail). In the centre of the work, the Chinese character *shin* (heart/mind) guides a disciple to seek freedom from the relentless return through meditation on the inner being. This type of mandala (symbolic diagram of the universe) was used as a teaching tool by itinerant nuns associated with the Kumano shrines

OPPOSITE (DETAILS LEFT)

Diptych print of the *Avatamsaka Sutra*

Hinokimae Hisei (*fl.* mid-1600s)

1669

Japan

Woodblock print

H 41.3 cm, W 29 cm

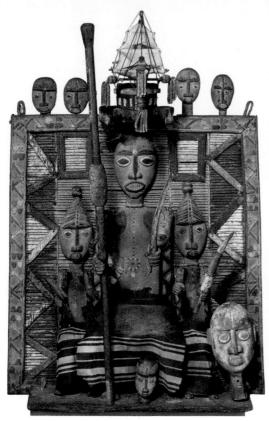

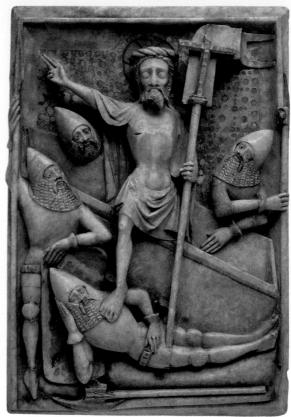

ABOVE

Carved wooden ancestral
screen (*duein fubara*) showing
the head of a trading house in
the masquerade outfit in which
he performed in life
19th century
Kalabari people, Nigeria
Wood
H 114 cm, W 73 cm

ABOVE, RIGHT

Panel of the Resurrection
c. 1370
Made in England
Alabaster
H 42.5 cm, W 29.5 cm

The head of a trading house portrayed on the Kalabari funeral screen is shown wearing the attire of the *Bekinarusibi* (big ship on head) masquerade, indicating his participation in the performance when he was alive. The sailing-vessel headdress symbolizes European trade connections; some of the lesser figures wear imported textiles, and one holds a European-style cane. Christ's crown of thorns recalls his earthly sufferings, while his nimbus proclaims divine immortality. The upper head of the Tang Dynasty fragment represents the Buddha with an *uma* (third eye) in the centre of his forehead; below him is the grimacing bodhisattva Avalokiteśvara, who relentlessly sought release for all beings from the endless cycle of birth, death and reincarnation.

Figure of two joined heads,
probably part of an eleven-
headed Avalokiteśvara statue
Tang dynasty, 8th–9th century AD
Dunhuang, China
Stucco
H 17.2 cm, W 6.8 cm

The Skull

'Life's true face is the skull.'

Nikos Kazantzakis, *Report to Greco*, 1965

Silver-cased verge watch
in the form of a human skull
Made by J. C. Vuolf
1655–65
Made in Germany
Silver (watch case)
H 3.9 cm, W 3.2 cm

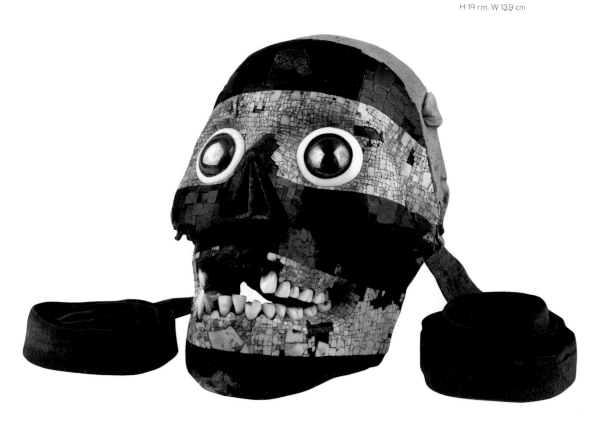

Human skull covered with
turquoise and lignite mosaic,
one of the Turquoise Mosaics
Mixtec-Aztec, 1400–1521
Mexico
Turquoise, pyrite, lignite, shell,
deer skin
H 19 cm, W 13.9 cm

Select Bibliography

Paloma Alarcó and Malcolm Warner, *The Mirror and the Mask: Portraiture in the Age of Picasso*, exhib. cat. New York and London: Yale University Press, 2007

David A. Bailey and Gilane Tawaduos (eds), *Veil: Veiling, Representation, and Contemporary Art*, exhib. cat. London: Institute of Visual Arts, 2003

Jonathan Bate and Dora Thornton, *Shakespeare: Staging the World*. New York: Oxford University Press, 2012

Brian Bates, with John Cleese, *The Human Face*. London: DK, 2001

Mary C. Blehar, Alicia F. Lieberman and Mary D. Salter, 'Early Face-to-Face Interaction and Its Relations to Later Infant-Mother Attachment', *Child Development*, 48:1 (March 1977): pp. 182–94

Anthony Bond and Joanna Woodall, *Self-Portrait: Renaissance to Contemporary*, exhib. cat. London: National Portrait Gallery, 2005

Milton Brener, *Faces: The Changing Look of Humankind*. Lanham; New York; Oxford: University Press of America, 2000

Richard Brilliant, *Portraiture*. London: Reaktion Books, 2002

The British Museum (Neil MacGregor, intro.), *Masterpieces of the British Museum*. London: The Trustees of the British Museum, 2014 [2009]

Marjorie Caygill, *A–Z Companion to the Collections*. London: British Museum Publishing, 1999

Marjorie Caygill, *Treasures of the British Museum*. London: The Trustees of the British Museum, 2009

Margo DeMello, *Faces Around the World: A Cultural Encyclopedia*. Santa Barbara, CA: ABC-CLIO, 2012

Robert Goldwater, *Senufo Sculpture from West Africa*, Greenwich, Conn.: New York Graphic Society, 1964

E. H. Gombrich, 'The Perception of Physiognomic Likeness in Life and Art', *The Image and the Eye: Further Studies in the Psychology of Pictorial Perception*. Ithaca, New York: Cornell University Press, 1982, pp. 105–36

Ian Jenkins, with Celeste Farge and Victoria Turner, *Defining Beauty: The Body in Ancient Greek Art*, exhib. cat. London: The British Museum, 2015

Charles T. Little (ed.), *Set in Stone: The Face in Medieval Sculpture*, exhib. cat. New York: Metropolitan Museum of Art/New Haven and London: Yale University Press, 2006

Neil MacGregor, *A History of the World in 100 Objects: From the Handaxe to the Credit Card*. New York: Viking, 2011

Charles Mack, *Masks: The Art of Expression*. London: British Museum, 2013

M. D. McLeod, *The Asante*. London: British Museum Publications, 1981

Daniel McNeill, *The Face: A Natural History*. Boston: Little, Brown, and Company, 1998

John Nunley and Cara McCarthy, *Masks: Faces of Culture*, exhib. cat. New York: Harry N. Abrams, Inc. Publishers, 2000

Daniel A. Offiong, 'The Functions of the Ekpo Society of the Ibibio of Nigeria', *African Studies Review*, 27:3 (September 1984): pp. 77–92

Louis Perrois, *Fang* (Visions of Africa series). Milan: 5 Continents, 2006

Tom Phillips (ed.), *Africa: The Art of a Continent*, exhib. cat. London: Royal Academy of Arts, 1995

Z. S. Strother, *Inventing Masks: Agency and History in the Art of the Central Pende*. Chicago: University of Chicago Press, 1998

Alexander Sturgis, *Faces* (Pocket Guide series). London: National Gallery Publications, 1999

David N. Wilson *The British Museum: A History*. London: British Museum Press, 2002

List of Illustration References

Index

Every book involves the ideas and talents of many different people, and I would like to thank those who contributed to *The Face*. I am very grateful for the support of everyone at Thames & Hudson, especially Julian Honer, editorial director, who initiated the project; Philip Watson, commissioning editor; Maria Ranauro, senior picture researcher; Kate Thomas, senior production controller; and Mark Ralph, editor. A special note of gratitude goes to the photographers and curators at the British Museum, as well as Claudia Bloch, senior editorial manager, and Sara Forster, editorial assistant, for their work, guidance and expertise. For the beautifully vital design of this complex book, I want to thank Peter Dawson and Alice Kennedy-Owen of Grade Design. Thanks as well to my colleagues Carley Altenburger, Paul B. Jaskot and Michal Raz-Russo, for their advice and encouragement, and to my scholarly home, the Newberry Library in Chicago, for continuing support.

Debra N. Mancoff is a Chicago-based author and Newberry Library Scholar-in-Residence who writes about the interconnections between the arts, culture and fashion. Her numerous books include *Danger! Women Artists at Work*, *Fashion in Impressionist Painting* and *The Garden in Art*.

The Face: Our Human Story © 2018 The Trustees of the British Museum/ Thames & Hudson Ltd, London
Text © 2018 Thames & Hudson Ltd
Images © 2018 The Trustees of the British Museum

Designed by Peter Dawson and Alice Kennedy-Owen, gradedesign.com

All Rights Reserved. No part of this publication may be reproduced or transmitted in any form or by any means, electronic or mechanical, including photocopy, recording or any other information storage and retrieval system, without prior permission in writing from the publisher.

First published in 2018 in the United States of America by Thames & Hudson Inc., 500 Fifth Avenue, New York, New York 10110

www.thamesandhudsonusa.com

Library of Congress Control Number 2018932317

ISBN 978-0-500-51862-5

Manufactured in China by Imago

For more information about the Museum and its collection, please visit
britishmuseum.org

On the cover
The objects shown on the back cover, which make up the composite image on the front, can be found on the following pages: (from left) 192, 62, 49 and 7.

Page 2
Maiolica basin with a profile portrait bust of a woman and the inscription 'Divine and beautiful Lucia'
Made by Master of the Triumph of the Moon at Marcigny
1524
Made in Italy
Tin-glazed earthenware
Diam. 42.2 cm, D 0.9 cm
See also p. 66

Page 4
Tomb painting of seated Nebamun
18th dynasty, *c.* 1350 BC
From Thebes, Egypt
Polychrome painted plaster
H 67.5 cm
See also p. 286

31192021656291